IMAGES
of America

BREEZY POINT

IMAGES
of America

BREEZY POINT

Peter James Ward Richie

ARCADIA
PUBLISHING

Published by Arcadia Publishing
Charleston, South Carolina

Library of Congress Control Number: 2015944541

For all general information, please contact Arcadia Publishing:
Telephone 843-853-2070
Fax 843-853-0044
E-mail sales@arcadiapublishing.com
For customer service and orders:
Toll-Free 1-888-313-2665

Visit us on the Internet at www.arcadiapublishing.com

*To love, leisure, and long-ago days at the Queen
Summer Resort of the Northern Pines*

CONTENTS

ACKNOWLEDGMENTS

For almost 100 summers, Breezy Point has offered crowded city folk a comfortable haven in the Northern Woods of Minnesota. I am a little embarrassed to admit that my first trip up to the storied resort came just a few years ago. Growing up in Whiz Bang's hometown of Robbinsdale, Minnesota, I heard tales of Breezy Point, but I didn't make it to Big Pelican Lake until I invited myself up to visit Captain Billy's log mansion. Breezy Point's owner, Bob Spizzo, and the editor of the resort's newspaper, George Rasmusson, graciously agreed to show me around. The idea for a Breezy Point addition to Arcadia Publishing's Images of America series was hatched in Captain Billy's living room. Since that day, the resort has been kind enough to create a temporary office for me in its file room and put me up overnight when the drive back down to the cities was dark and snowy. Breezy Point's owner, management, and staff all pitched in to make sure I had everything I needed to complete this book. Hospitality is their business and they do it better than anybody else. My heartfelt appreciation goes out to the resort's owner, Bob Spizzo; the general manager, Dave Gravdahl; and marketing director, Bonnie Tweed. Thanks to Whiz Bang enthusiast Shaun Clancy, the City of Breezy Point's deputy clerk Kathy Millard, and the volunteers at the Crow Wing County Historical Society, this book contains the finest Breezy Point photograph collection ever published. When I needed details or inspiration, I leaned on George Rasmusson's history of Breezy Point as detailed in the resort's *Breezy Pointer* newspaper and on Alvin Husom's book, *Riviera of the North: Breezy Point Resort 1920's–1930's*. Thank you, Lisa Bergin, for love and proofreading. Thank you, Jeff, Tricia, Samantha, and Ellie Hempel, for showing me around and providing many years of friendship and support. Additional appreciations go out to Carl W. Faust, Kelli Engstrom, Gil Bergin, Chris Brookes, Marcia and Dan Richie, Florence Ann Michaud, Paul De Kock, Hennepin County Library, Rollie Heywood, and the Robbinsdale Historical Society. Unless otherwise stated, all of the photographs in this volume appear courtesy of Breezy Point Resort.

INTRODUCTION

At the age of 16, Wilford Hamiliton Fawcett, better known as Captain Billy, ran away from home, joined the Army, and shipped out to the Philippines. Fawcett served as a private during the Philippine Insurrection. After the kris blade of a Moro tribesman tore through Fawcett's leg, Army doctors recommended an amputation. Fawcett rejected the operation, returned home, and found a backwoods doctor who had a reputation for saving doomed limbs. When he was back up on his feet, Fawcett married Viva Claire Meyers. In 1906, the couple settled in Minnesota, where Fawcett took a job as a railway clerk. Soon his wife gave birth to twins, and Fawcett took a second job as a police reporter for a Minneapolis newspaper. At the outbreak of World War I, he returned to the Army, where he worked on the military newspaper, *Stars and Stripes*. Fawcett rose to the rank of captain and adopted his famous nickname, "Captain Billy." When he returned from the war, Fawcett opened a bar called the Army Navy Club. Unfortunately, Prohibition became the law of the land in 1920. The bar closed, and Fawcett was left scrambling to support his growing family. During his Army days, Fawcett collected saucy stories he did not dare print in *Star and Stripes*. Inspired by a North Dakota periodical called *Jim Jam Jems*, Fawcett decided to risk $500 to print a humor magazine for veterans. Named after its creator and the sound of an incoming artillery shell, the first issue of *Captain Billy's Whiz Bang* sold out in less than a week. By the time the fourth issue hit the newsstands, the little magazine had sold over 500,000 copies. Fawcett became rich and famous almost overnight. In 1920, Captain Billy and his brothers Harvey and Roscoe Fawcett formed Fawcett Publications. The men set up shop in the upper floors of the Security State Bank Building in Robbinsdale, Minnesota, and went to work creating Jazz Age America's best-loved periodicals.

Captain Billy liked to fish in the summer and hunt in the fall. It was on a fishing trip during the summer of 1920 that he fell in love with Big Pelican Lake. New wealth fueled an ambitious sense of adventure in life and business. Despite the rumors of a coming recession, Captain Billy bought an 80-acre tract on the shore of Big Pelican Lake and went into the resort business. The property came with a handsome frame house and four or five cabins. In 1921, construction began on 26 well-appointed cabins named after the alphabetical streets of Robbinsdale and Minneapolis. Visitors were thrilled to find electric lights and running water in the middle of the wilderness. Word of the resort spread and advertisements began appearing in Captain Billy's magazines. In 1922, Fawcett Publications brought out the first issue of *True Confessions*, and construction began on the Breezy Point Lodge. Completed in 1924, the magnificent log building contained 140 modern rooms, a bowling alley, beauty parlor, billiard room, and one of the largest dining rooms in the state. Captain Billy built his own home a stone's throw from the new lodge. The Y-shaped, nine-bedroom log mansion was listed in the National Register of Historic Places in 1980.

Fawcett Publishing came of age with Hollywood. Captain Billy published a long list of screen-fan magazines and used his gift for promotion to lure celebrities and movie stars deep into Minnesota pine country. Breezy Point had something for everyone and no expense was spared. Guests filled

long summer days with tennis, horseback riding, trapshooting, and archery. The wide beach featured a 300-foot dock, waterslide, and a fleet of canoes. Guests in search of a thrill could take an airplane ride or zip across Big Pelican Lake in Captain Billy's *Whiz Bang* boat. The propeller-powered craft had a top speed of 45 miles per hour. In 1925, the golf course, carved out of 150 acres of adjacent woodland, hosted an exhibition tournament featuring golf legend Walter Hagen. After the golf game, Captain Billy brought Hagen to the trapshoot range. Before the demise of Prohibition, Breezy Point operated a speakeasy bar and casino in the basement of the lodge. The hooch was kept in a tunnel that led to Captain Billy's house. Captain Billy burned the candle at both ends, and Breezy Point was his plaything. The astute businessman, who made money on all of his publishing ventures, did not mind losing money on Breezy Point. Magazines like *Modern Mechanics*, *Screen Secrets*, and *Triple X Western* kept Fawcett Publications and Breezy Point afloat during the Great Depression. Captain Billy eventually stepped down from his role at the head of the company and devoted himself to circling the globe in search of big game. Trophies from every continent decorated the lodge, and Captain Billy's log mansion became a museum of Japanese tea gowns, Algerian handicrafts, and Hawaiian antiquities.

In 1940, Wilford Hamilton Fawcett, better remembered as Captain Billy, passed away in Hollywood, California. The resort was closed during World War II and sold to the owner of a Coca-Cola bottling franchise in 1946. Breezy Point changed hands several times before a devastating fire reduced the main lodge and annex to ashes in 1959. In the early 1960s, Breezy Point was rebuilt and reimagined by Hollywood entertainer Ginny Simms and her husband, the former attorney general for Washington State, Don Eastvold. The glamorous couple invested millions in new buildings and facilities. They envisioned a year-round vacation community and built the first condominiums in Minnesota. Unfortunately, Breezy Point's miraculous change of fortunes was undone by financial mismanagement, and the resort endured a few uncertain years before the Twin Cities–based Hopkins House motel and restaurant chain acquired it. The new owners took advantage of regional developments like the Brainerd International Raceway and the advent of snowmobiling to put the resort back on track. In 1981, Bob Spizzo bought Breezy Point and introduced Minnesota to time-sharing. The resort has been growing ever since. Today, Breezy Point is the largest resort operation in the state. The sprawling vacation community encompasses three golf courses, a busy hotel and convention complex, an ice arena, and over 750 recreational vehicle campsites. Change is always in the wind along the sandy shores of Big Pelican Lake, but Captain Billy's vision and adventurous spirit will forever soar above the piney woods and clear waters of Breezy Point.

One

THE WHIZ BANG RESORT

"THIS is the season of the year when the women change the song to read 'Home, Sweep Home.' Ye old farmer from Robbinsdale, 'whoe eydits this bundle of ye filosophy,' as Ben Franklin might have written it, also has been about as busy as a two-headed cat in a bird show. Between taking care of farm chores; putting the Whiz Bang to bed regularly; petting and coddling our new magazine, 'True Confessions' into life being, and installing a flock of fol-de-rols at Breezy Point Lodge—Whiz Bang's summer resort on Pelican Lake. . . . WHICH reminds that up at Breezy Point, this old hayseed-editor has not only the finest all-around summer resort in the northern hemisphere but also the finest equipment for 'space killing' ever gathered under one tent—to-wit: One aeroplane; 160 h. p.; one seaplane, 100 h. p.; one sea sled, 90 h. p., and one Henry Ford, 16 candlepower. The seaplane—a former navy boat—arrived last week and everybody on the ranch, from the culinary maid to the stable boy, has been busy fiddling around to make sure that the carburetor doesn't get mixed up with the water pump in the setting up process. There are so many small lakes and rivers in Minnesota that one can fly from Breezy Point Lodge to Minneapolis—150 miles—with always a landing place for a seaplane within gliding distance. Two weeks ago Sunday Mrs. Billy and I flew down to Minneapolis from Breezy Point for over-Sunday and on the return trip we had a nice flop in a farmer's field as a result of a blown valve or something akin. . . . If this were a confessing day I fear this old farmer might be able to tell a few, himself, but it isn't, and anyway when Captain Billy loses his love for the good old-fashioned kissing smack he will be so old that the mosquitoes will not bite him."

—*Captain Billy's Whiz Bang*, July 1922

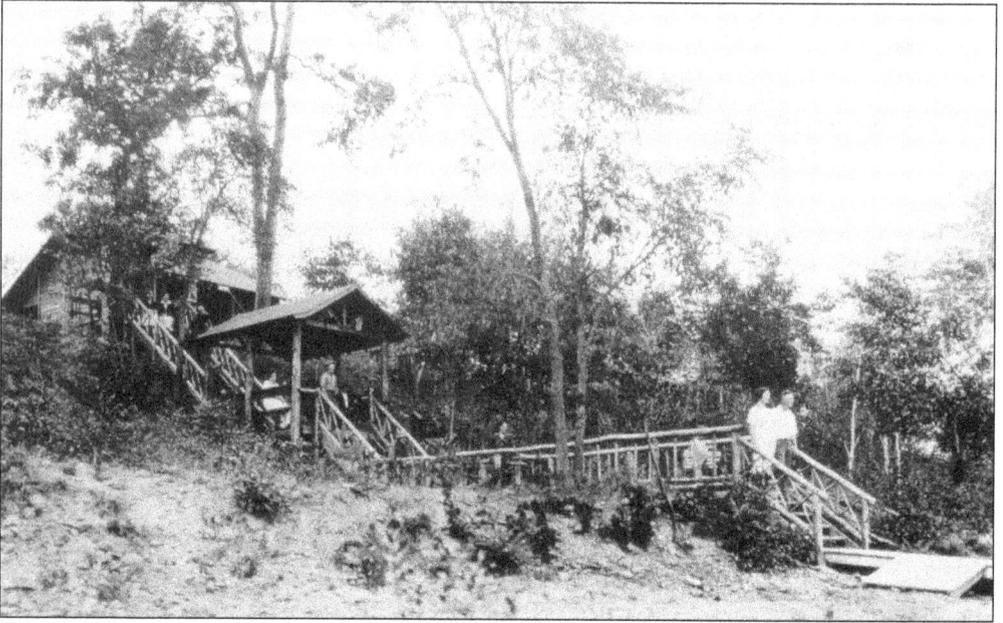

On February 13, 1921, a newly rich publisher put $500 down on an 80-acre Big Pelican Lake property called Breezy Point. Legend has it that the seller, Fred LaPage, and his eccentric buyer left Robbinsdale, Minnesota, and drove 150 miles of blizzard and bad road that same night. Upon arrival at Breezy Point, the buyer waded through the snow and sketched out plans for a retreat among the pines.

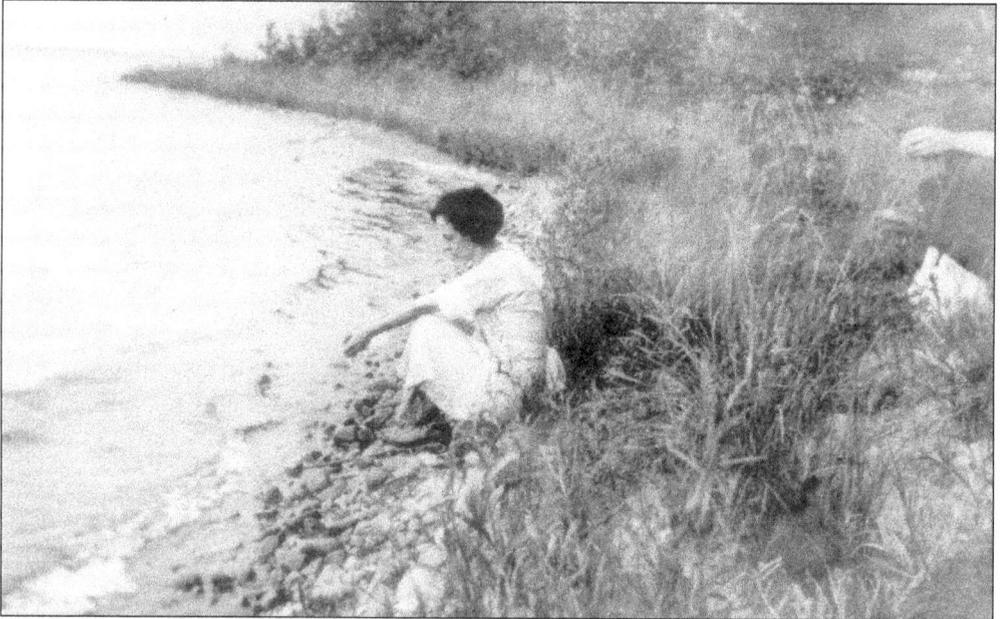

An advertisement in *Captain Billy's Whiz Bang* magazine announced the opening of the 1922 season at Breezy Point and invited the public to "get close to nature! Surrounded by health-giving pine trees and facing a white sandy beach of a clear water lake, Breezy Point Lodge offers to the crowded city folk a comfortable haven in the northern woods of Minnesota."

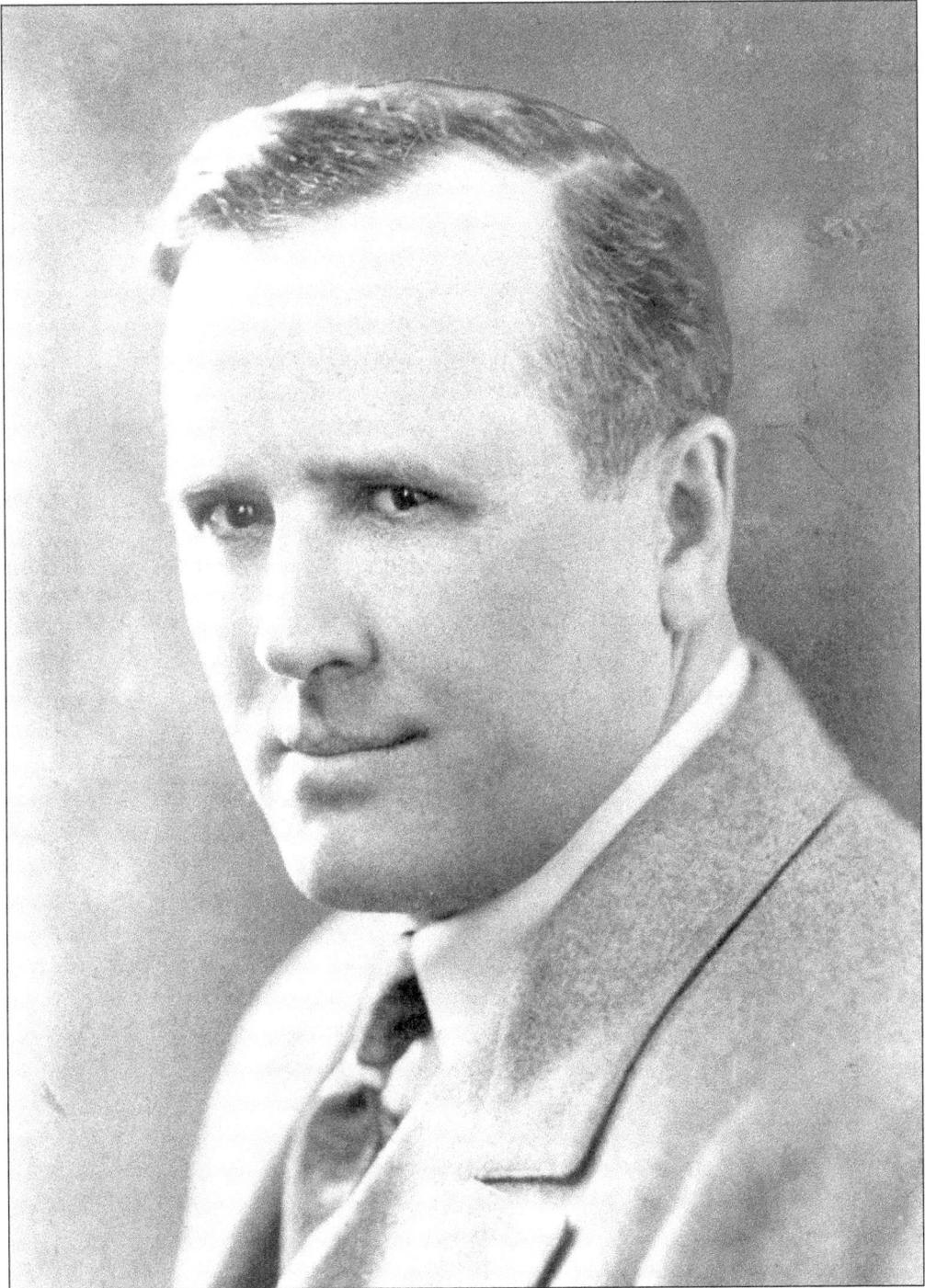

Born 1885, Wilford Hamilton Fawcett, better known as Captain Billy, is fondly remembered as an Olympic athlete, veteran of two wars, big-game hunter, millionaire publisher, and the owner of Breezy Point Resort. He made his fortune on a men's humor magazine called *Captain Billy's Whiz Bang*. The first issue appeared in October 1919. By 1923, the magazine was selling 425,000 copies a month. (Courtesy of Hennepin County Library.)

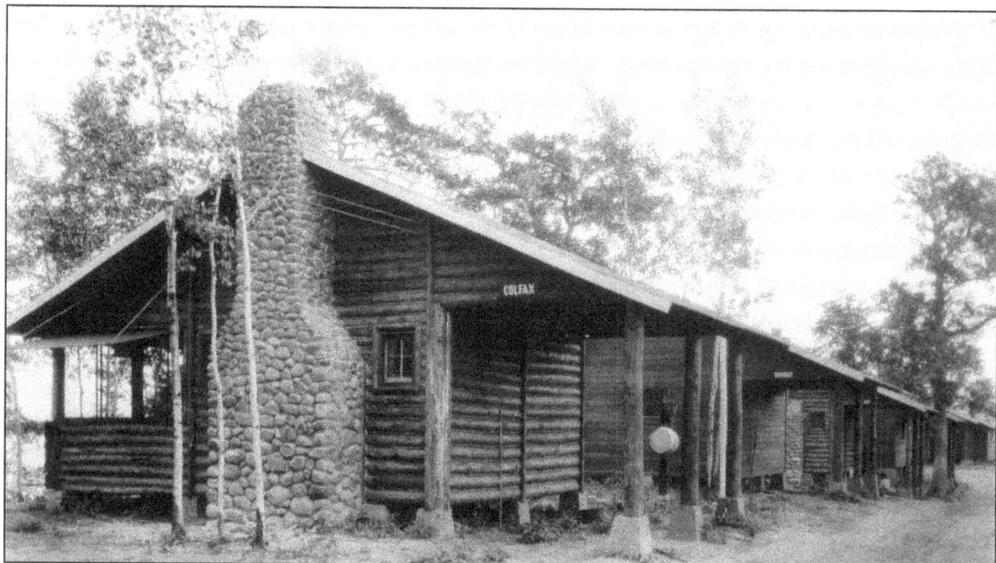

Two months after Captain Billy purchased Breezy Point in 1921, construction started on a row of cabins named alphabetically after Minneapolis streets. These accommodations were a big hit with tourists and additional cabins were built the following summer. After 26 cabins named after Minneapolis streets were completed, 8 more cabins were named after streets in St. Paul.

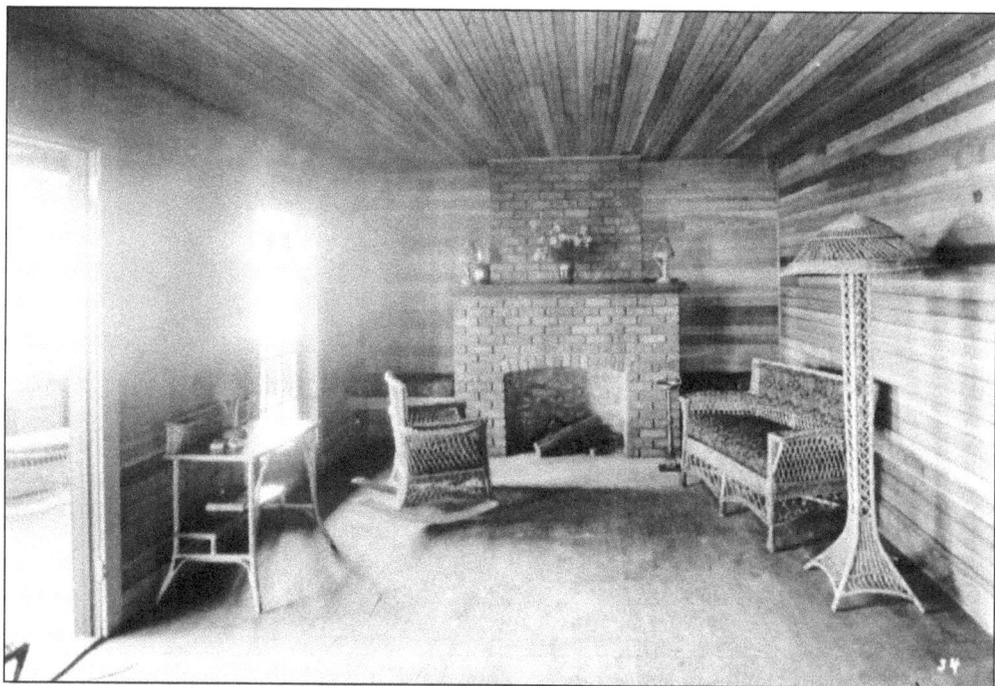

Before Captain Billy built the Fawcett House, he stayed a little further up the cottage road at Thomas Cabin. In the late 1920s, the cabin became a favorite retreat for World War I flying ace Eddie Rickenbacker. Slightly larger than the other cabins, Thomas provided guests with a wonderful view of Pelican Lake and Gooseberry Island.

12

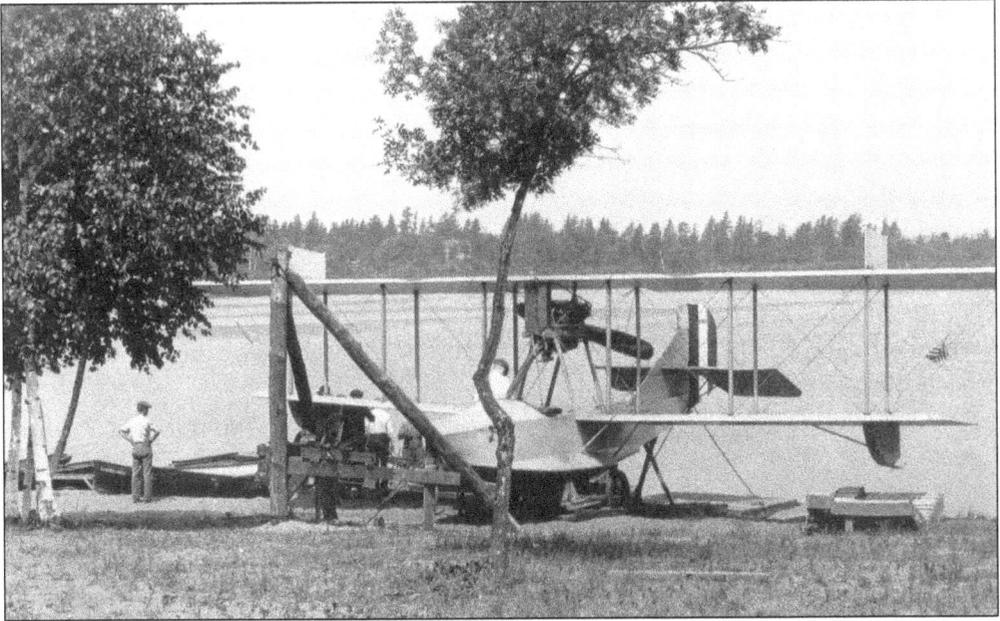

In 1922, a Duluth businessman bought an OXX-6 engine Curtiss Seagull flying boat. During delivery, the plane ran into trouble and was forced to land on an isolated lake. Wind and weather stranded the flying boat for days. Captain Billy heard about the marooned aircraft and bought it for $12,000. That summer, he hired Robbinsdale Airfield pilot Walter Bullock to deliver the plane and fly guests high above Breezy Point.

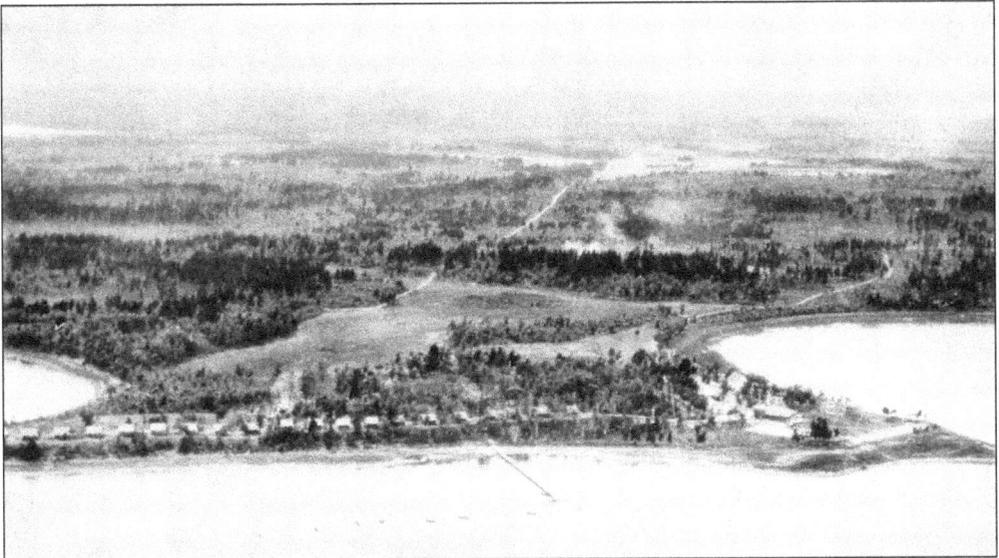

Captain Billy was one of Minnesota's aviation pioneers. Between 1921 and 1925, he maintained an airplane and seaplane for business and pleasure purposes. The site of the present-day Traditional Golf Course at the resort was used as a landing field. In the early years, Captain Billy flew back and forth between Breezy Point and his Fawcett Publishing offices in Robbinsdale three times a week.

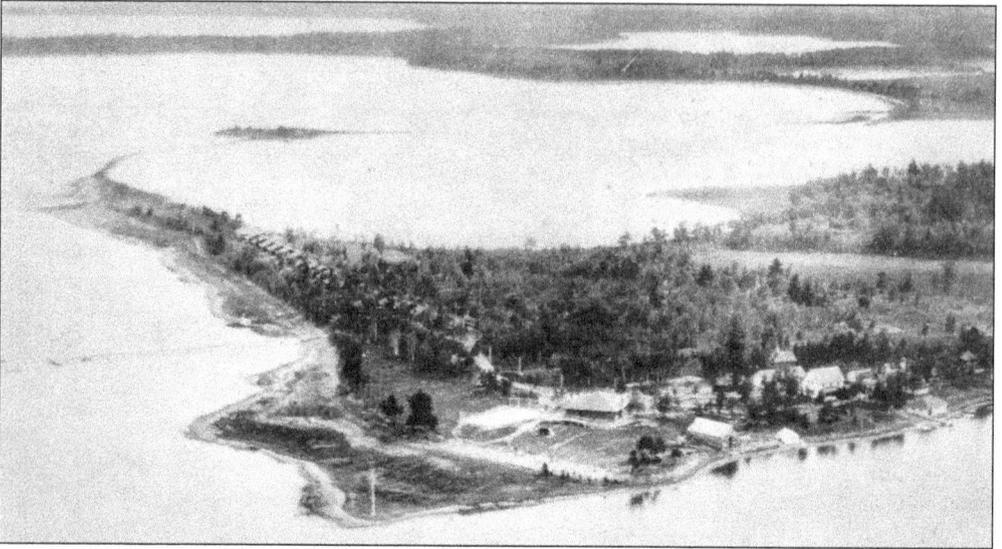

Originally built for family and friends, the cabins on Cottage Hill became a popular retreat and additional cabins were built as rental properties. A clubhouse and pavilion provided a gathering place for Fawcett's faithful followers. Before the end of 1921, $70,000 to $80,000 had been spent on Breezy Point, and plans were being drawn up for further development.

Breezy Point and Fawcett Publishing were a family affair. One of Captain Billy's elder brothers, Harvey Fawcett (right), ran the business end of Fawcett Publications from its inception until he was fired in 1923 for taking commissions on pulp paper purchases. After leaving the family business in disgrace, he purchased and began publishing a Whiz Bang–inspired Canadian magazine called *The Calgary Eye Opener*.

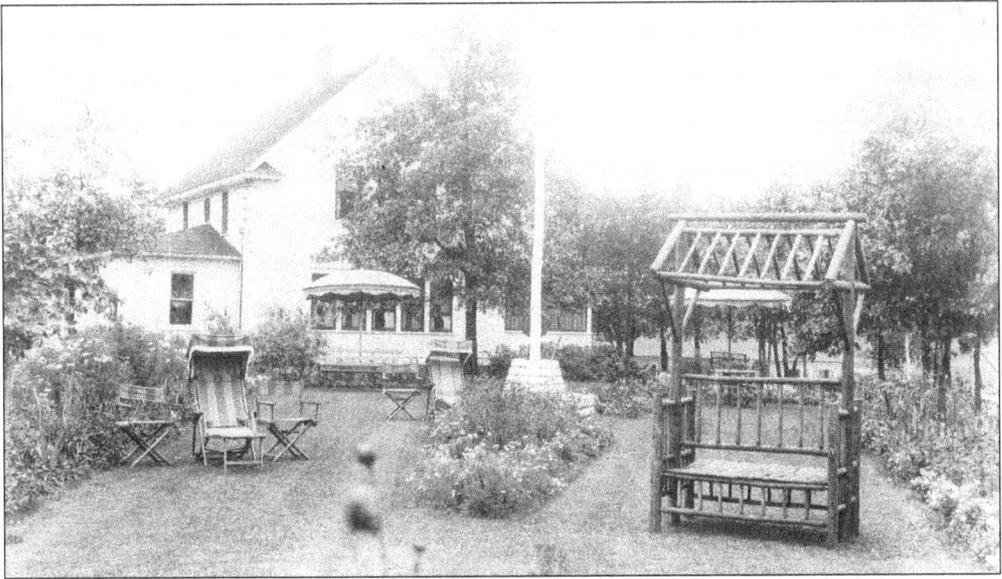

This little frame house and four rustic cabins were the only structures when Captain Billy bought his resort from Fred LaPage in 1921. The following spring, plans were drawn up for a small subdivision of cabins overlooking Big Pelican Lake. The house was converted into a boys' dormitory after the main lodge at Breezy Point was completed in 1924.

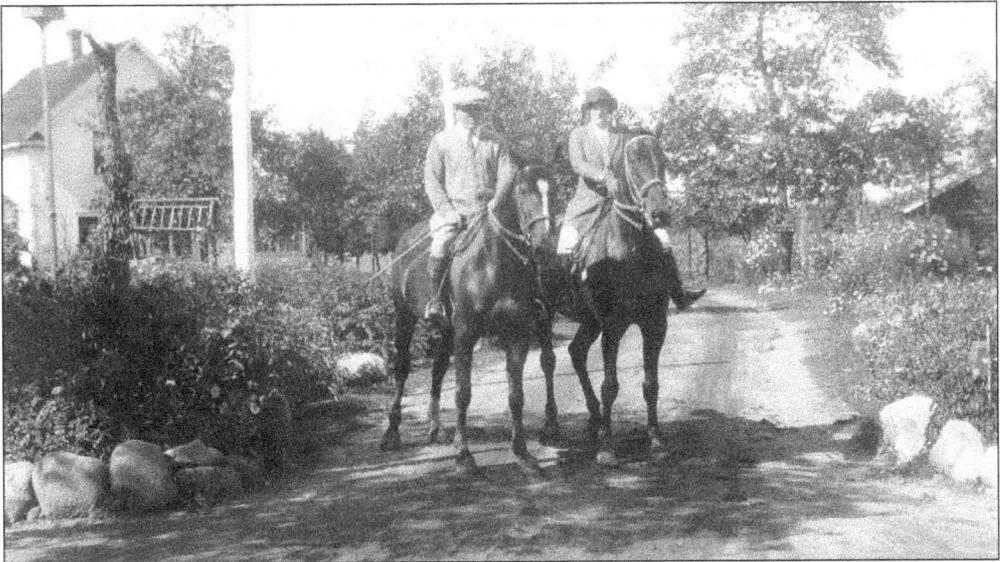

Horseback addicts could spend all their waking hours in the saddle. Dozens of bridle paths led out of Breezy Point's stable into endless stands of pine and mixed timber. Guests selected their mounts from a stable of 20 horses. The resort's thoroughbreds were taken care of by the colorful English hostler Percy Walker. Captain Billy and his wife, Claire Fawcett, dressed to the nines for their morning rides.

Pequot stonemason Charlie Skoog's work can be found all over Breezy Point. In addition to the front gates, Skoog's hand is evident in the steps and retaining walls at the Fawcett House and the steps built in 1928 leading up to the Breezy Point Chapel. Captain Billy Fawcett called them the "Golden Stairs." For decades, the mysterious stairs led to an empty lot. In 1965, a chapel was built on the site.

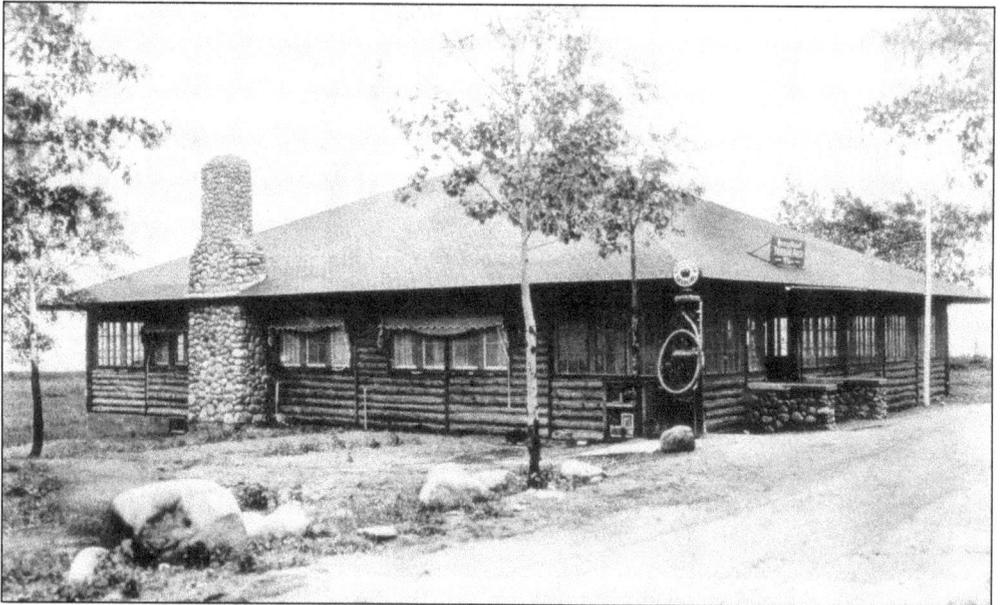

Built as a dance hall in 1921, Breezy Point's clubhouse was extensively remodeled over the years. The front porch was enclosed and extended a year after the resort opened. At the dawn of the automobile age, a gas pump was installed near the front door. In 1950, a kitchen, dining area, and bar were added. Eight years later, construction was completed on a second-level duplex apartment.

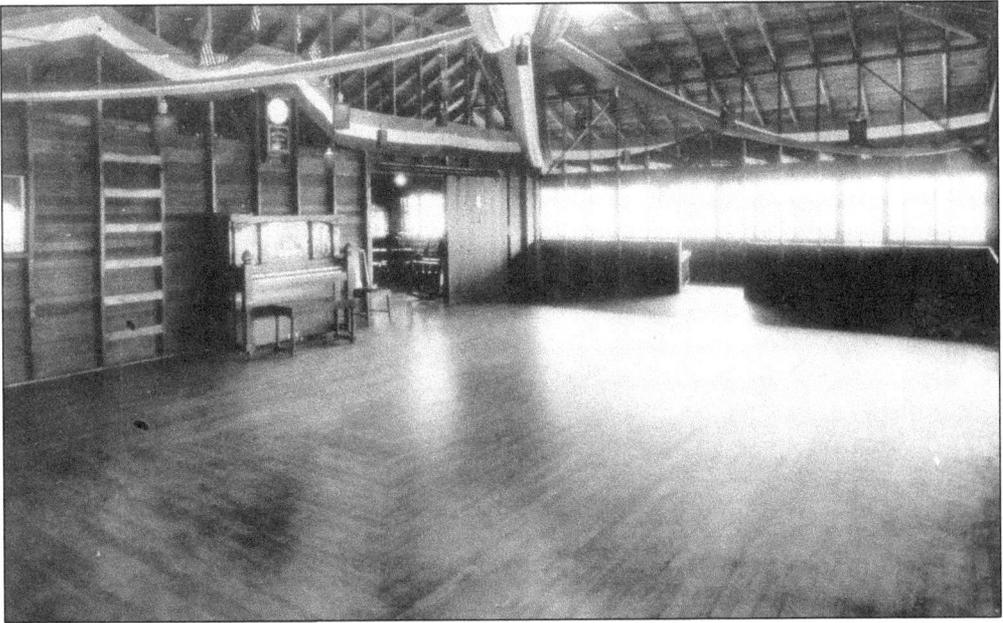

The clubhouse, like all pretentious structures carrying that name, had no excuse for being, except that it was in the center of things with tennis courts on one side and trapshooting on the other. During the day, the building was a nice place to loaf, have a drink, meet people, and play a hand of bridge. On Saturday evenings, the room was filled with orchestra music and dancing.

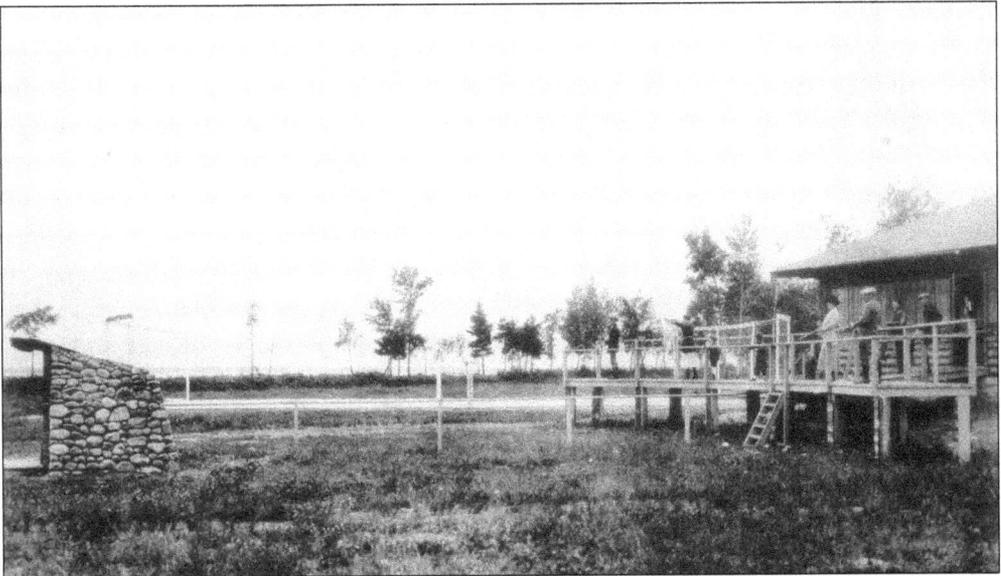

In 1924, Captain Billy competed with America's Olympic trapshooting team in Paris, France. Back home in Minnesota, Captain Billy designed trap- and skeet-shooting ranges for his resort. Many of the Midwest's most important shoots were held at Breezy Point. Guns were provided, but guests were also encouraged to bring their own.

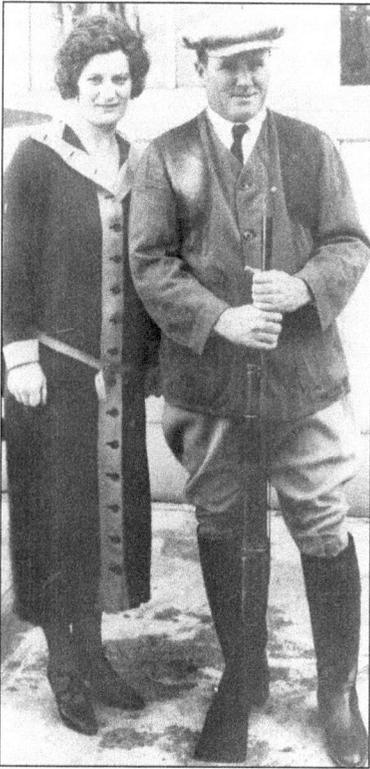

Captain Billy divided his time between Breezy Point and his adopted hometown. References to Robbinsdale and the resort appeared in every magazine. A 1925 *Whiz Bang Winter Annual* features a photograph spread depicting life on the "Whiz Bang Farm." The caption under this photograph of Captain Billy and his first wife, Claire, claims their smiles are the result of a good score at the traps. (Courtesy of Hennepin County Library.)

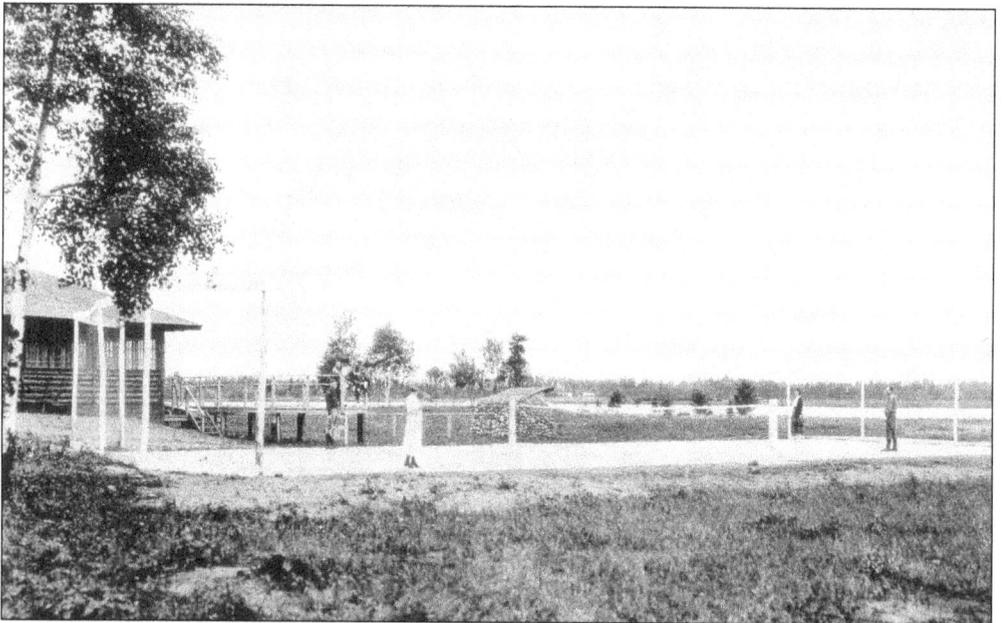

The golden age of tennis began in 1920s. People across the country were thrilled by reports of Bill Tilden's Wimbledon performances. Helen Wills became the first American woman to achieve international celebrity as an athlete after her 1924 Olympic victories in Paris. An early Breezy Point brochure reminded guests that although tennis was strenuous, young people loved it, and therefore, they would find good courts, well kept up.

In the summer of 1924, Captain Billy packed his bags and joined America's Olympic trapshooters in Paris, France. It was the fifth appearance of the event. The men's trap was held at Issy-les-Moulineaux on July 8 and 9. Forty-four shooters from 14 nations competed. Captain Billy came in 18th place with a score of 91. Upon his return to the states, he published a magazine of naughty French prints.

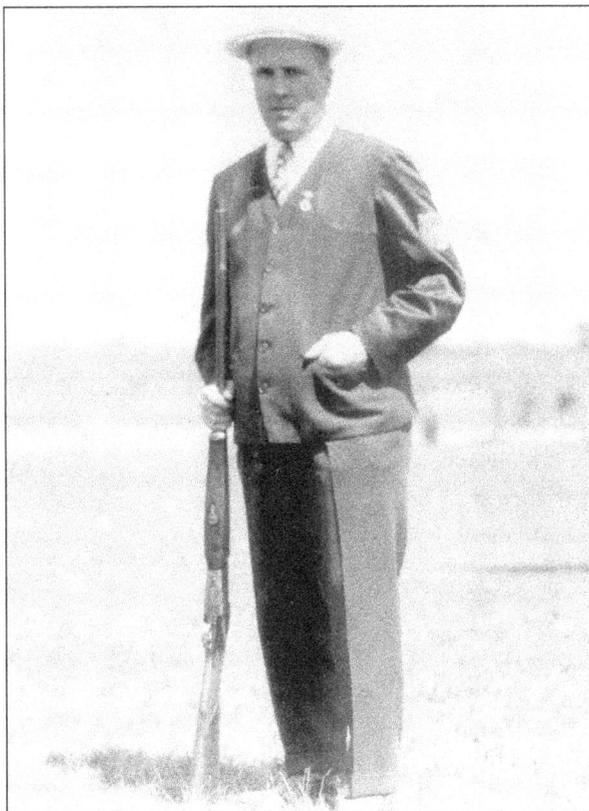

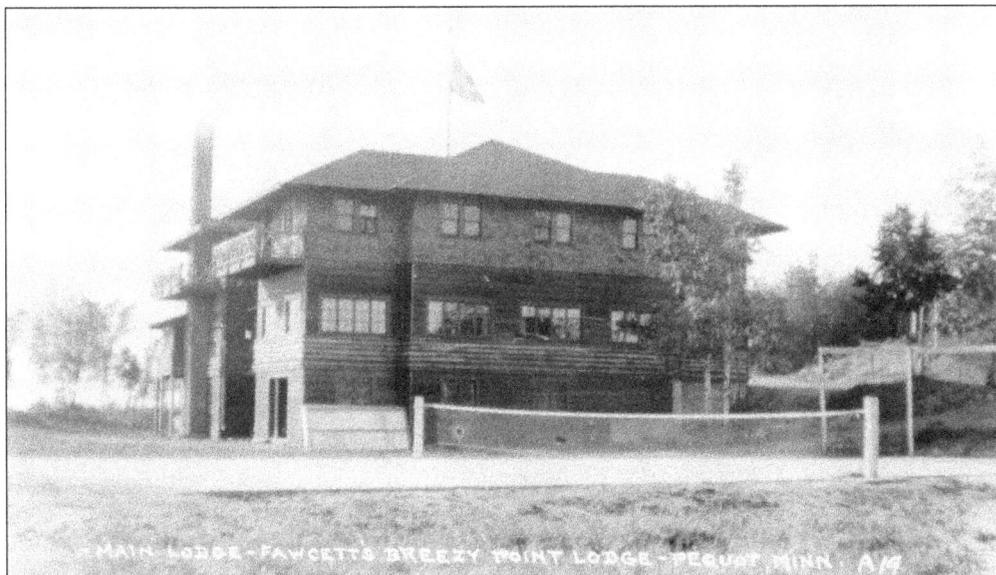

At the end of 1922, construction began on Breezy Point Lodge, designed by the architectural firm of Magney and Tusler. The lodge was an impressive sight. Built on a slope, its first floor was exposed only on the lakeside. After the main lodge was finished, plans were drawn for another building called the Edgewater Annex. In 1928, Magney and Tusler were hired to create the Foshay Tower in Minneapolis.

Captain Billy's Whiz Bang was the little magazine that started it all for Fawcett Publications. The first issue appeared on Minneapolis newsstands in October 1919. Fawcett sold out the first run of 5,000 copies. Four years later, the company had three million readers. In September 1924, Harvey Fawcett claimed that expenditures for printing and publishing from January 1921 to March 1924 exceeded $2,250,000 and payroll amounted to $125,000 annually.

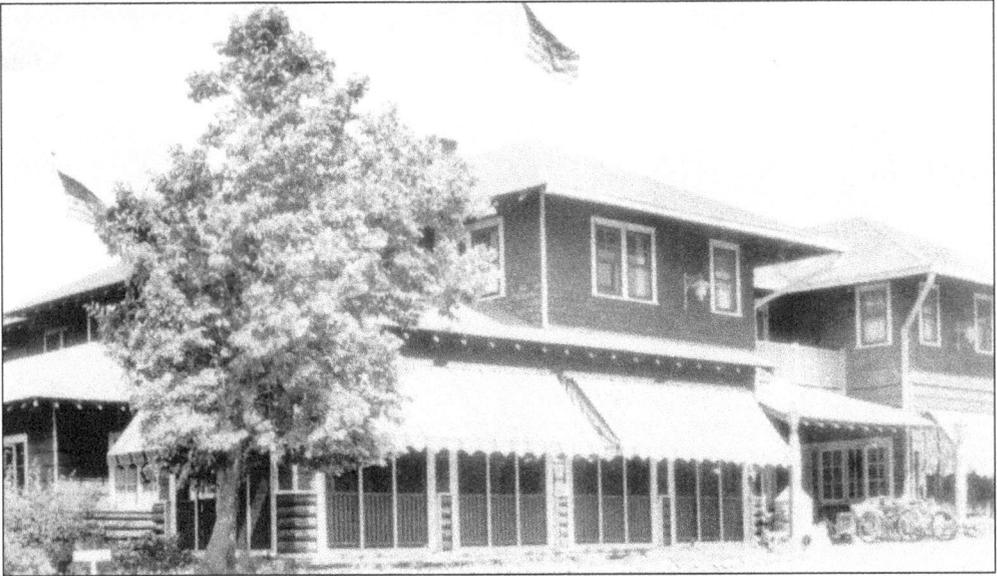

Slot machines and illegal gambling were an added attraction at Breezy Point. The casino, located in the basement of the lodge, was owned and operated under a leasing agreement with a man named Bob Hamilton. Local law enforcement officers made frequent midnight raids, but Hamilton always received a tip off. Slot machines were loaded on trucks and sent up a logging road. Gambling continued at the resort until the late 1940s.

On May 14, 1926, the *Brainerd Dispatch* reported on the planned expansion of Breezy Point's golf course and noted "that Captain Fawcett is regaining his pep and vigor is noticeable from fact that at the last Fort Snelling trap shoot he broke 50 straight, winning the tournament there. When a man's shooting eye is working then the whole human machine must be functioning one hundred percent."

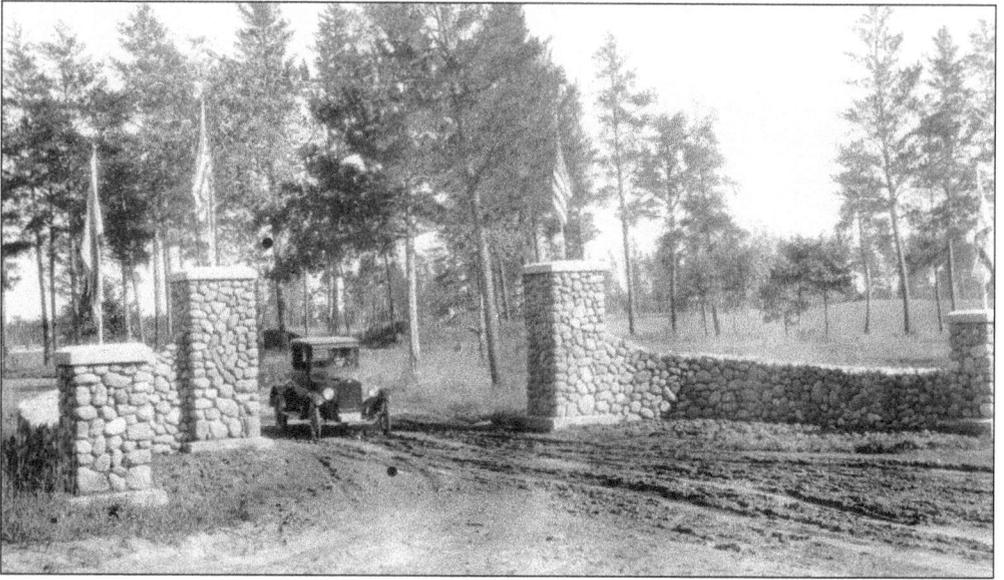

In 1926, local stonemason Charley Skoog was commissioned to create a gateway for Breezy Point. Captain Billy's wife, worried her husband would run his Stutz Bearcat into the solid stone pillars, told Skoog to demolish the gateway. Sticks of dynamite were used. The ensuing explosion brought Captain Billy out to the road. Skoog explained the situation, and Captain Billy told him to ignore his wife and rebuild the gateway.

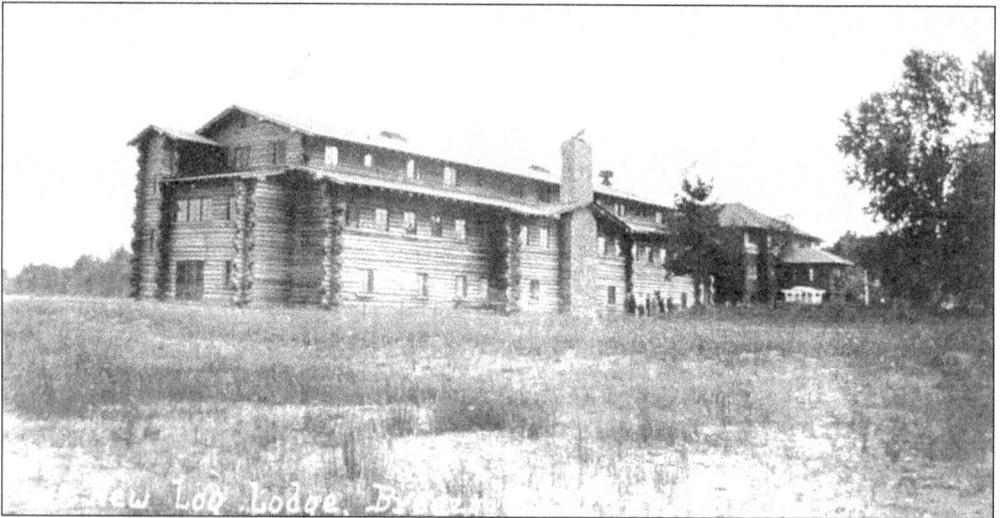

When the lodge and hotel were completed, the building measured 160 feet from the front entrance to the back of the dining room. The width on the main floor was 80 feet across. Eventually, the lodge, hotel, and Edgewater Annex would form a U-shaped structure containing 63 guest rooms and could accommodate 125 people at a time. Construction costs for the buildings exceeded $500,000. The annex was finished in 1928.

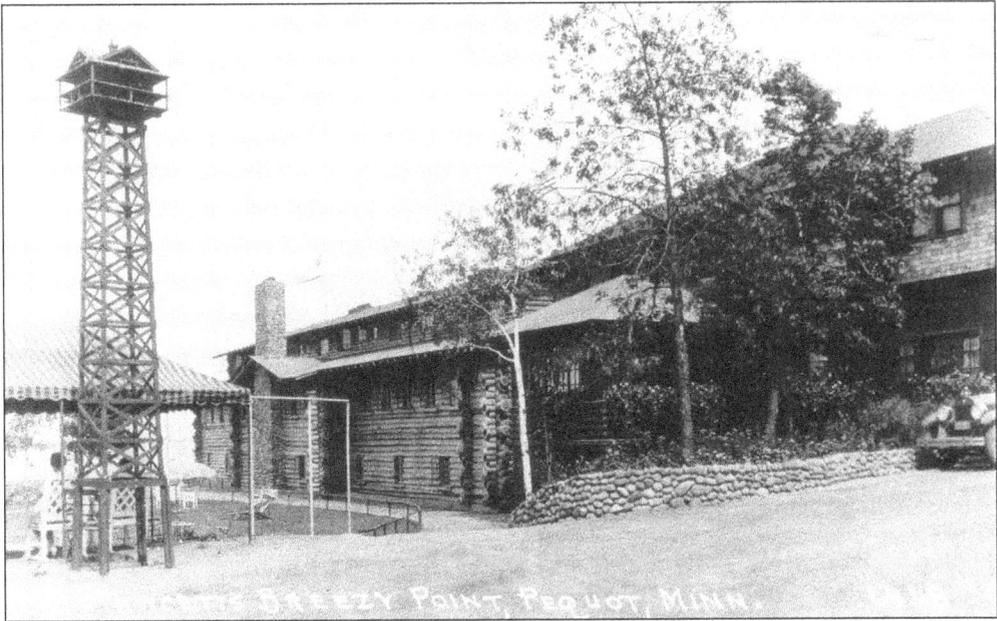

In June 1926, Sinclair Lewis came up to Big Pelican Lake. When he was not writing, Lewis could be found in the lodge, singing hymns around the piano. Unfortunately, the author's alcoholism became such a problem that Breezy Point had to assign employees to see him safely to bed after the bar closed. Lewis managed to get some work done, and by August, half of the manuscript for *Elmer Gantry* was finished.

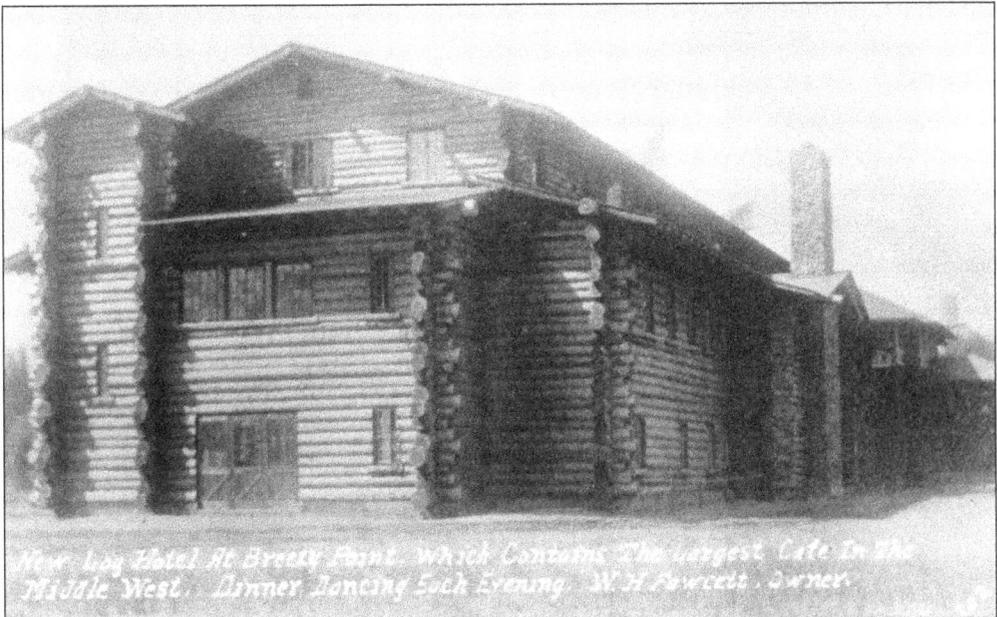

During Prohibition, Breezy Point jumped through hoops to bring in the hooch. Captain Billy got help from his bootlegging friend Charlie Saunders, the owner of Charlie's Café Exceptional in Minneapolis. Booze was brought in from Canada by logging road and railroad track. Occasionally, one of Captain Billy's pilot pals would drop buoyed canvas bags into Breezy Bay. Liquor was stored in the Fawcett House and served in the casino.

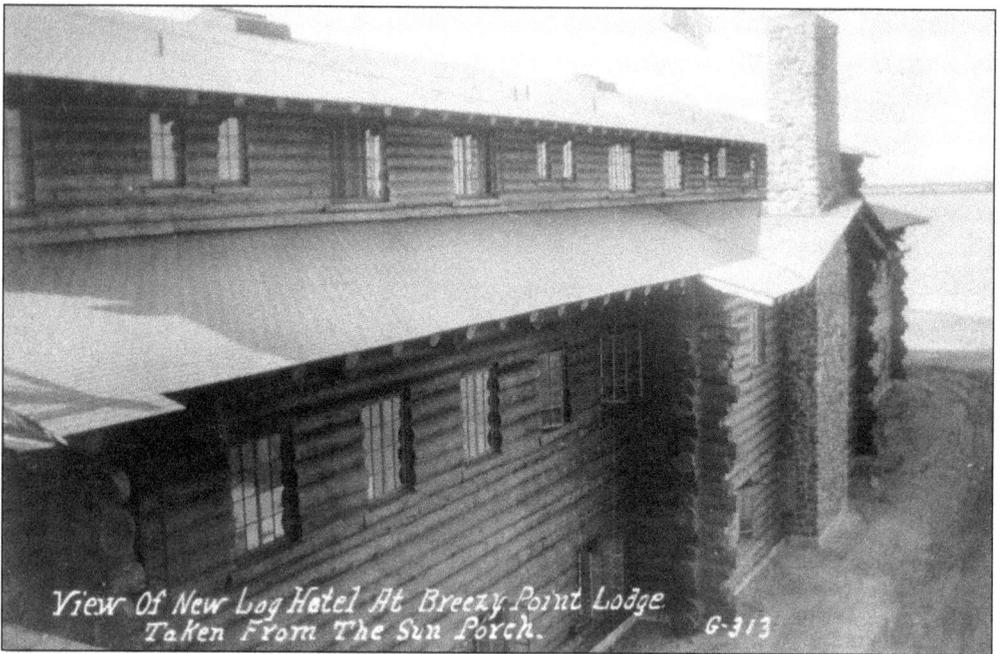

View Of New Log Hotel At Breezy Point Lodge.
Taken From The Sun Porch. G-313

There were always whispers of gangster involvement in Minnesota's resort business. Captain Billy may have fanned the flames when Fawcett Publishing brought out a one-shot Al Capone magazine, but there is no evidence that the resort's owner or management was friendly with the mob. In the late 1990s, Captain Billy's son Roscoe Kent Fawcett told Breezy Point's general manager Dave Gravdahl that "Father would never allowed them on the property."

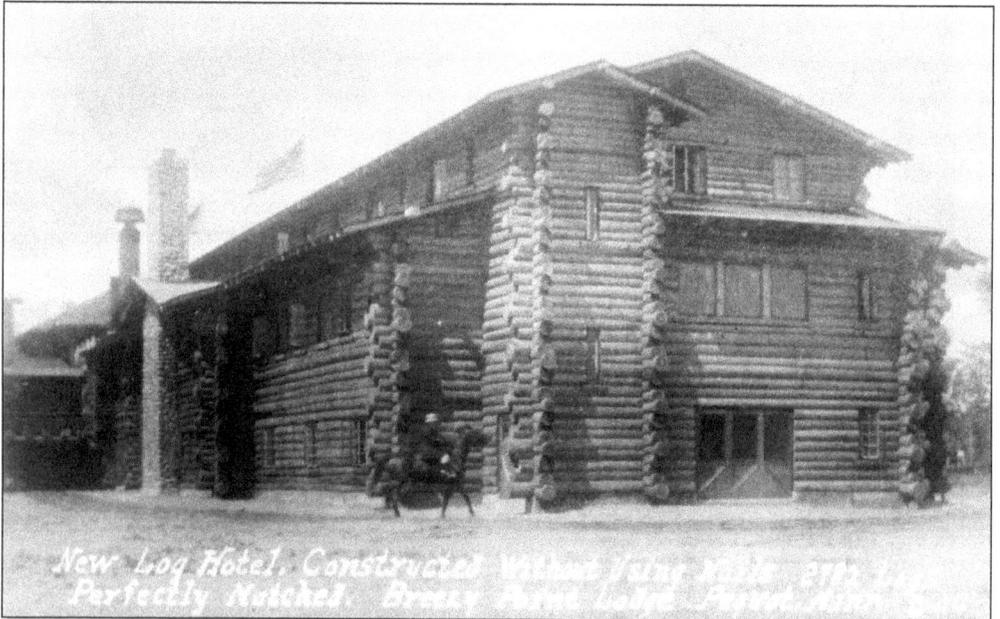

New Log Hotel, Constructed Without Using Nails.
Perfectly Notched. Breezy Point Lodge Point Aiton

Breezy Point Lodge was built with full-round Norway pine logs. They arrived by rail in Pequot Lakes, then were trucked to the construction site and put in place without the benefit of nails. Captain Billy's imported Finnish and Norwegian carpenters who favored a combination of pins, scribing, and cupping. The magnificent lodge opened on June 10, 1925.

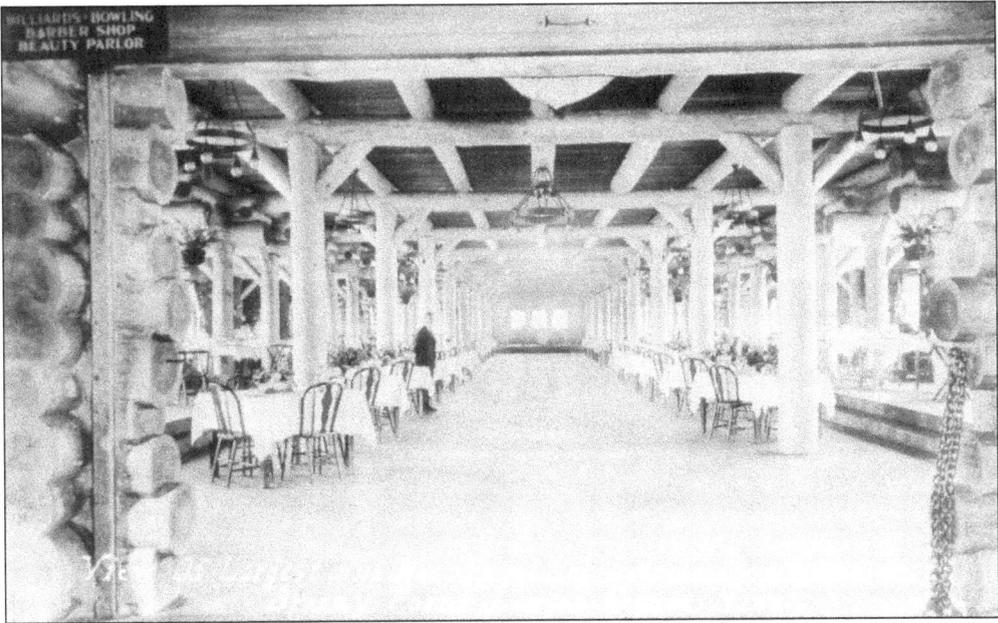

A 1920s Breezy Point prospectus asks, "Which is the most important, food, service or surrounding? There is no choice—for not one of the three can be slighted the tiniest iota without wrecking the perfect enjoyment of dining. Therefore, at Breezy Point the menu offers all that the most fastidious can conceive of, prepared by skilled chefs and served by waiters imported for the season from the country's best hotels and clubs."

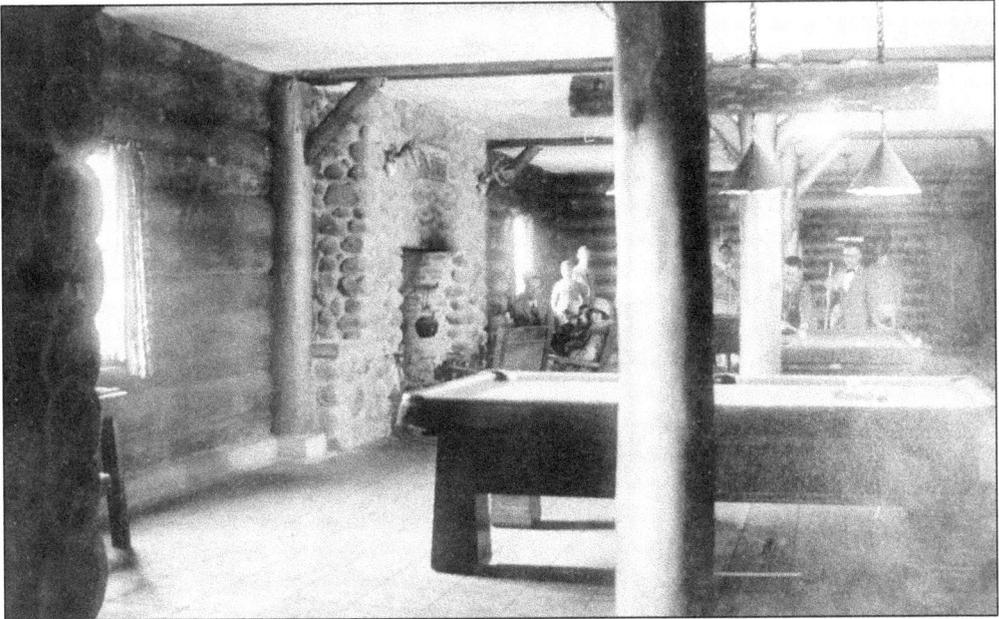

In the early 20th century, a poolroom was usually a betting parlor for horse racing. Billiard tables were installed so patrons could pass the time between races. In marked contrast to the Minneapolis pool halls where men loitered, smoked, drank, placed bets, and got in trouble, Captain Billy maintained a friendly six-tabled billiard room. Women were welcome, families gathered, and fires were lit in the evenings.

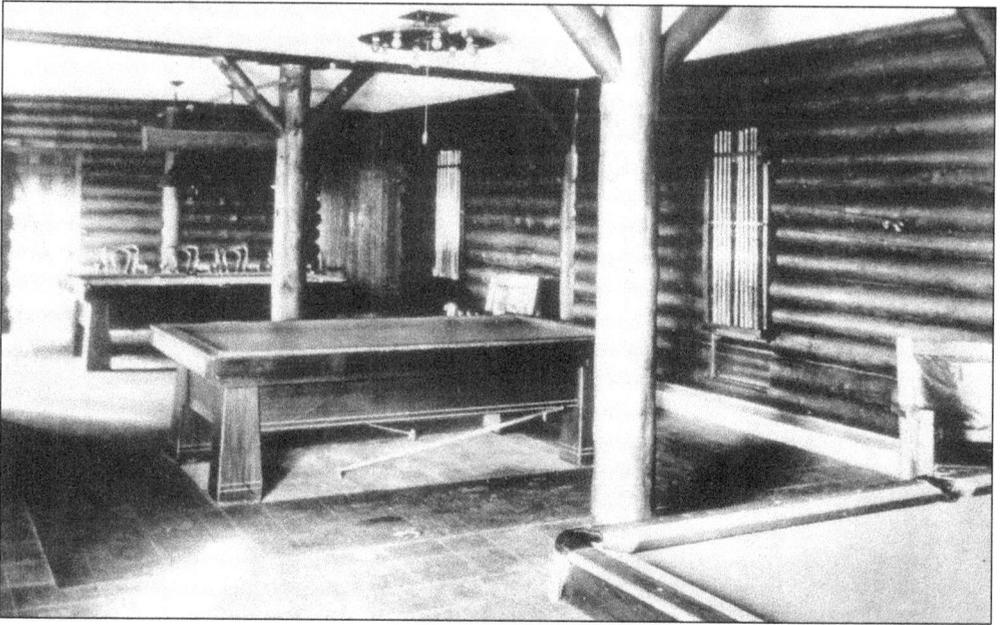

Breezy Point's billiard tables were covered in green wool. The balls were made of ivory cut from the center of an elephant tusk. At the turn of the century, pool became popular and elephants grew scarce. Desperate for an alternative, suppliers offered prizes for an ivory substitute. The invention of celluloid and Bakelite may have saved elephants from extinction. By the 1940s, even big tournaments were played with plastic balls.

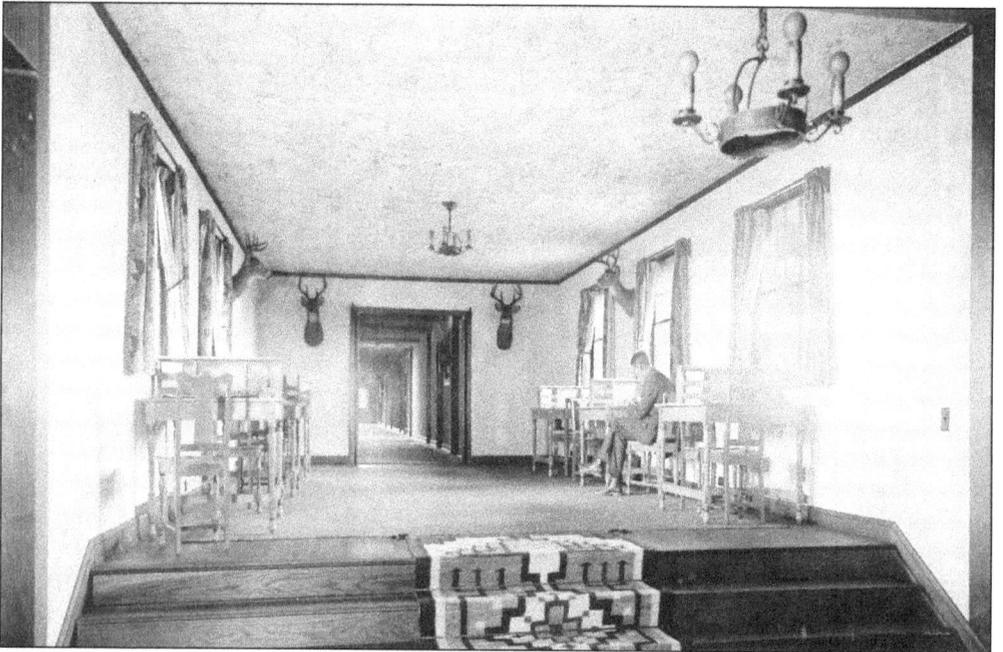

The Edgewater Annex was connected to the main lodge by the "Deer Writing" room. Guests were invited to use the little desks on either side of the hall to maintain business correspondence and write to relatives back home. Breezy Point provided pen, ink, stationery, and envelopes. Picture postcards could be purchased in the lobby and the deli.

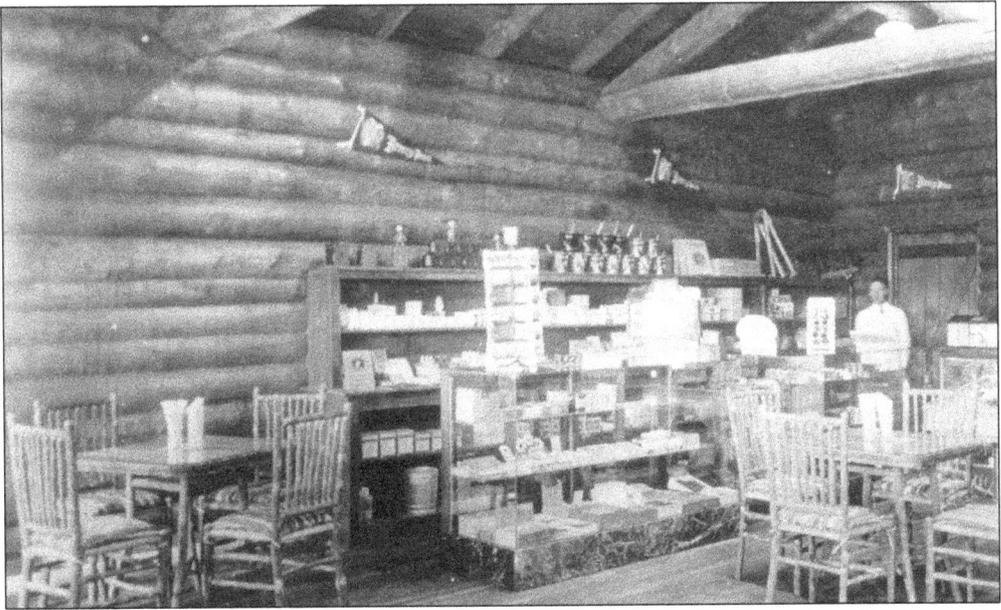

Breezy Point maintained a grocery and delicatessen for the convenience of guests who wanted to prepare their own meals. According to legend, the Fawcett House was built without a kitchen, and a tunnel was dug over to the lodge so Captain Billy could mosey over and get a sandwich from the deli. Another story has it that the tunnel was used to bring booze from the house to the casino during Prohibition.

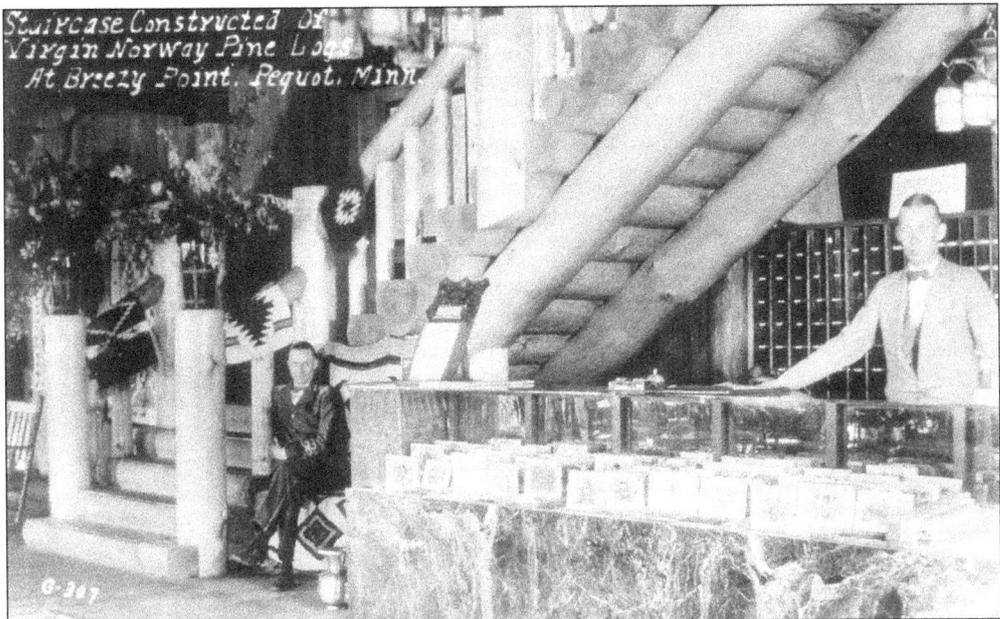

Breezy Point's lobby drew visitors into the lodge. The log interior opened up into an inviting lounge. The hotel's clerks and bellboys greeted guests from a marble and glass counter, below a giant virgin Norway pine stairway. Some builders said the stairway was too massive to install, but Captain Billy did not do anything small so they made it work and the steps became the centerpiece of the entrance.

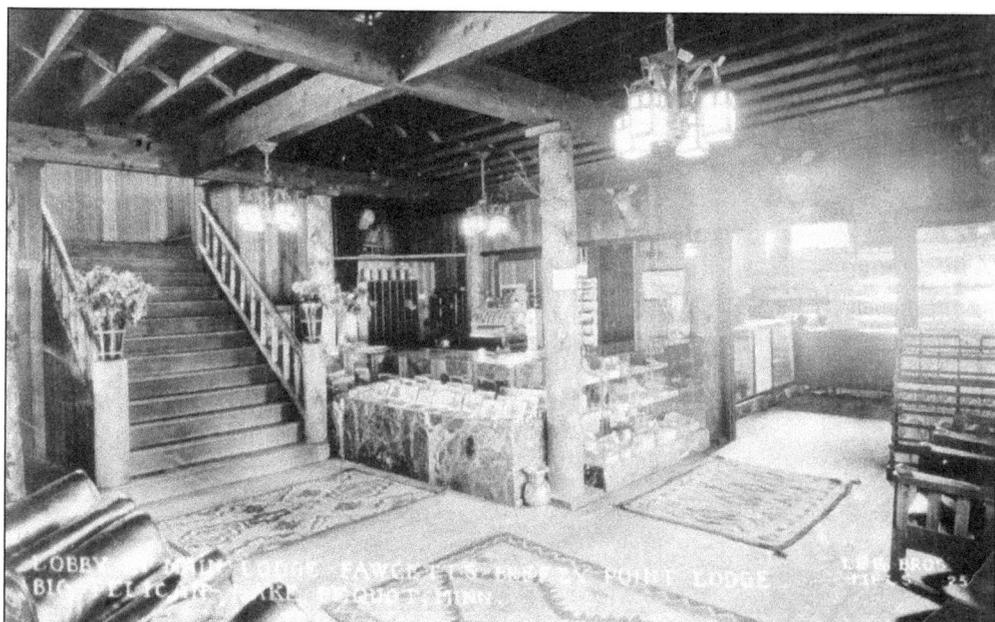

The first floor of Breezy Point's main lodge faced Big Pelican Lake. The main entrance was at street level, on the second floor. The lobby's eccentric decor combined worldly elegance and rustic utility. Glass and marble cases contained fine and expensive cigars. The newsstand was stocked with the latest from Fawcett Publications. An extensive selection of food was available in an adjacent grocery and deli.

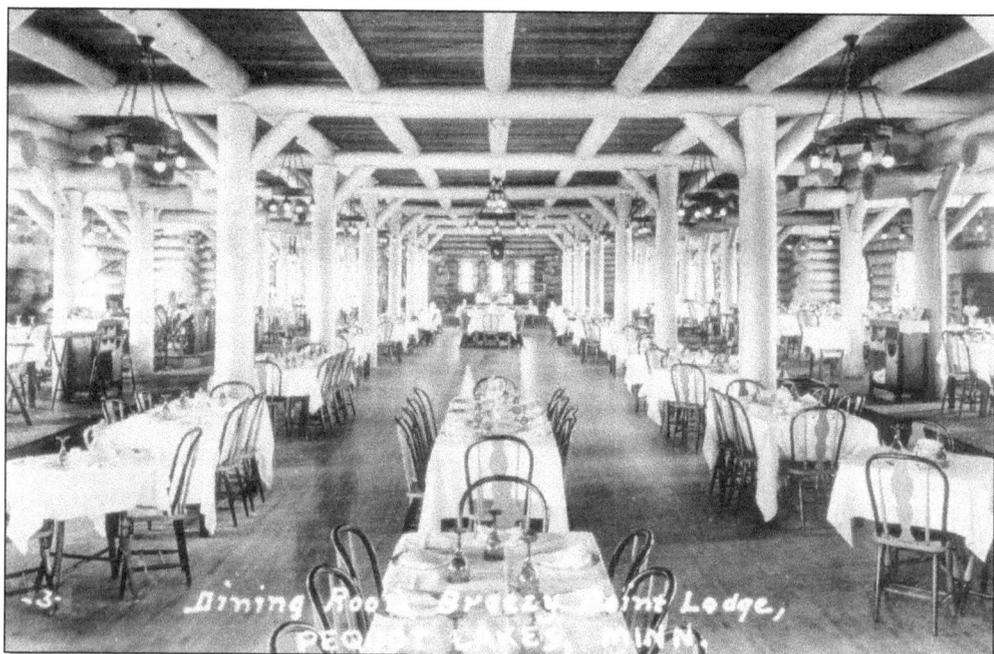

Breezy Point's dining area may have been the largest in the state. The room was 120 feet long and walled by gigantic varnished logs. Massive stone fireplaces, 12 feet wide and 44 feet high, stood like sentries on either side of the hall. The dining room seated 700 guests on busy weekends. A spacious stage at the far end of the room hosted big bands, weddings, and elaborate stage productions.

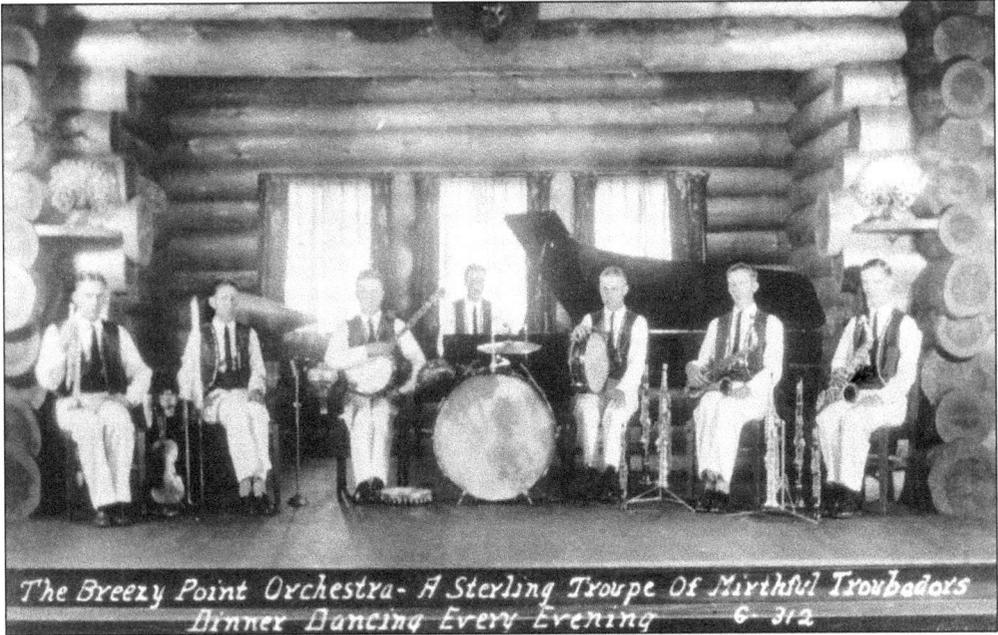

The Breezy Point Orchestra- A Sterling Troupe Of Mirthful Troubadors
Dinner Dancing Every Evening 6- 312

Strike up the band! Breezy Point came alive in the Jazz Age. There was room for a thousand after the tables were cleared in the dining hall. During the Great Depression, town and gown dances were sponsored by Twin City boutiques and department stores. At each event, judges selected the lady wearing the loveliest gown.

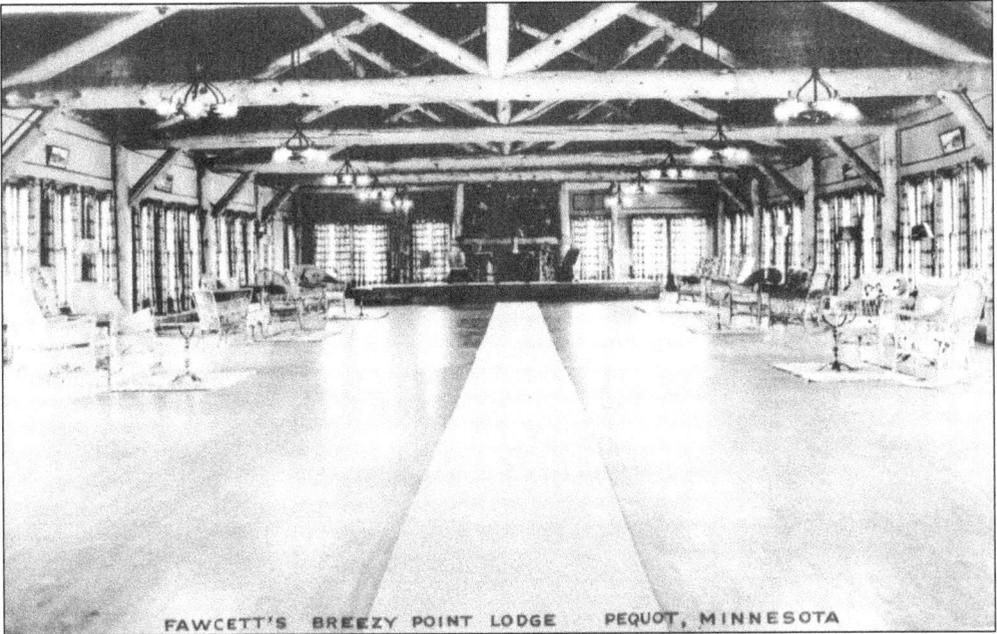

FAWCETT'S BREEZY POINT LODGE PEQUOT, MINNESOTA

Located on the third floor of the Edgewater Annex, Breezy Point's convention hall comfortably seated over 600 people. Windows on three sides of the room provided spectacular views of Big Pelican Lake. The elaborate facilities at the lodge became popular with business groups and fraternal organizations. Captain Billy often sent marching bands out to greet conventioneers at the depot in Pequot Lakes.

Many of Captain Billy's rental cabins came with an unobstructed view of Big Pelican Lake, Mousseau Bay, and Gooseberry Island. Breezy Point brochures advertised built-in garage space, screened sleeping porches, completely equipped kitchenettes, iceboxes filled with ice, indoor toilets, electric lights, efficient maid service, and bellboys on bicycles. Captain Billy's first 19 rental cabins were completed in 1921. Three years later, 22 more cabins were built.

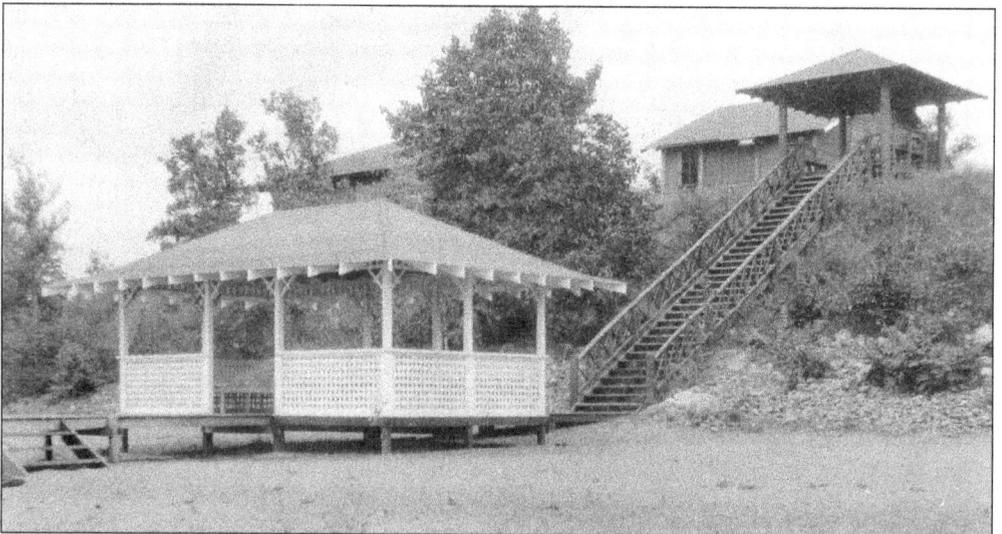

Breezy Point brought revenue and renown to the Brainerd area. The lodge frequently hosted luncheons for local businessmen and became a popular weekend destination for families from all over Crow Wing County. Breezy Point became an integral part of the community, employing up to 129 people each summer. Come spring, Captain Billy paid schoolchildren from Pequot Lakes to pick pebbles off the beach.

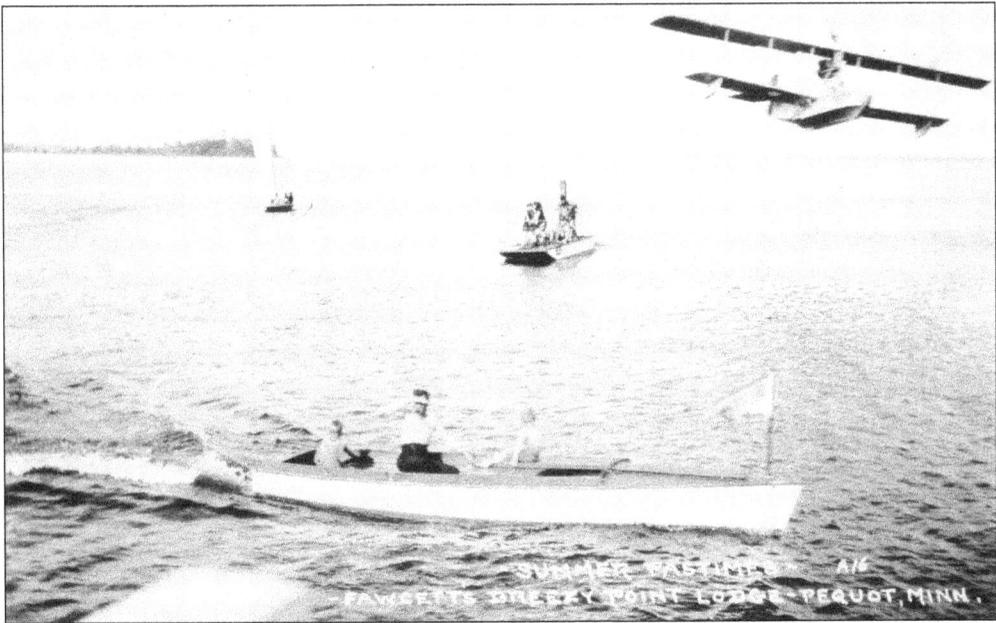

"SUMMER PASTIMES" A/6
FAWCETT'S BREEZY POINT LODGE-PEQUOT, MINN.

Here, guests looking for a thrill head for the beach on Big Pelican Lake. The flat-bottomed, airplane-motored, propeller-driven *Whiz Bang* boat took visitors across the lake at speeds approaching 45 miles per hour. Airplanes were rarely used for transportation in the 1920s so a ride above the pines on Captain Billy's flying boat was a unique attraction.

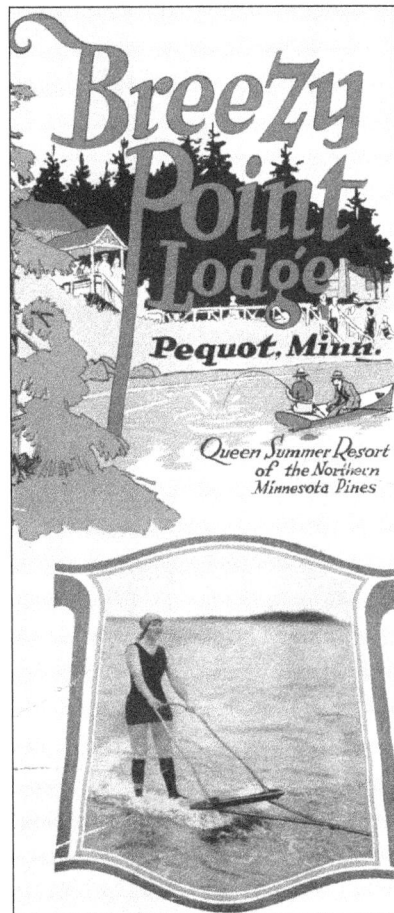

Breezy Point Lodge
Pequot, Minn.

Queen Summer Resort of the Northern Minnesota Pines

Advertisements for the "Queen Summer Resort of the Northern Pines" began appearing in *True Confessions* and *Captain Billy's Whiz Bang* magazines as early as 1921. Readers were invited to come to Breezy Point and fill their lungs with the invigorating balm of the pine forest. This early brochure beckons guests to take advantage the resort's waterslide, diving floats, and surfboards.

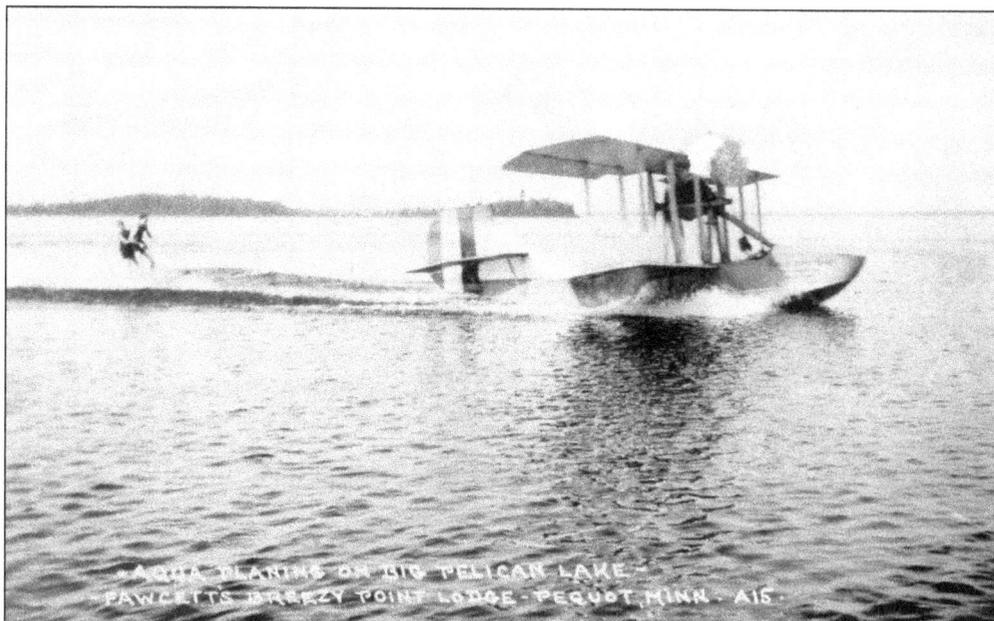

In the early 1920s, aviation was still a novelty and waterskiing was unheard of. The combination gave Breezy Point guests something to write home about. In 1924, Ralph Samuelson, the inventor of waterskiing, hired Walter Bullock to fly Captain Billy's seaplane down to Lake City, Minnesota, and pull him across Lake Pepin. Somehow, Samuelson managed to hang on as he crossed the waves at 80 miles an hour.

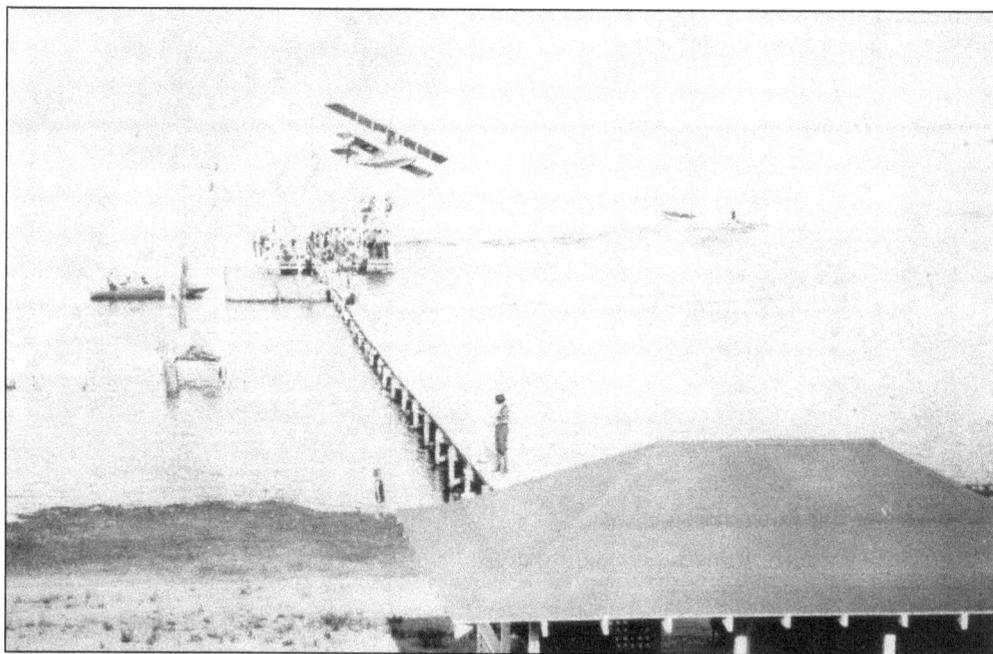

Captain Billy's pilot, Walter Bullock, had full-time work at the resort with Captain Billy's planes making daily flights. During the summer of 1921, the Brainerd Dispatch reported that 250 guests had free flights and that 23 had been taken aloft in a single day. In 1922, Bullock convinced his sweetheart Lillian Larson to drop out of school, elope, and spend the summer at Breezy Point.

Breezy Point's 300-foot dock paralleled a giant shoot-the-chute slide and waterwheel. Guests who were not ready to get wet could choose from an endless list of other activities. Caddies and golf professionals were provided at the resort's nine-hole course, hunters could sharpen their skills at the trapshooting range, and a colorful English hostler was available for instruction and horseback rides through the woods.

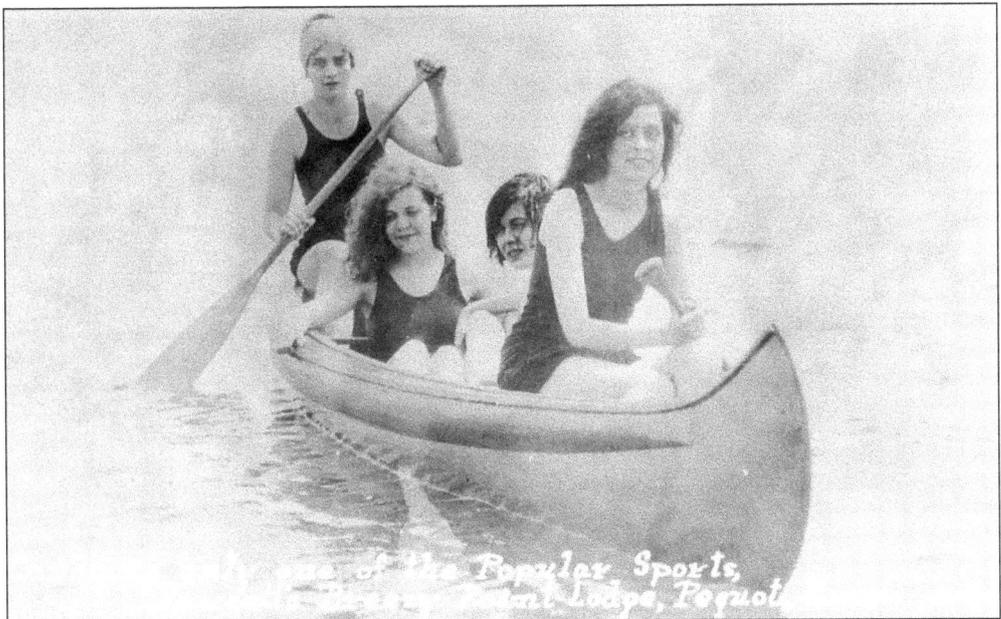

Pelican Lake provided Breezy Point with one of the finest beaches in Minnesota. Deep, white sand runs for about a half mile in front of the resort and extends far out into the swimming area. Guests in canoes spent long summer days exploring the lake's 23 miles of shoreline in Captain Billy's canoes.

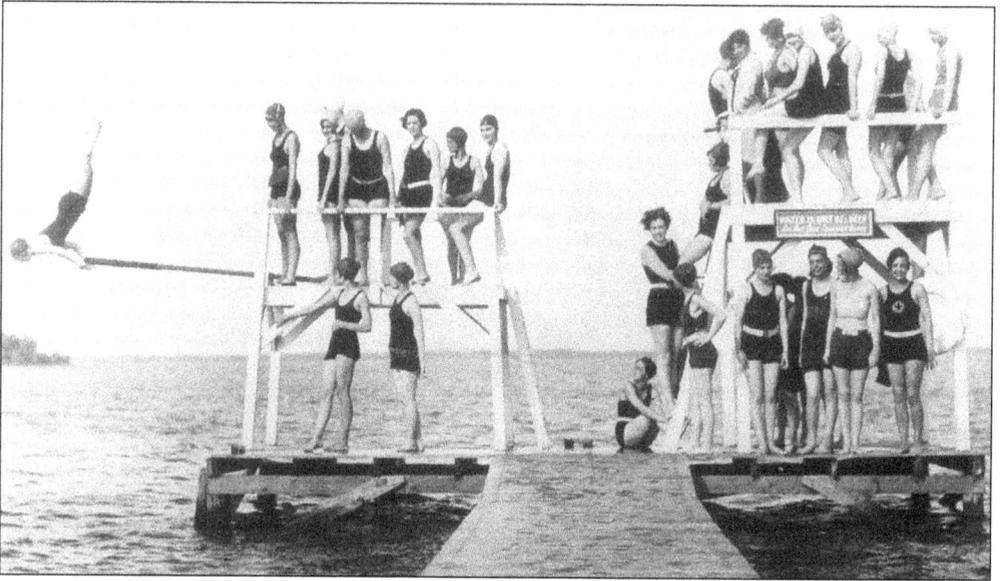

In the early 1920s, function took a back seat to fashion at the beach. Bathing suits were usually made of wool. Water sports were just coming into vogue when Jantzen introduced "The Suit That Changed Bathing to Swimming." Made of stretchy material, the new swimming suits were sexy, snug, and comfortable. Breezy Point's beach was notoriously shallow. A sign warned divers not to dive straight down.

Captain Billy invited Minnesota novelists and journalists to come up north and rub elbows with Fawcett Publications screen magazine and pulp fiction writers. Erskine Caldwell visited the lodge. *Minneapolis Tribune* reporters Cedric Adams, Dick Cullum, and Charlie Johnson were frequent guests, and best-selling author Margaret C. Banning gathered material for her book *Country Club People* at the resort.

Season openings were gala affairs at Breezy Point. In early June 1925, the resort held a costume ball. Guests from the Twin Cities traveled to the resort in a procession of 30 cars decorated with pennants. The evening's events included dining, dancing, and fireworks. The *Brainerd Dispatch* reported that Captain Billy carried a riding whip and played master of ceremonies in a red coat and black silk hat.

Fawcett Publishing came of age with the film industry and Captain Billy used his business connections to promote Breezy Point. At the height of the Jazz Age, the resort became a favorite hideaway for Hollywood. Captain Billy's brother Roscoe Fawcett was rumored to be dating Jean Harlow and the resort had frequent visits from the likes of Delores Del Rio, Tom Mix, Lillian Gish, Clark Gable, and boxing champion, Jack Dempsey.

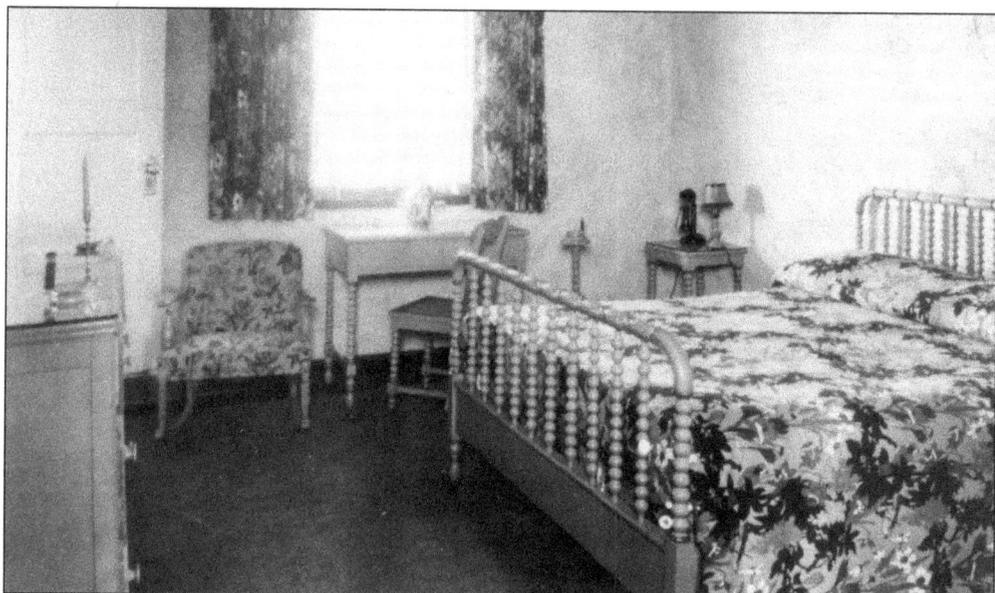

Most of the buildings at Breezy Point, including the massive main lodge, were made of peeled and varnished logs. Inside walls were plastered with cement and straw, but everything rustic stopped with the walls. Rooms were described as on par with accommodations in America's finest hotels, luxuriously furnished with private baths of shining tile, electric lights, and telephones. Uniformed maids and bellboys could be summoned and counted on to provide extraordinary service for discriminating guests.

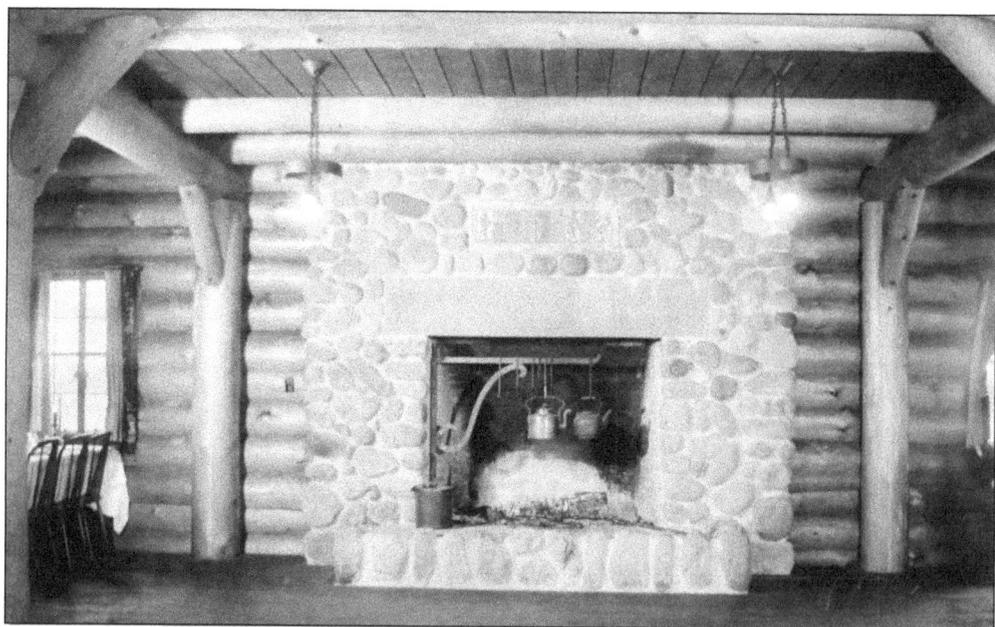

Giant, 11-foot-wide, 5-foot-thick split-rock fireplaces stood on either side of the old Breezy Point Lodge. The 42-foot-high chimneys climbed the outside of the building from the basement to beyond the roofline. Many of the rocks used in the construction of these massive structures were from Gooseberry Island. In the winter, workers placed the stones on sleds and horses hauled them across Big Pelican Lake.

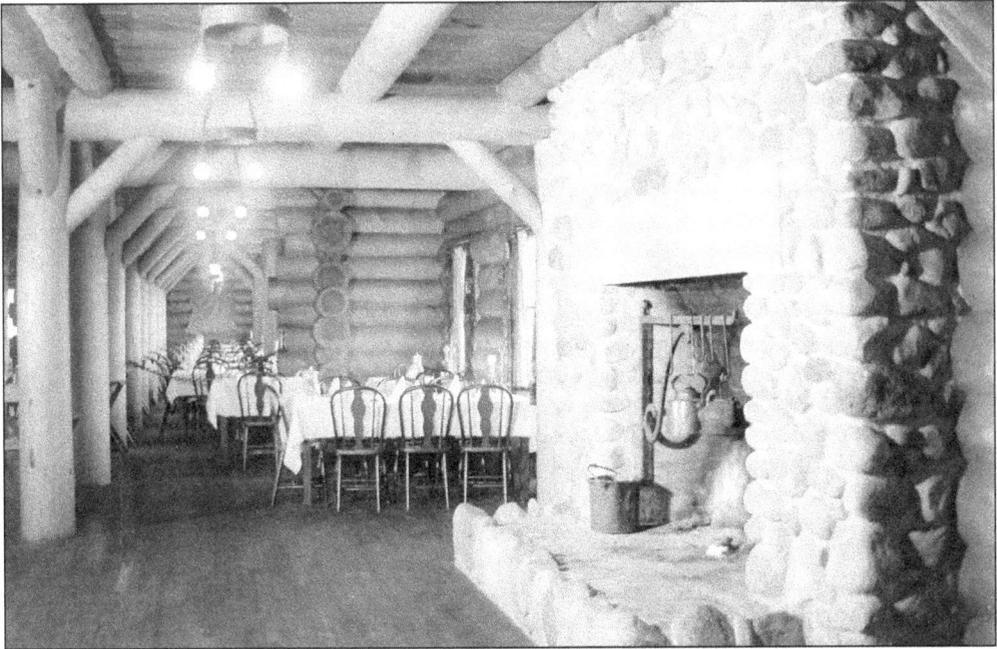

Heavy log chains separated the tables on the dining room's upper level. The table settings had base plates adorned with hand-painted peacocks and the initials BPL trimmed with an inlaid gold border. The plates cost $75 a piece. No plate was ever washed with another dish. Heavy sterling silverware, blue goblets, and white linen napkins completed the setting. Tables along the wall were lit by electric lights.

Breezy Point made headlines when Captain Billy and his second wife, Antoinette "Annette" Fawcett, hosted Hollywood actress Dolores Del Rio's 23rd birthday party at the lodge. A crowd of area residents turned out to greet Del Rio and film star Claire Windsor at the Ransford Hotel in Brainerd. The young starlets received giant bouquets. As their motorcade left town, Del Rio tossed flowers to fans lining the side of the road.

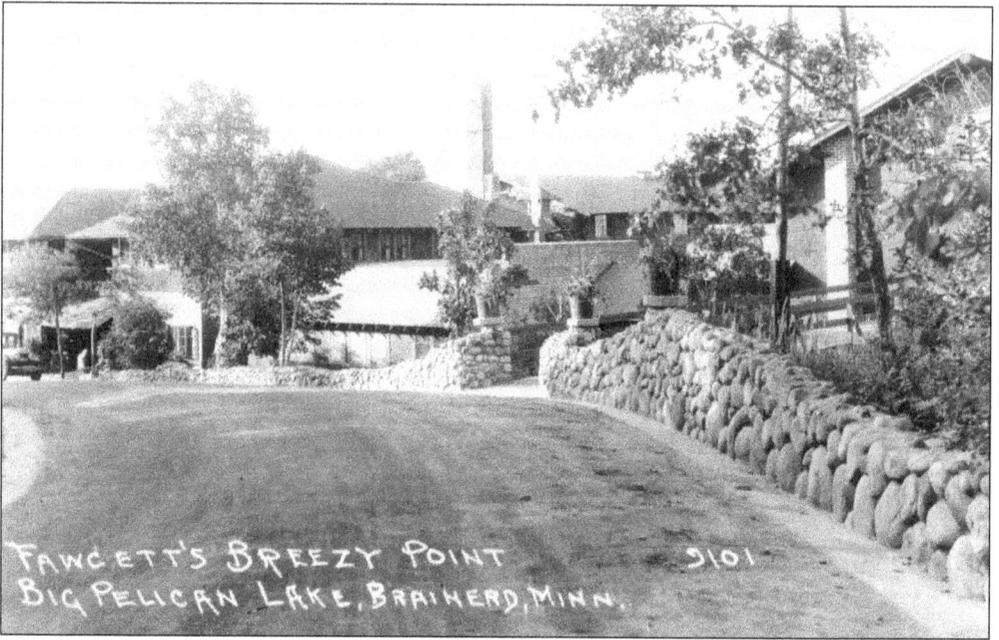

FAWCETT'S BREEZY POINT 9101
BIG PELICAN LAKE, BRAINERD, MINN.

Captain Billy loved the sporting life. He was a fan and friend of the former world heavyweight champion Jack Dempsey. Breezy Point invited locals to meet the boxer at the lodge and Dempsey became the guest of honor at a variety of promotional events. Captain Billy owned boxing clubs in Minneapolis and St. Paul. When Dempsey was in the Midwest, Captain Billy accompanied the "Manassa Mauler" to fights and sat ringside.

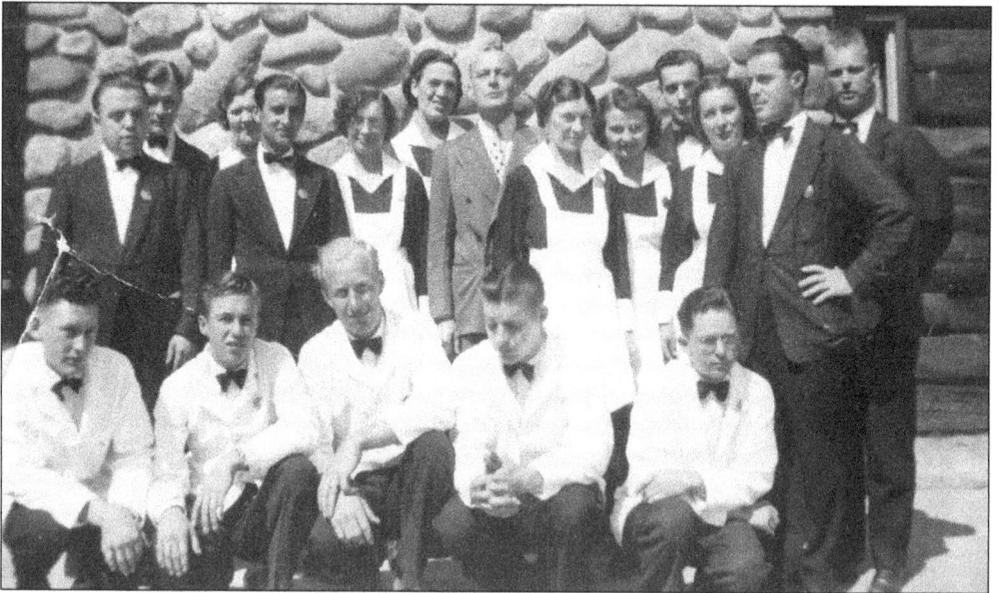

Breezy Point had a full-time manager, but Captain Billy liked to get his hands dirty. He spent his mornings riding around the resort on horseback. The resort's famous owner's military-style bark was usually worse than his bite. Rewards were as common as reprimands, and Captain Billy often joined in the work. Gene Hawkins, pictured here in a business suit, was the resort's hotel manager from 1921 until 1940.

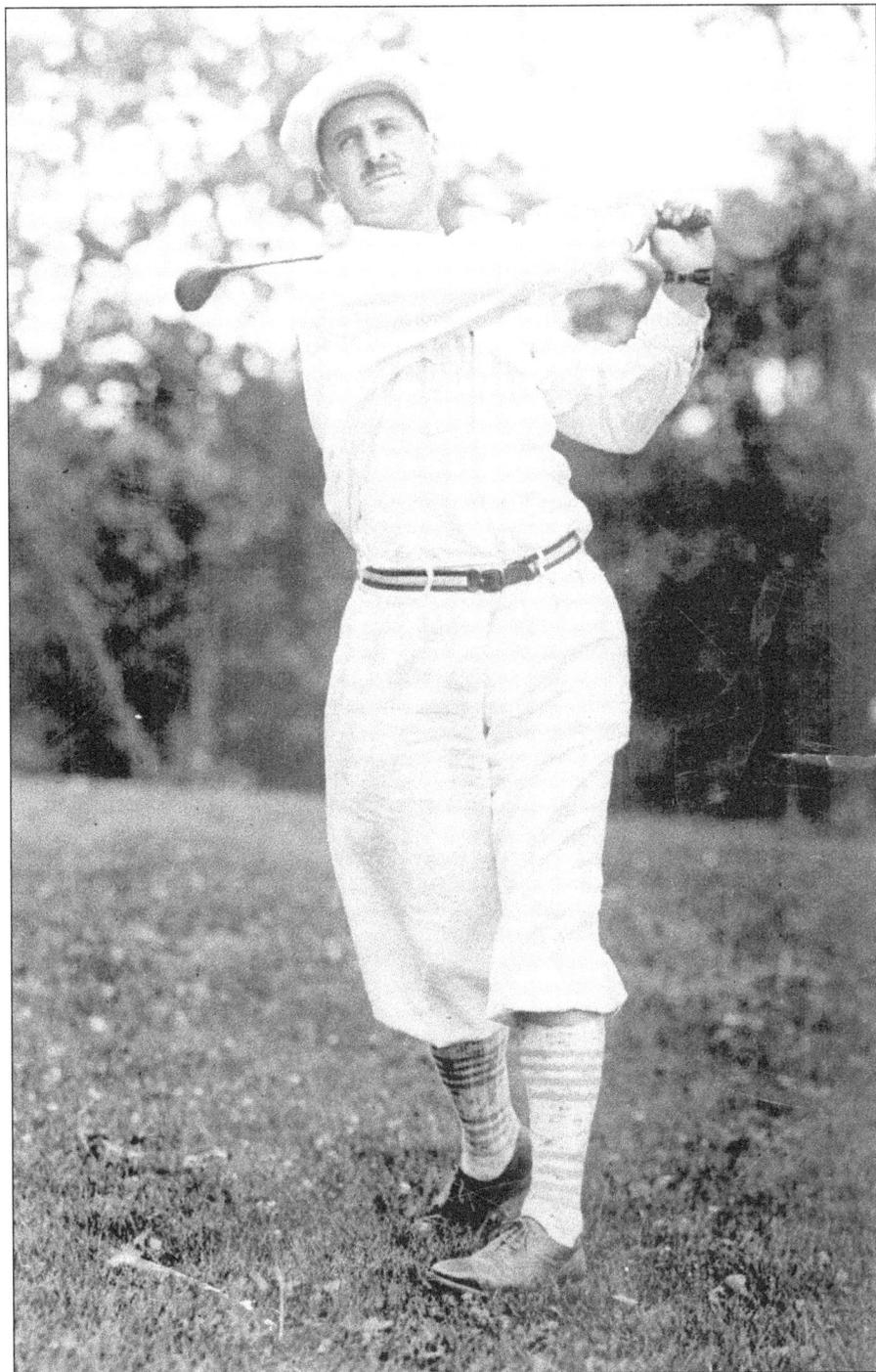

Captain Billy's brother Roscoe Fawcett was a terrific golfer. Par on Breezy Point's Chippewa Links golf course was 72. Fawcett held the course record with a score of 71. On July 17, 1925, world champion golfer Walter Hagen appeared at the resort for Breezy Point's 10,000 Lakes Golf Tournament. Hagen's score of 78 was the poorest showing of his two-month American tour. (Courtesy of Hennepin County Library.)

Captain Billy married his first wife, Viva Claire Meyers (right), in 1906. The couple had five children together. Fraternal twins Marion (left) and Wilford Jr. were born in 1908. Three more sons—Roger, Gordon, and Roscoe Kent—followed over the next five years. Captain Billy's children spent summers working at the resort and followed their father into the publishing business. (Courtesy of Hennepin County Library.)

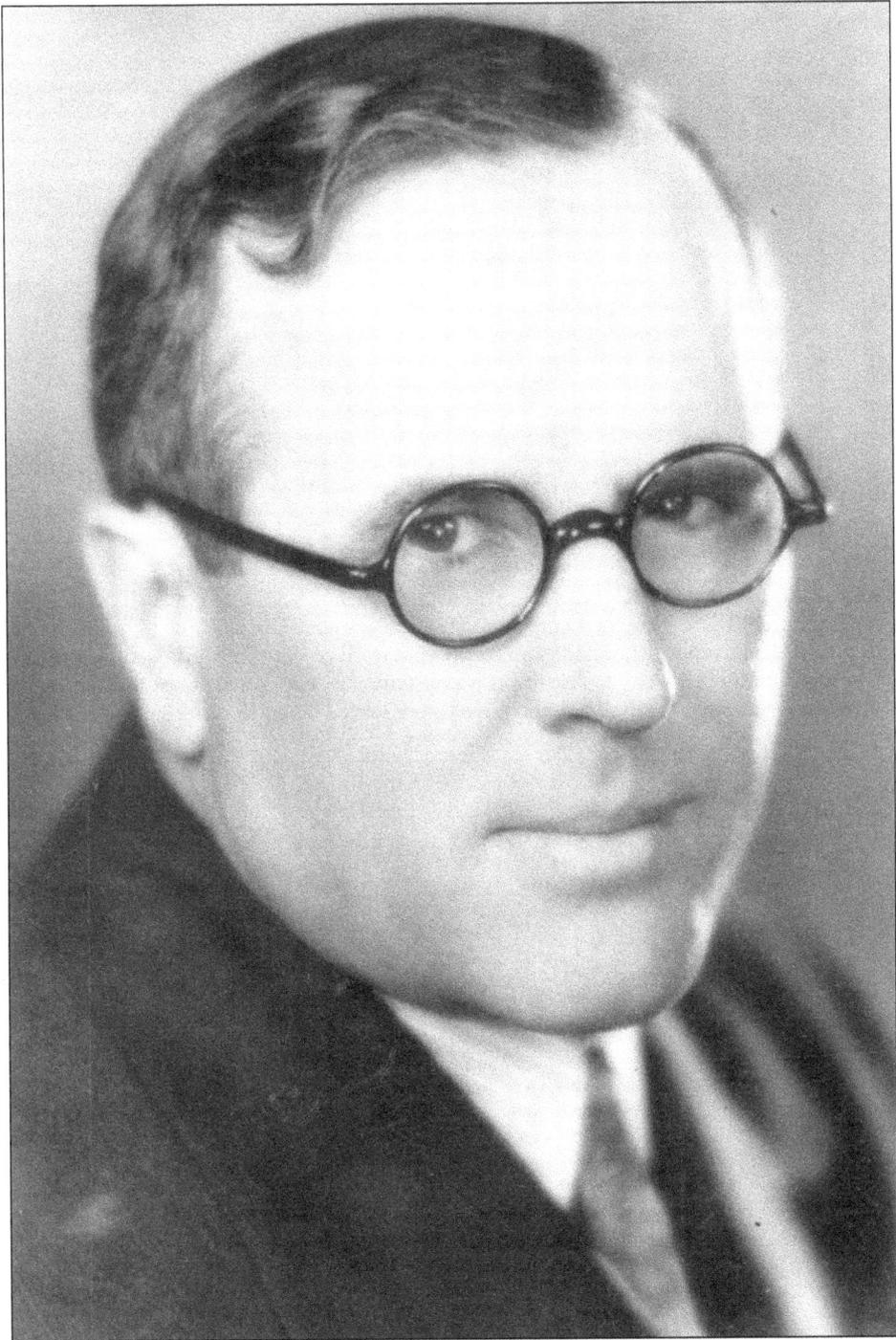

By 1929, Fawcett Publishing had a stable of popular magazines. Captain Billy brought his brother Roscoe into the business, and the two spent much of the summer working at Breezy Point. Fawcett's popular line up of magazines like *True Confessions*, *Modern Mechanics*, *Triple X Western*, *Screen Secrets*, *Motion Picture*, and *Daring Detective* made for a combined circulation of 10 million a month. (Courtesy of Shaun Clancy)

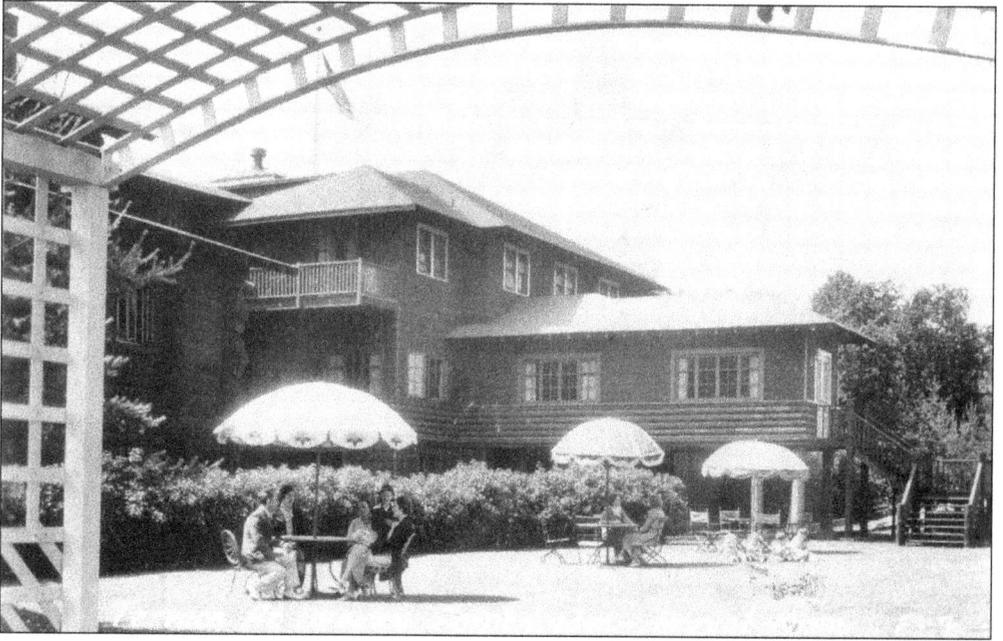

In 1964, Captain Billy's son Roscoe Kent Fawcett told the *Brainerd Dispatch* that although his father was an astute businessman who made money on almost all of his publishing ventures, he could not show a profit on Breezy Point. The resort was just another expensive hobby for Captain Billy, and there were times when a half a dozen guests were served by up to 70 resort employees.

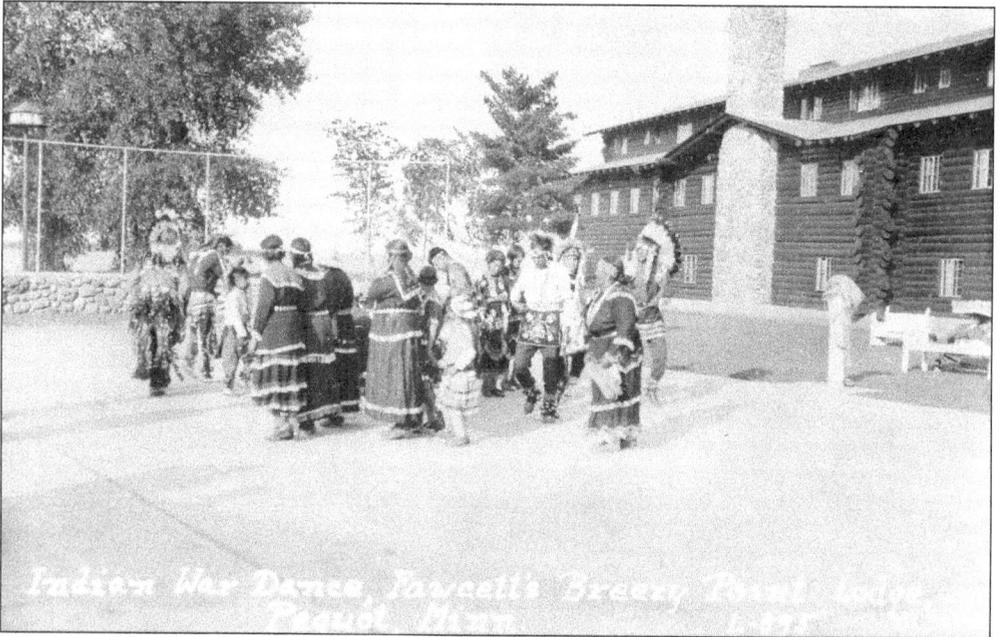

Breezy Point played up the area's Native American connections, and the resort occasionally employed dancers and entertainers from the Leech Lake Reservation. Captain Billy, in true Whiz Bang fashion, placed a large sign on a grassy mound near the lodge that read, "Chief Pequot is not buried here."

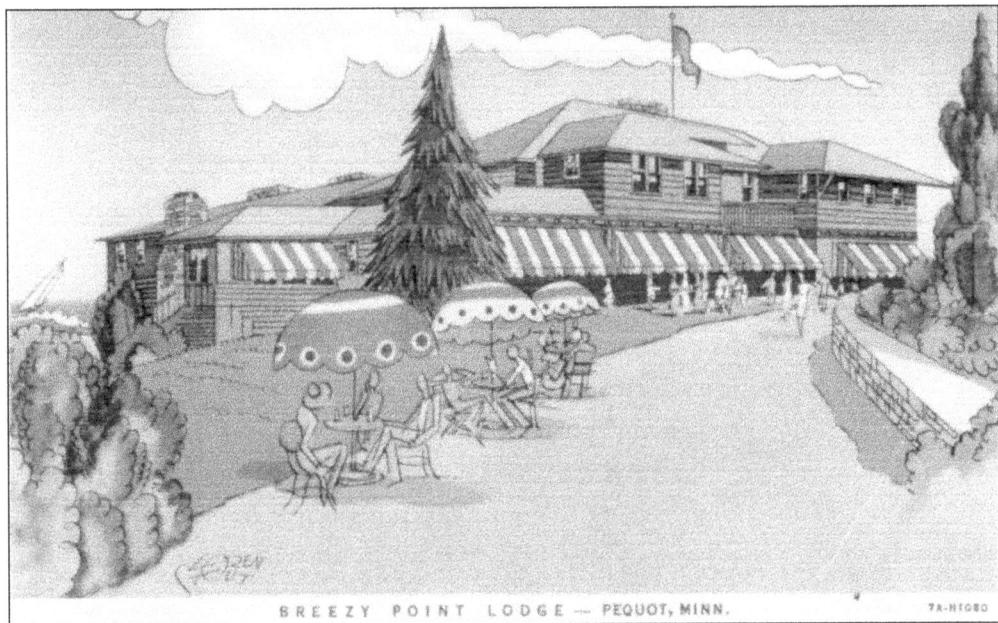

BREEZY POINT LODGE — PEQUOT, MINN. 7A-H1080

During the Depression, gambling brought all sorts to Breezy Point. In 1932, Harry S. Truman is rumored to have hit the jackpot on a slot machine. In 1937, Truman expressed his preference for the resort in a letter written to Col. John W. Snyder: "It would suit me immensely to hold our maneuvers at Captain Billy's lake. I have been informed we have our choice of going either to Minnesota or Fort Riley; I prefer Minnesota."

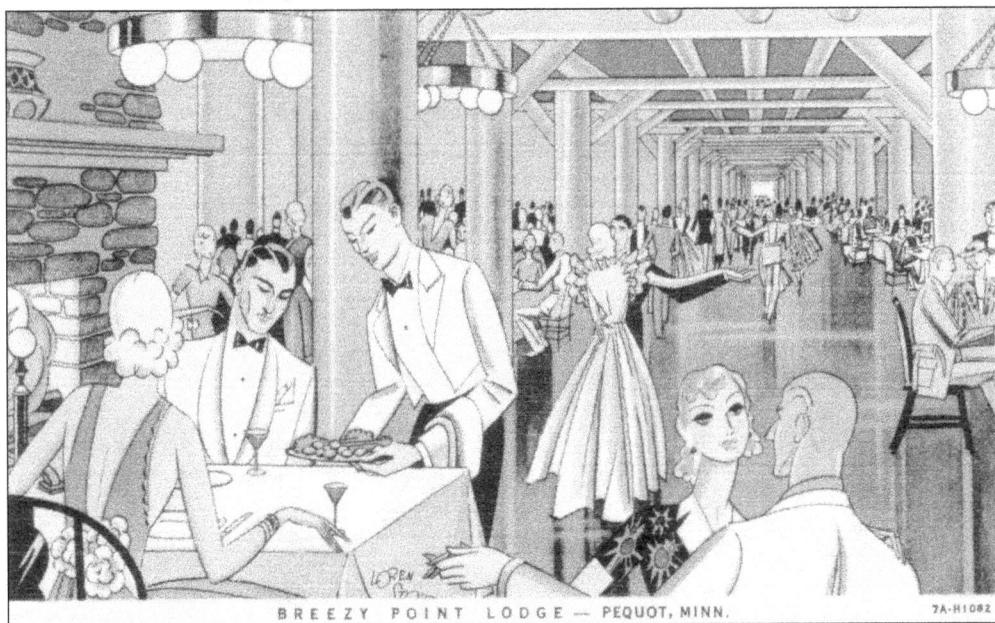

BREEZY POINT LODGE — PEQUOT, MINN. 7A-H1082

On June 27, 1935, the *Minneapolis Tribune* reported, "A crowd attended the opening of Breezy Point Lodge on Pelican Lake Saturday evening. A good orchestra and floor show entertained the guests. With the best food cooked and served in the best manner in the Northwest, everyone was treated like a king. Noted guests were Governor Floyd B. Olson and Major-General George E. Leach, head of the Minnesota National Guard."

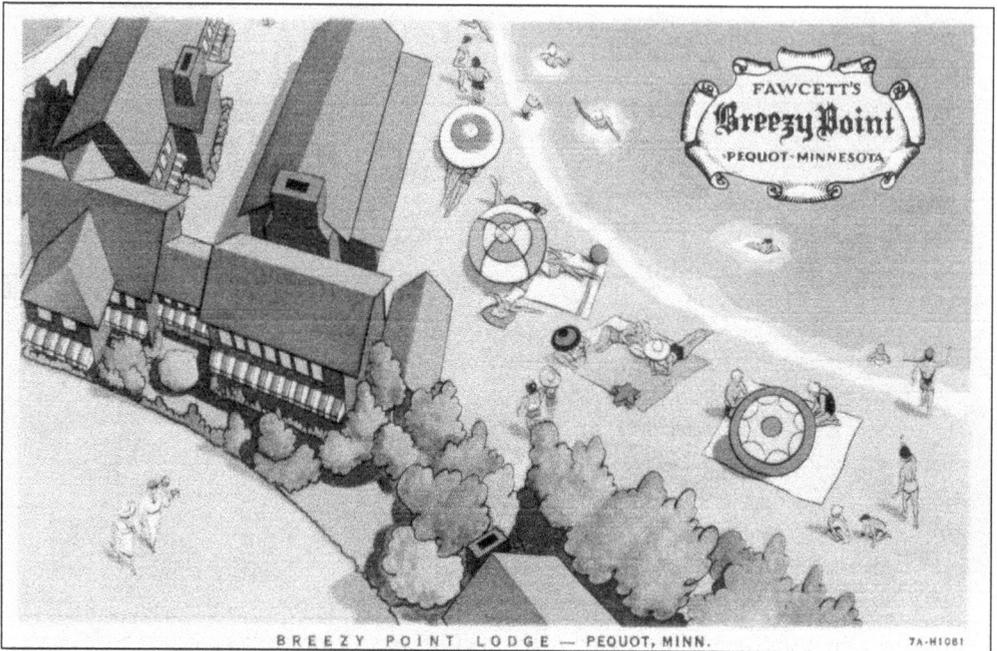

BREEZY POINT LODGE — PEQUOT, MINN. 7A-H1081

A 1930s Breezy Point advertisement claims the following: "Whether you are strictly sun-tan or the dynamic athletic type who thrills to aqua antics, you'll find complete enjoyment at this popular beach with its gay colored beach umbrellas. Children love it too, and mothers know the gentle shelving beach with no deep water near shore is safe."

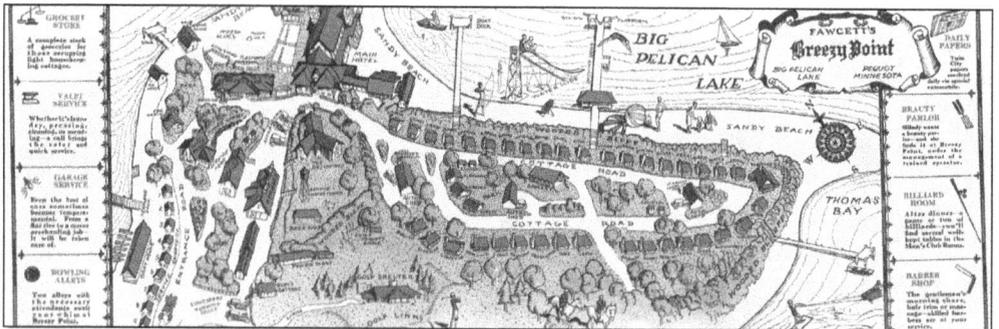

This early illustrated map depicts many Breezy Point amenities. The grocery store, beauty parlor, barbershop, and billiard room were located in the main hotel. This massive three-story building boasted modern rooms with large innerspring beds, electric lights, and private baths. Breezy Point cottages were complete vacation homes. Every cottage had a screened-in sleeping porch, electric lights, a private bath, and running water.

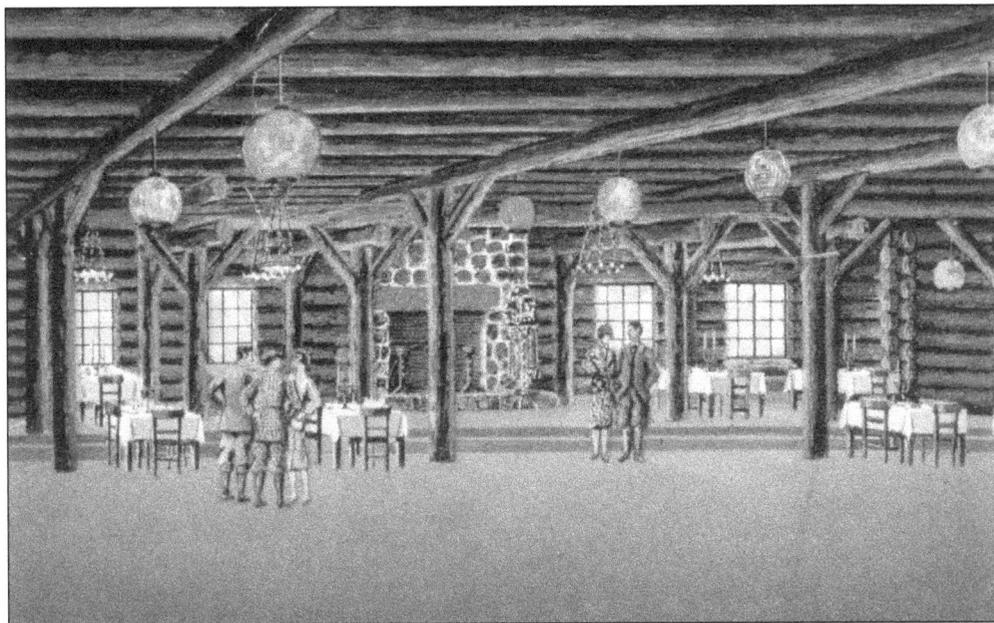

In an effort to provide world-class service, Captain Billy lured the resort's maître d', Oscar Tschincky, away from his job as a headwaiter at the Waldorf-Astoria in New York. Breezy Point had an international clientele. Waiters spoke more than one language and memorized the names of guests. In the evenings, Breezy Point's dining room became a ballroom. After dinner, entertainment included orchestras and dancers.

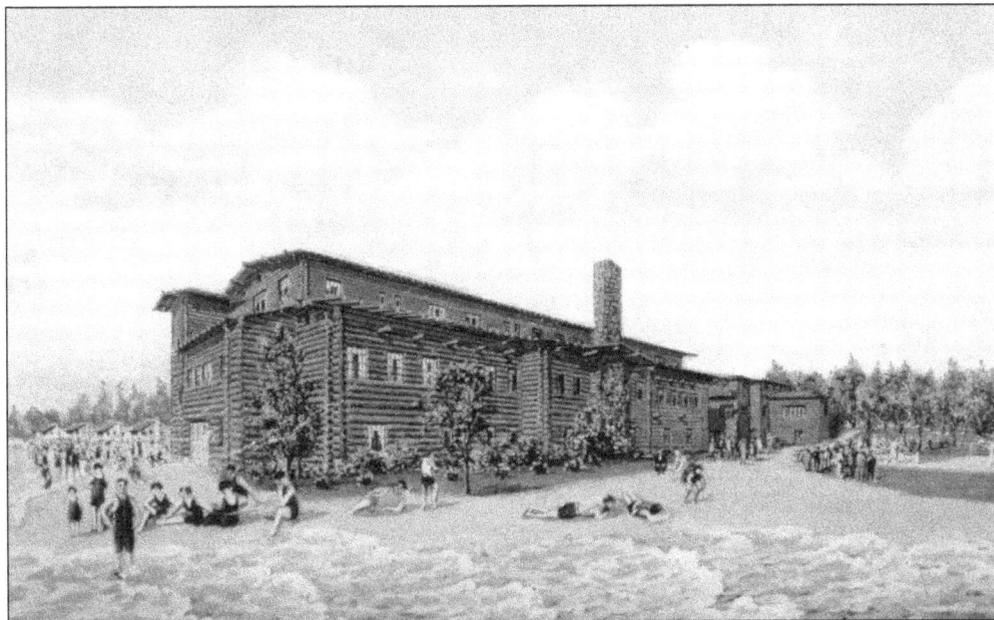

A string of dry summers managed to turn Big Pelican Lake into a collection of eight smaller lakes. Captain Billy hatched a plan to raise the water level by digging a channel between Big Pelican and nearby Lake Ossawinnamakee. After years of delay and debate, Works Progress Administration (WPA) laborers completed the project in 1937.

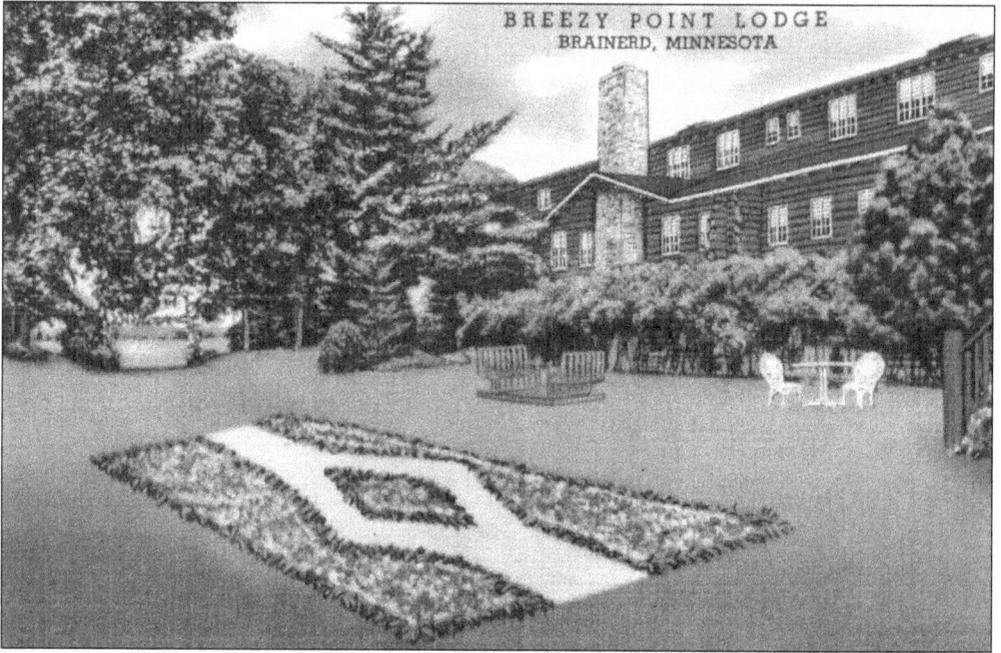

BREEZY POINT LODGE
BRAINERD, MINNESOTA

After Breezy Point hosted a Pi Beta Phi convention, the following reflection appeared in the fraternity's newsletter: "There in the heart of Minnesota's land of 10,000 lakes, 150 miles from the Twin Cities where wood and waters are rich in the lore of Chippewa and Sioux, with the romance of frontier days still haunting the region, Phi Beta Phis from every section of the country enjoyed to the utmost their stay."

BREEZY POINT LODGE — BRAINERD, MINNESOTA

The spring of 1922 saw work start on the front nine of what is today's Traditional Golf Course. The course was ready for play in the spring of 1923. Captain Billy hosted the first 10,000 Lakes Golf Tournament in 1924. The following year, he brought Walter Hagen to the lodge for an exhibition game. In the 1930s, Patty Berg won three back-to-back tournaments at the resort.

This Depression-era brochure describes Breezy Point as a million-dollar playground situated on a high wooded bluff above the sparkling waters of Big Pelican Lake and occupying the site of the ancient tribal village of Pequot Indians. Another piece of literature claimed the golf course was built on a Pequot battleground. Historically, the tribe made its home in Connecticut. Only Captain Billy knows how or when they migrated to Minnesota.

COOL NORTHWOODS

Fawcett's

BREEZY POINT

Minnesota

COUNTRY CLUB LUXURY

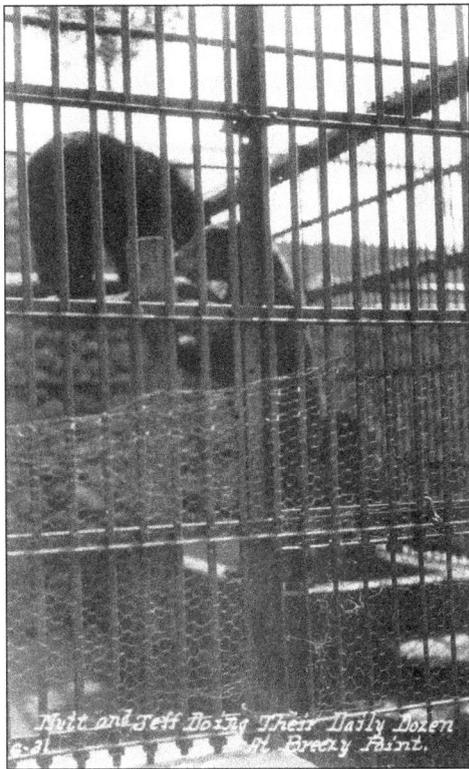

Mutt and Jeff Doing Their Daily Dozen at Breezy Point.

Captain Billy was always looking for new ways to attract guests to his resort. After the Longfellow Zoological Gardens in Minneapolis closed in 1931, Captain Billy built a new home for some of the animals. The Breezy Point menagerie included elk, owls, bears, deer, ducks, buffalo, rabbits, peacocks, lynx, eagles, and turkeys. The little zoo attracted locals and visitors from all over the state.

47

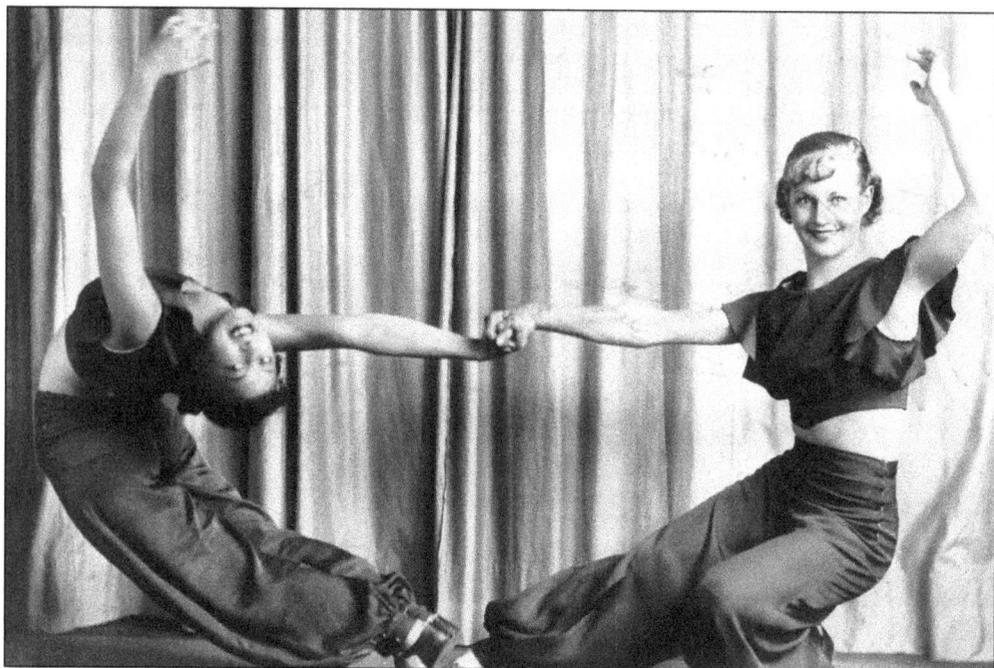

When she was 17, Florence Ann Michaud (left) got a dance scholarship and went on the road with the Orpheum Theatre chain. When the theater business dried up, her agent started booking her in resorts. Michaud spent a summer performing evening shows in Breezy Point's dining room and playing golf with her partner all day. Michaud turned 100 on April 15, 2015. (Courtesy of Florence Ann Michaud)

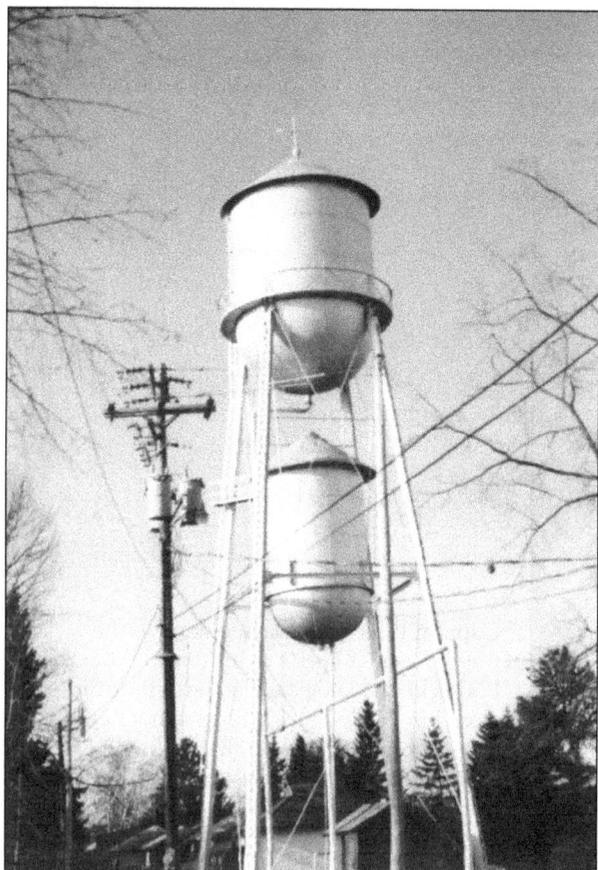

In 1930, Breezy Point replaced a system of wells and pumps with a new 85-foot, double-tanked water tower. Steelworkers came in the spring to assemble the tower parts on the ground. Locals visited the resort to watch cranes lift completed pieces into the air. The 50,000-gallon top tank drew water from Pelican Lake for irrigation and fire control. The lower 20,000-gallon tank drew well water for washing and drinking.

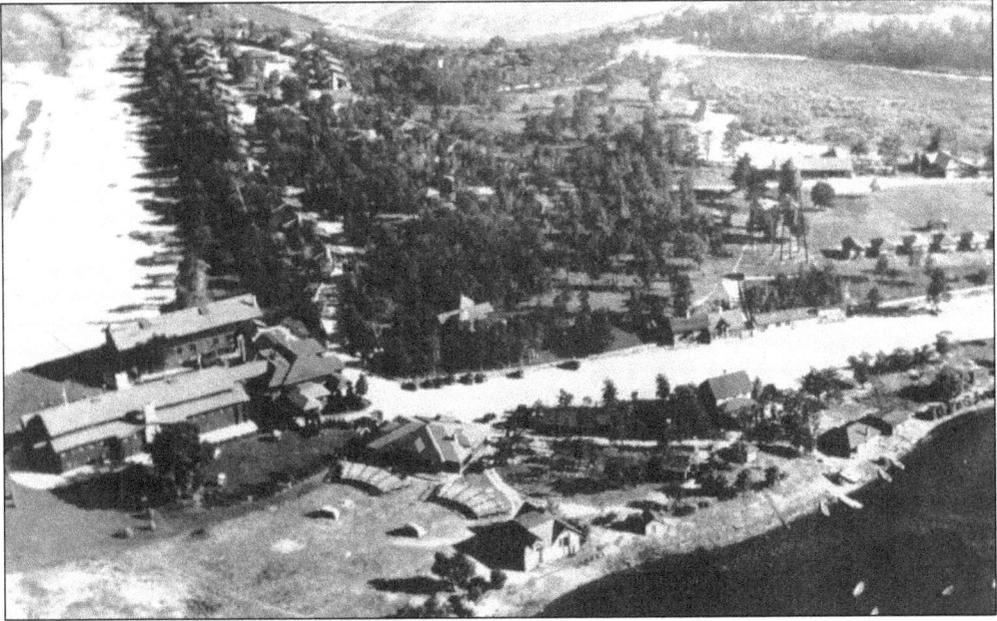

The resort season in Minnesota ran from Memorial Day to Labor Day. One September, Captain Billy had a rush of business and kept the resort open for 700 delegates attending an Equitable Life Assurance Society convention. Brainerd businessmen proposed an extended season to take advantage of duck hunters, but Breezy Point was usually closed before the middle of September. (Courtesy of the Crow Wing County Historical Society.)

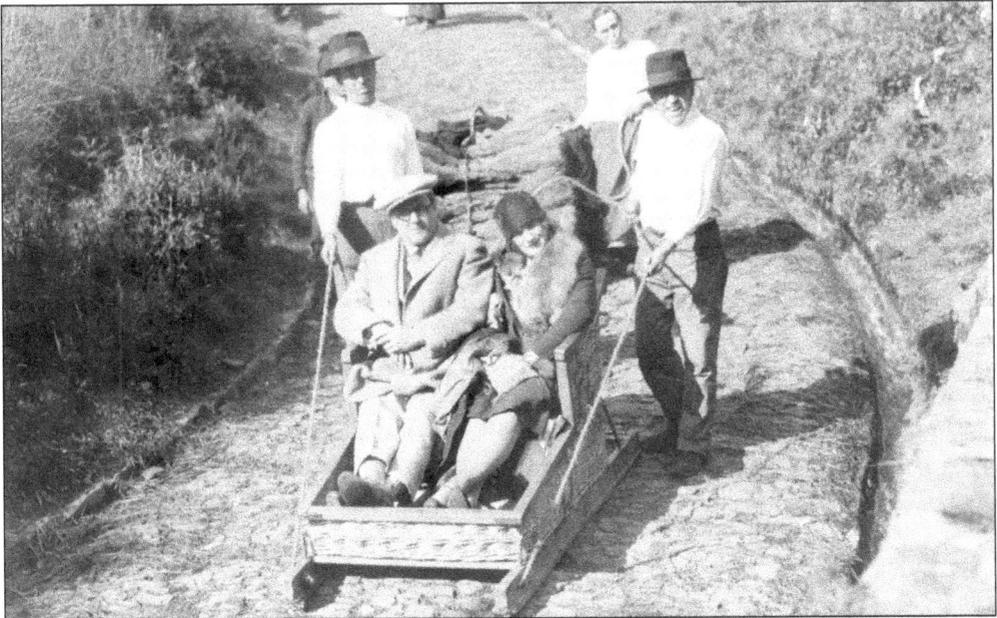

Captain Billy's love of travel took him everywhere. In India, he met with the Maharajah of Indore and his American bride. While in Peking, he entertained a contingent of US Marines. He hunted lions in Africa and caught a 232-pound shark off the coast of New Zealand. On the island of Madeira, Captain Billy and Claire Fawcett (pictured) took an iceless toboggan ride. (Courtesy of Hennepin County Library.)

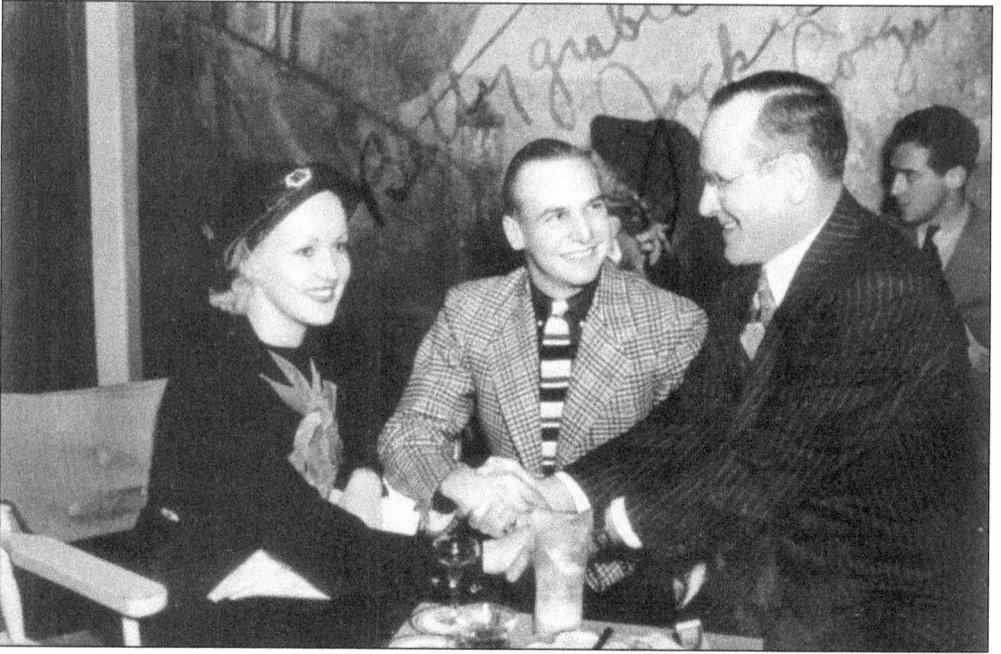

Captain Billy congratulates Betty Grable and Jackie Coogan after their wedding in 1937. Captain Billy loved rubbing elbows with celebrities, and the stars shone bright at Breezy Point. In the 1930s, Clark Gable, Bob Hope, Bing Crosby, Rita Hayworth, Gene Autry, Greta Garbo, Joan Crawford, and Lionel Barrymore all signed the guestbook at Breezy Point.

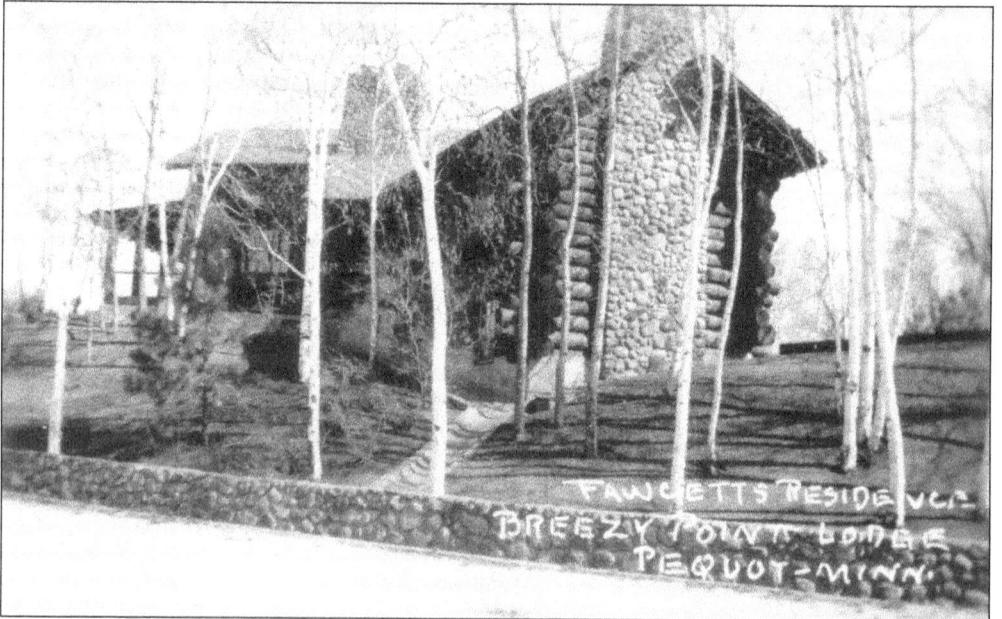

In 1924, Captain Billy hired the Minneapolis architects Magney and Tusler to design his Swiss Chateau–style log cabin. The center of the Y-shaped house has a circular staircase leading to a reading balcony above the main hall. The building's peeled and trimmed Norway pine logs are stained on the outside and coated with a golden varnish throughout on the interior. The home was placed in the National Register of Historic Places in 1980.

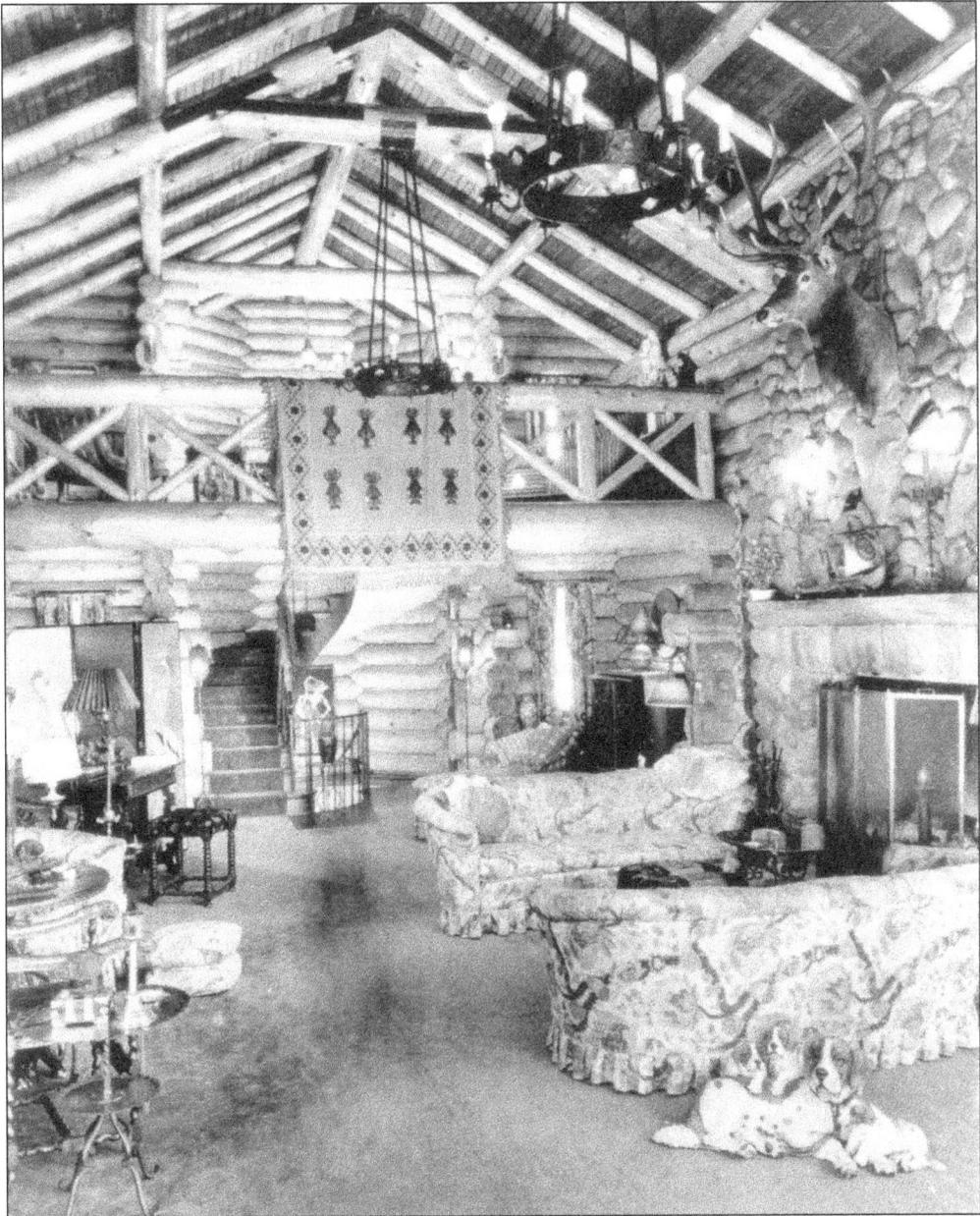

Captain Billy stored curios from all over the world in his log mansion at Breezy Point. In 1928, the *Brainerd Dispatch* reported the Fawcett House contained a treasure of Oriental rugs and tapestries, autographed books, Chinese shawls, Japanese tea gowns, Algerian handicrafts, Hawaiian antiquities, the complete apparel of a millionaire Mandarin, and cunning West Indian cigarette cases that defied opening by anybody who could not find their hidden springs.

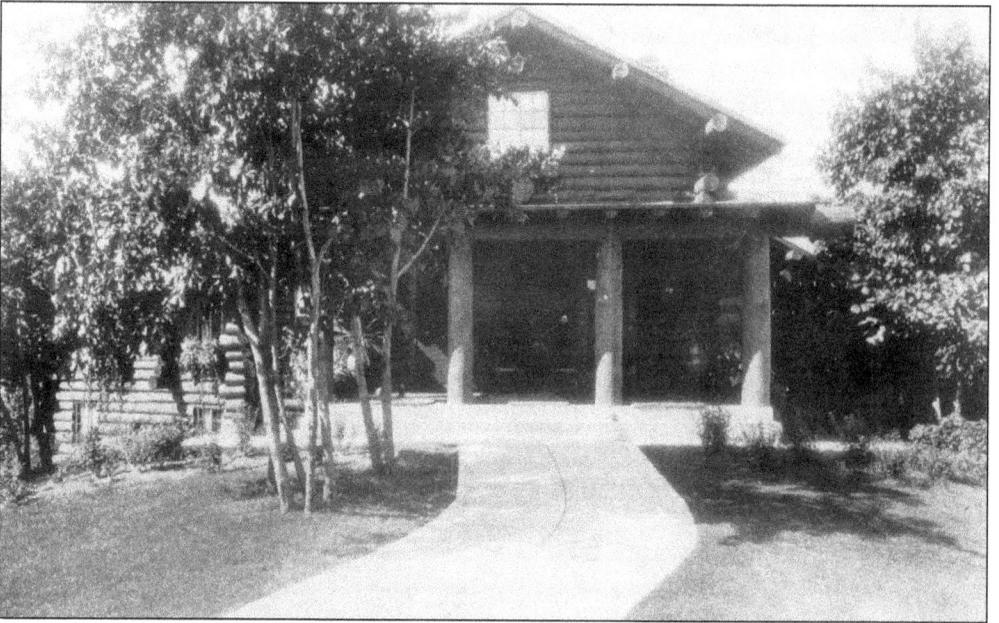

In his 1982 book *Riviera of the North: Breezy Point Resort, 1920's–1930's*, Alvin Husom tells the story of how Captain Billy returned to his home unexpectedly one Christmas and found the resort's caretaker, Alfred Kline, celebrating with his family in the living room. Kline apologized, but Captain Billy found the scene heartwarming and told him, "By all means, always let your family come here. This is beautiful."

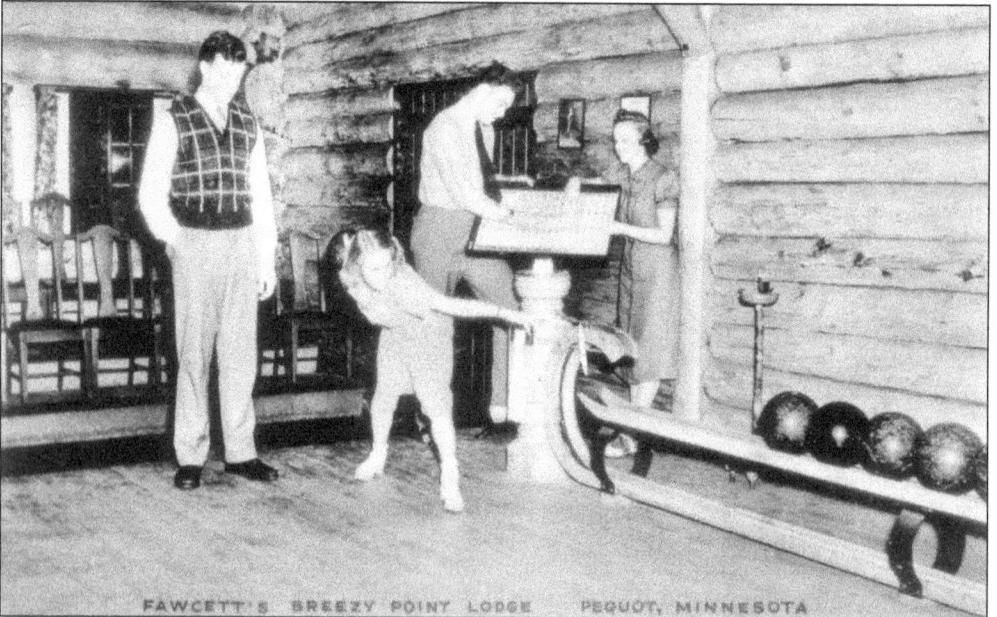

FAWCETT'S BREEZY POINT LODGE PEQUOT, MINNESOTA

The first floor of the lodge offered guests all sorts of indoor recreations. A six-table billiard room, gambling casino, and bowling alley were popular with visitors. There were slot machines throughout the resort. In 1932, Harry Truman hit the jackpot in the lobby. Truman was staying 30 miles away in Brainerd, but he was so impressed with the resort that he drove up to play the slots several nights in a row.

On February 7, 1940, Captain Billy died of a heart attack in Hollywood, California. A few weeks before his death, his children and their mother joined him for a family reunion. Newspapers marked the publishing giant's passing on front pages. Funeral services were held in Minneapolis, and Captain Billy was buried in Lakewood Cemetery next to his brother, Roscoe Fawcett. Captain Billy was 55 years old. (Courtesy of Shaun Clancy.)

In *Afternoons in Mid-America*, Erskine Caldwell writes, "It's a rare thing for a dynamo of a man like Captain Billy Fawcett to leave behind a world so full of friends when he dies and so few—if any—detractors." Caldwell goes on to speculate that Captain Billy might have accumulated a few enemies had he lived out all the years a man like him was entitled to. (Courtesy of Shaun Clancy.)

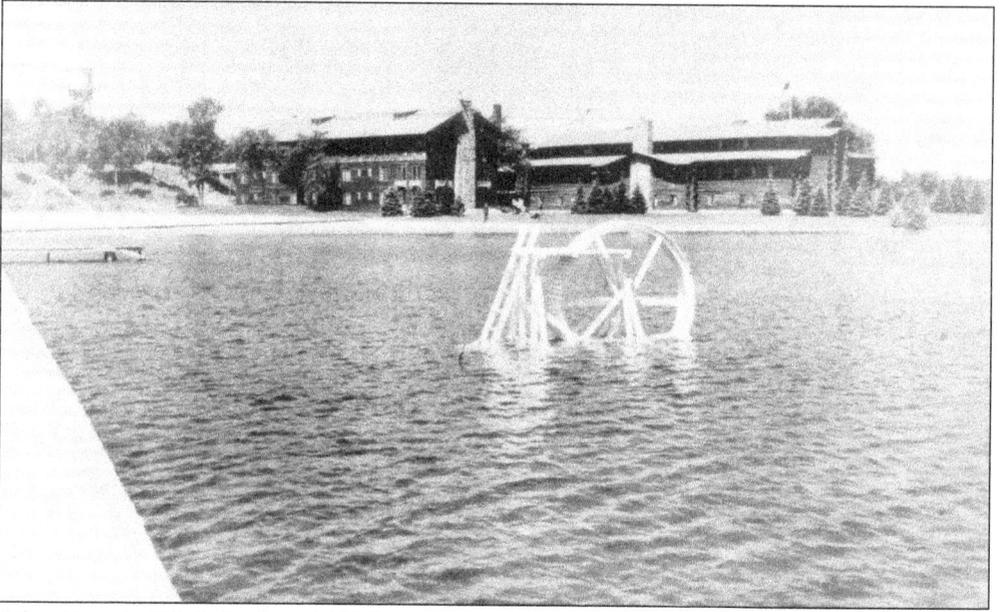

After Captain Billy's death in 1940, his son, Gordon Fawcett, became the managing director of Breezy Point and Fawcett Publications. General manager Gene Hawkins opened the resort for a 19th season. War broke out in Europe, and American tourists looked for destinations closer to home. Hawkins managed to book several large conventions, and Fawcett Publications continued to promote Breezy Point in its ever-expanding line of periodicals.

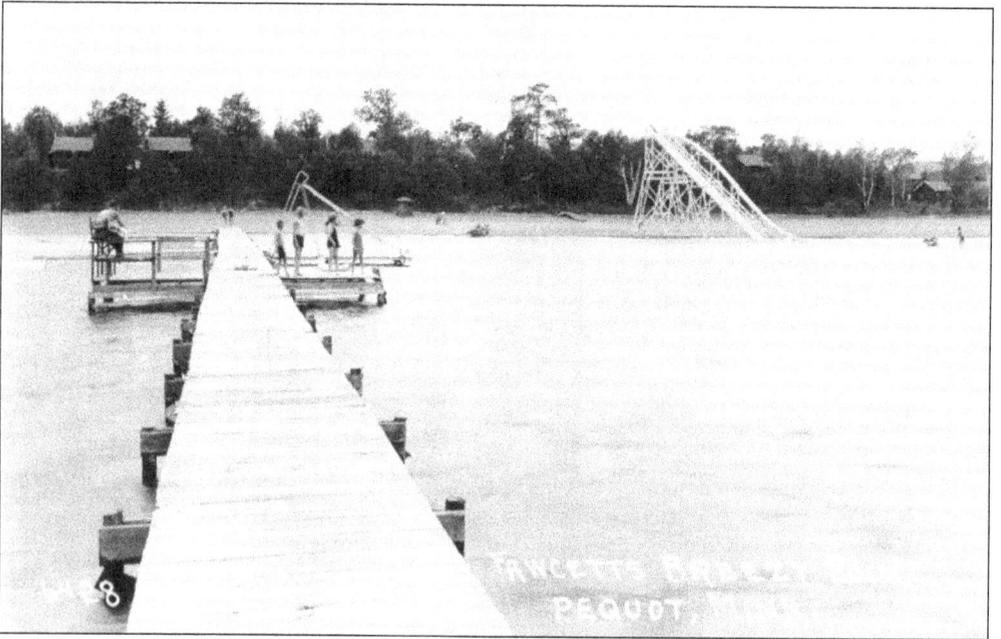

During World War II, gas rationing boarded up resorts all over Minnesota. Captain Billy's children grew up at the resort, but their hearts were not in the business. In 1946, Breezy Point was sold to the holder of the Brainerd Area Coca-Cola bottling franchise, Theron "Tiny" Holmes. (Courtesy of the Crow Wing County Historical Society.)

World War II was finally over. America's prospects were soaring as 10 million demobilized veterans and millions of wartime workers found their places in civilian life. Area residents were thrilled when Breezy Point reopened on Memorial Day 1946. The resort's seasonal employees were picked up at the train station in Pequot Lakes by the head of housekeeping. Ed Thielman (pictured) just could not wait to get back to work.

A summer job at Breezy Point meant 14-hour days, seven days a week. Employees were up before dawn to rake the beach, grind ice blocks into pieces, and arrange table cloths, china, and silver. Then, there was changing linens; sweeping, moping, and waxing floors; and moving furniture down to the beach for lunch and lugging it all back up to the dining room for dinner.

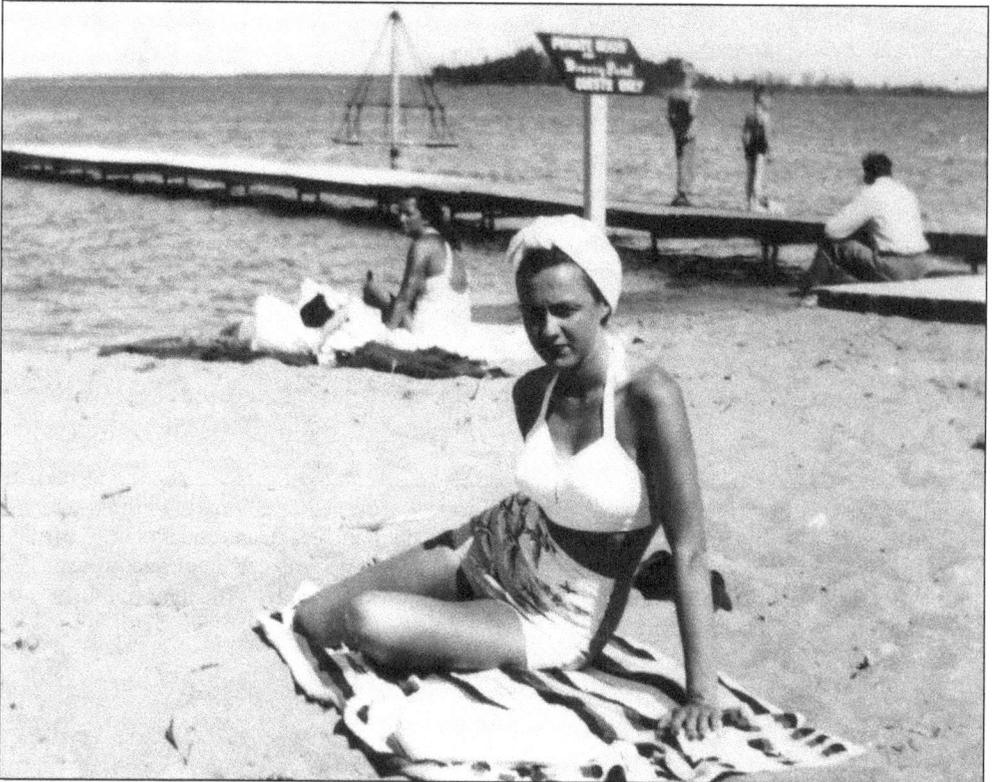

In the 1940s, the defense industry expanded, and women found work in previously unavailable fields. Many of the traditionally male factory jobs paid better than the teaching, nursing, and clerical positions women could usually find work in. After the war, most of the women working in manufacturing were let go, and their jobs went to returning soldiers. At Breezy Point, women worked in the kitchen, dining room, and housekeeping.

The midriff, modeled here by Breezy Point waitress Mary Ellen Koop, was born in the 1940s. Women's swimsuits and playsuits were usually tight-fitting two-piece outfits made of rayon or cotton. Some suits featured flattering Lastex control panels in the stomach and bra cups. Patriotic colors were popular on the beach. Toward the end of the decade, bandeau and strapless tops, requiring ever more Lastex, began appearing on American beaches.

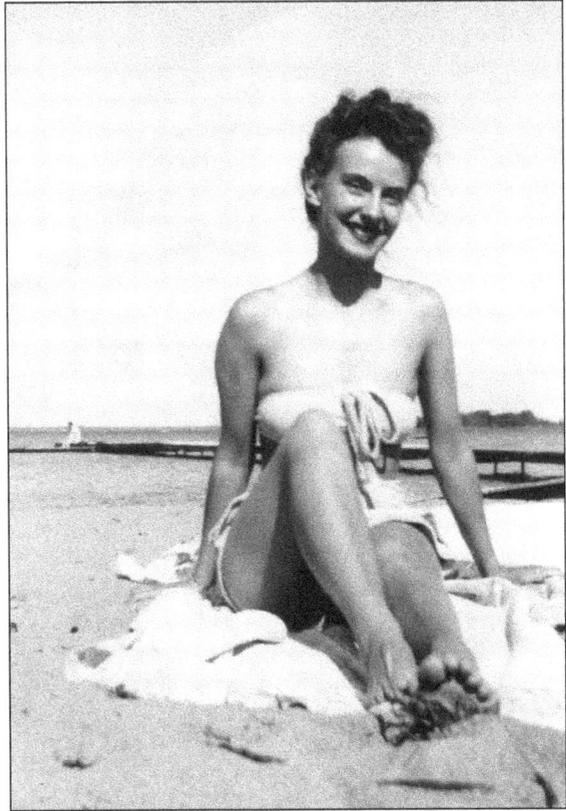

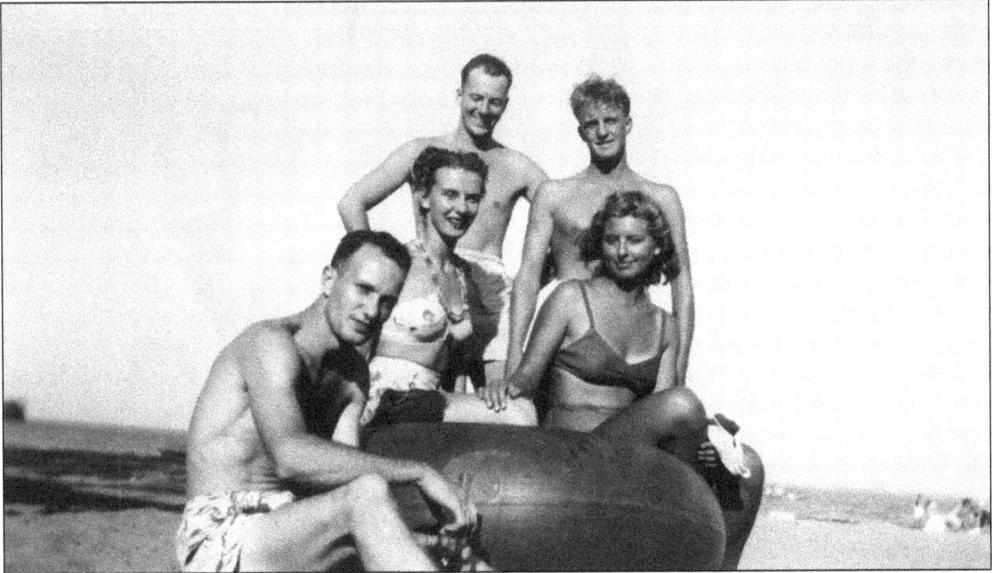

Tourists came north for cooler temperatures. Advertisements for the resort claimed that the mercury in Minnesota's Northern woodlands rarely climbed above 80 degrees. When it did, the best place to be was on the shores of Big Pelican Lake. Breezy Point employees like, from left to right, Bob Richardson, Mary Ellen Koop, Rush McClinton, Bud Borgen, and Carrie Berg were allowed a few hours on the beach when business was slow.

Breezy Point's busboys were show-offs. In the enormous dining room, they carried large aluminum trays filled with hot dinners or dirty dishes on their fingertips. Competition for tips was fierce. Busboys ran with their trays. If anyone dropped a tray the maître d' told him that he would be out of a job if he dropped another. Dick Zeleng (left) never dropped a tray.

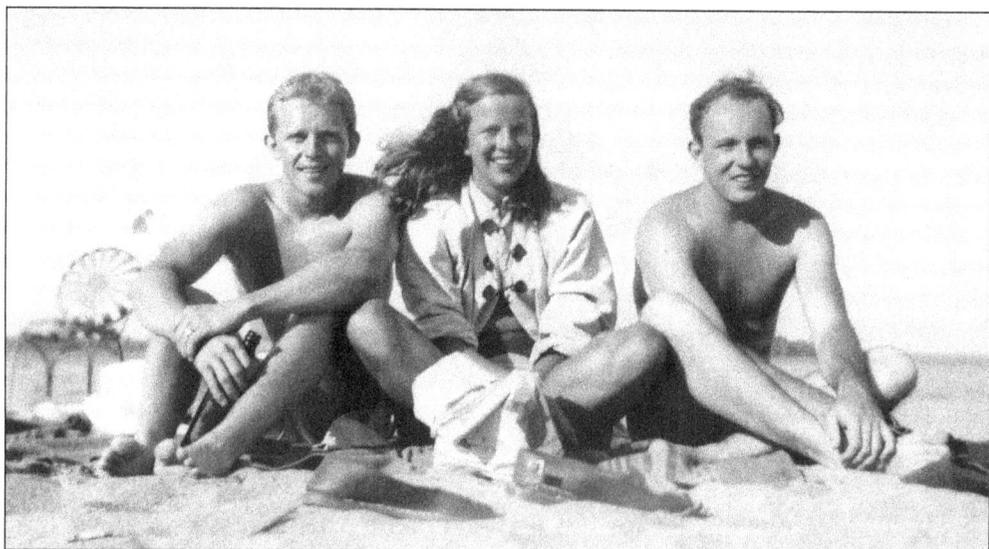

Breezy Point had a strict policy against employee-guest fraternization. The rule was slightly relaxed on the beach. Employees rarely found a free moment for swimming, and when they did, it was usually because business was slow. One Sunday, during the summer of 1947, Ken "Spruce" Earley (left), Peg Edwards (center), and Vance Walters managed to slip out and spend an afternoon swimming and drinking beers. Either Earley or Edwards was a guest.

After the war, a man could buy a swimsuit made of quick-drying materials for as little as 69¢. Swim shorts like these worn by Breezy Point bellboy Leo Swanson (pictured) were high in the waist and usually had a pocket. Bikinis were officially invented in 1946. The swimsuit, named after a Pacific island where America tested nuclear weapons, was banned on beaches in most Midwestern states.

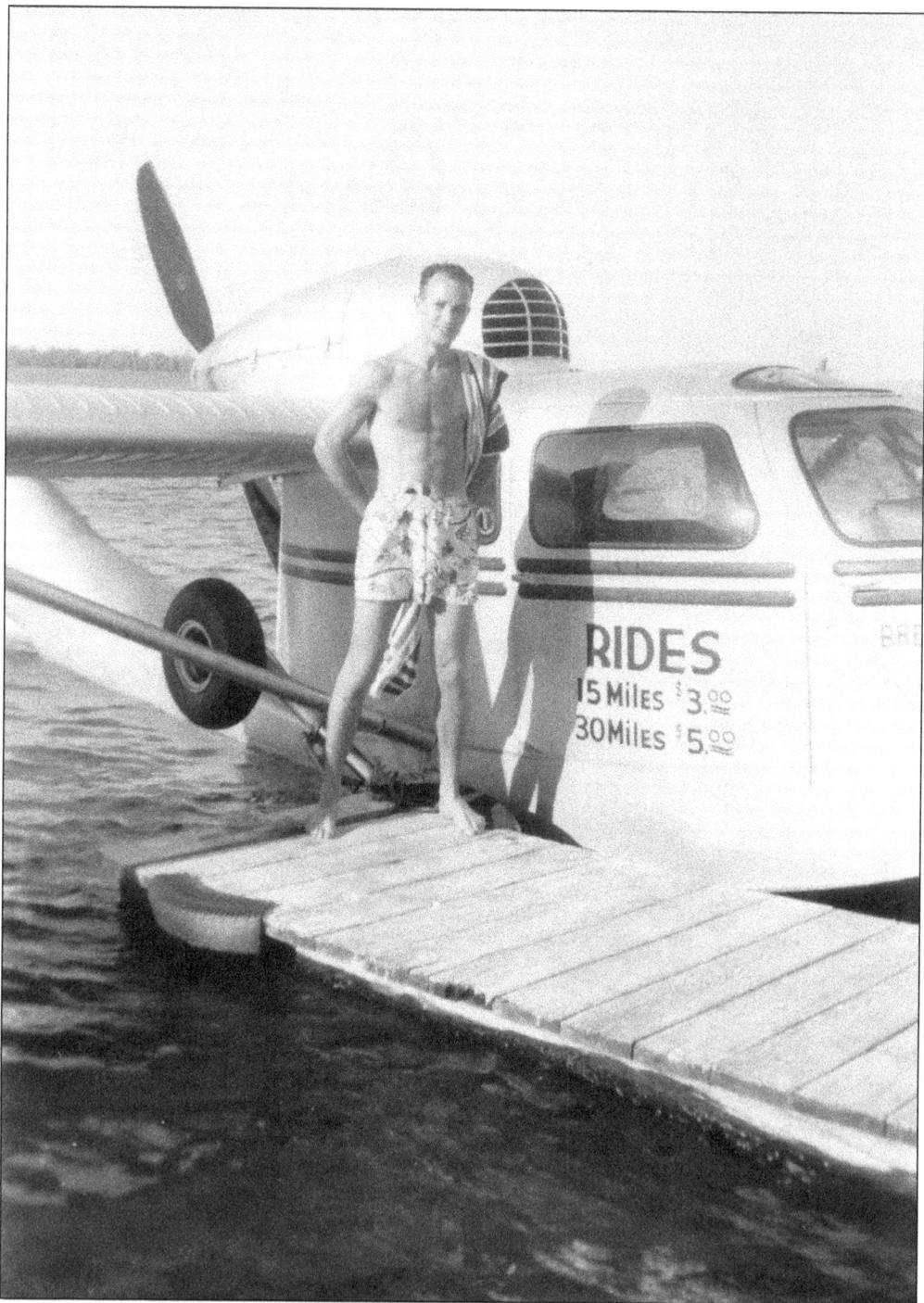

Airplane rides above Pelican Lake resumed when Breezy Point reopened after World War II. During the summer of 1947, visitors could take a ride in this all-metal, Republic RC-3 Seabee amphibious aircraft, and $3 bought a 15-mile ride. A 30-mile ride could be had for $30. Over 200 of these durable little aircraft are still flying, and a few Seabees are still operating commercially as bush planes and air taxis.

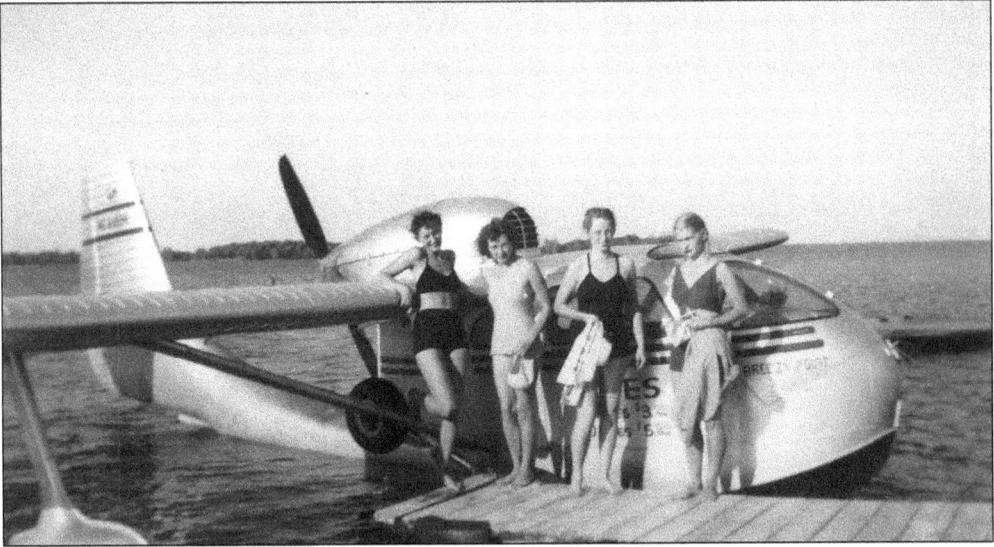

After World War II, aircraft manufacturers imagined returning pilots would create a market for a variety of civilian planes. Republic Aviation had hoped to sell over 5,000 RC-3 Seabee amphibians a year. Priced under $6,000, this four-seat aircraft was an incredible bargain for Breezy Point. But after two years of sluggish sales, the plane was discontinued in 1947. At the end of production, 1,060 Seabees had been built. Republic sold the last one in 1948.

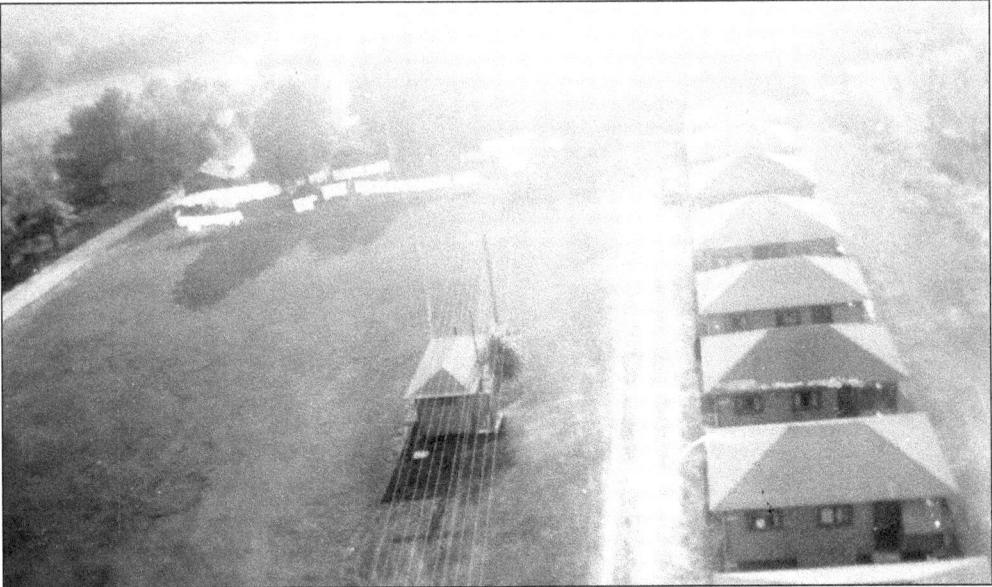

The view from the water tower was less expensive than the view from the windows of Breezy Point's seaplane. The management declared the water tower off limits to employees, but few could resist the temptation, and the narrow metal ledge that wrapped around the tank became a favorite haunt for thrill-seeking busboys and bellboys at the resort.

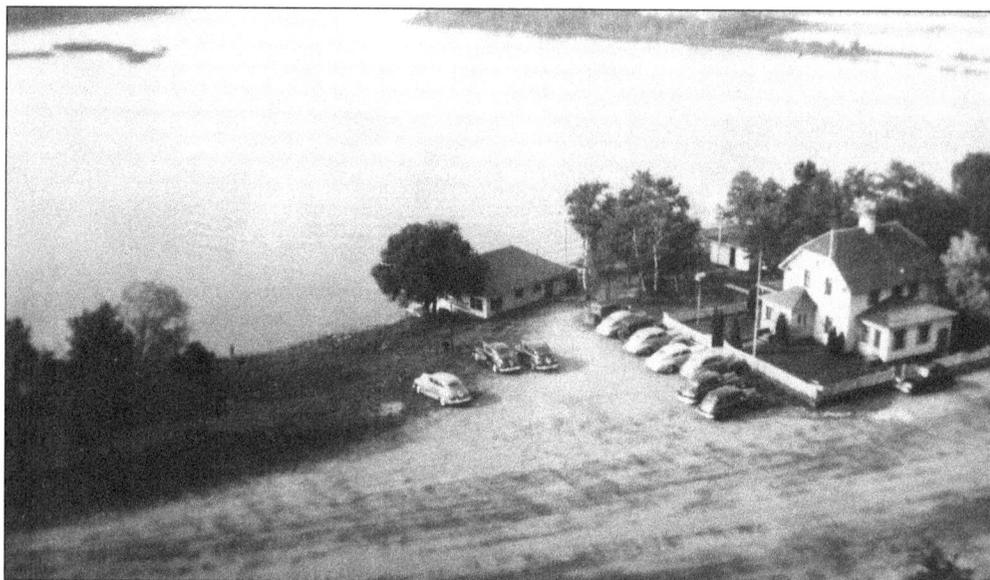

Here is another view from the water tower, looking north toward the bay. The day after Labor Day, seasonal employees headed home with fat wallets. In September 1950, Breezy Point busboy, Paul DeKock recorded his earning in a journal. Over the course of the summer, DeKock made $150 in wages, $200.22 in tips from dining room guests, $67.80 in tips from waitresses, and $45.10 for babysitting and shoe shining.

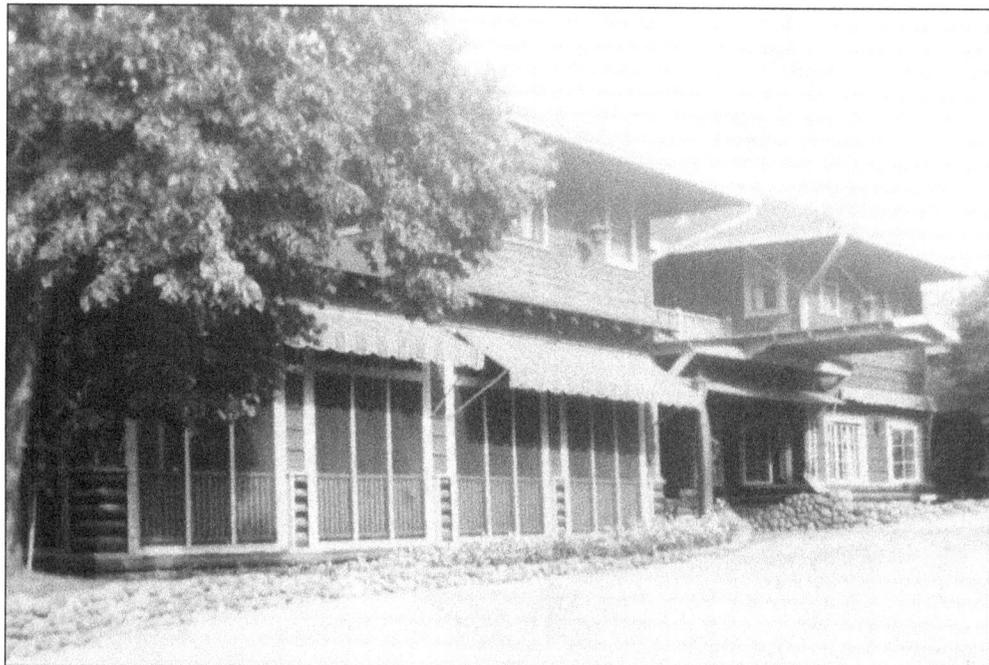

Even in the late 1940s, Jewish families were excluded from resorts all over the Midwest. Breezy Point bought space in Jewish newspapers, advertising rates as low as $84 a week at a welcoming resort. Vacation packages included golf, horseback riding, three meals a day, and nightly entertainment provided by Kiki Ochari's Cuban rhumba band. Hundreds of families from as far away as Chicago and Milwaukee drove north to Breezy Point.

The summer of 1947 remains one of the hottest in living memory. Late-season temperatures soared across the nation. On August 10, Beardsley, Minnesota, set the record at 110 degrees. Twin City residents drove north for cooler temperatures, and the resort was busy. All the hot weather only partially explains why Bob Richardson appears without a shirt in so many of these photographs.

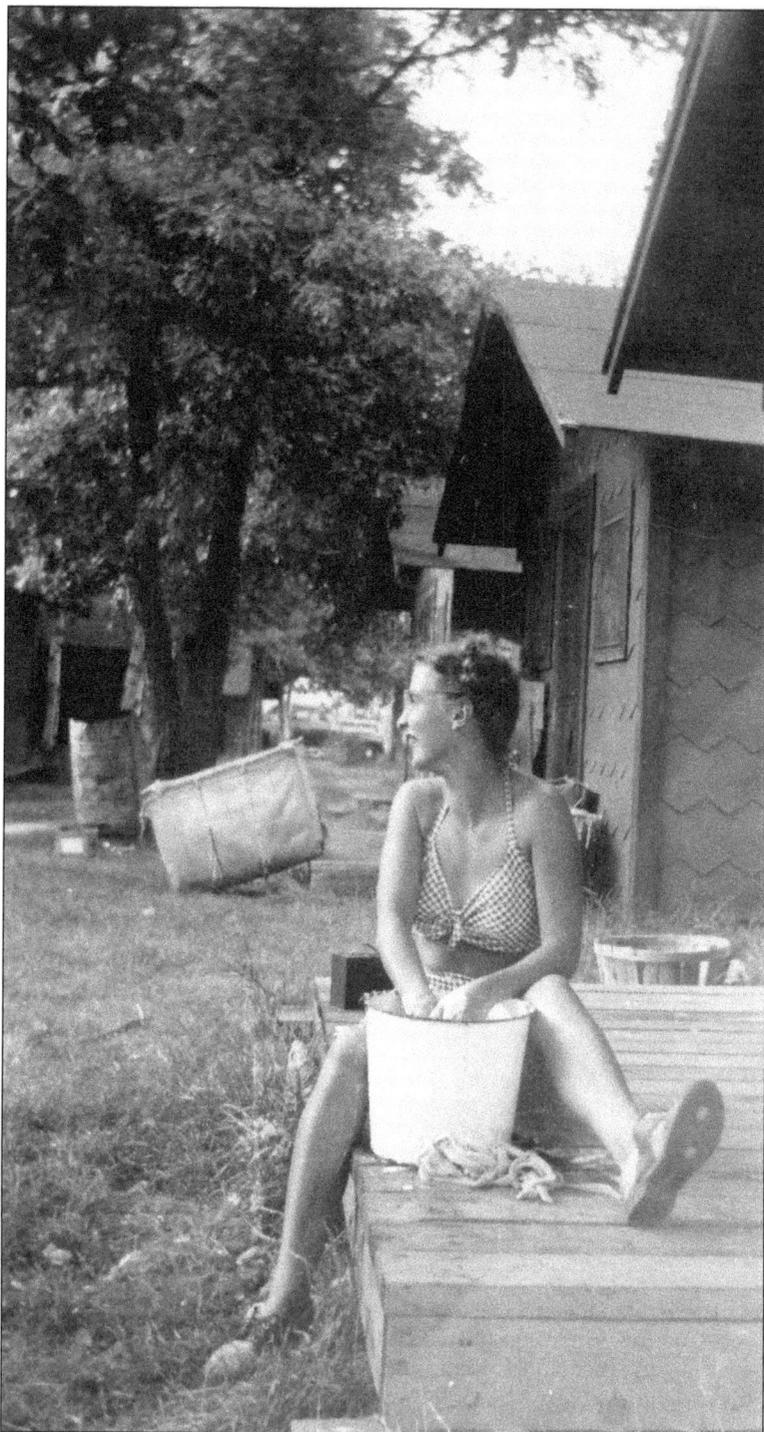

The shower house was located next to the toilets and the laundry. A seamed metal wall separated two shower areas. In a letter full of memories, former employee Paul Dekock recalls pushing on the flimsy barrier. The girls on the other side pushed back and shouted an invitation. Paul located a space in the seam, knelt to take a peep and found a blue eye looking back at him.

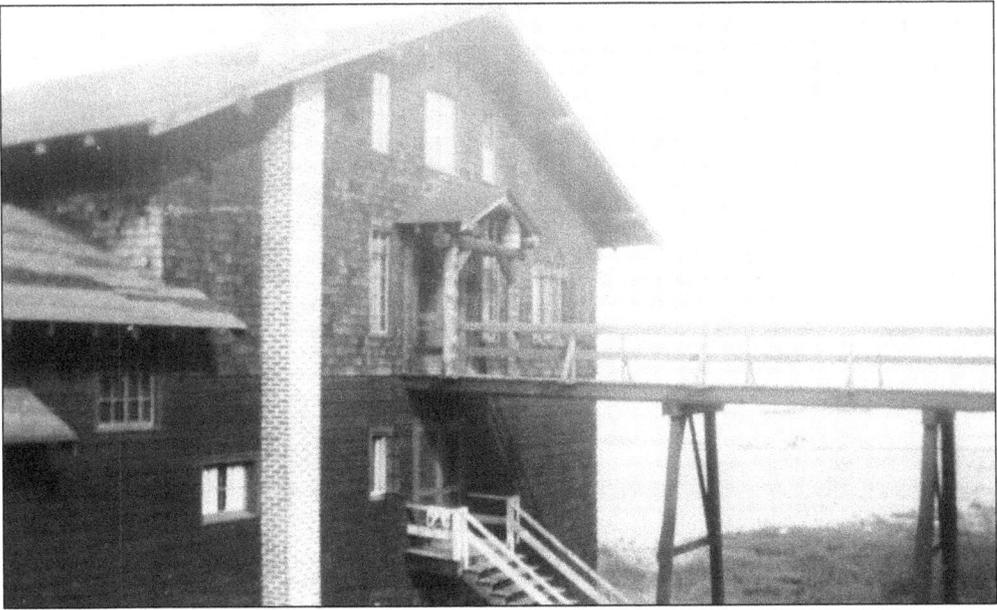

In 1947, Theron "Tiny" Holmes sold Breezy Point to Jack Salenger and his partner Reynolds "Brownie" Cote. No stranger to the resort business, Cote owned the Grandview Lodge in Nisswa, Minnesota. Salenger was president of Overland Printing in Chicago. A twist of fate occurred when Holmes met with an early death and his widow married Roscoe Kent Fawcett in 1956. This walkway led from the Edgewater Annex to Cottage Road.

Employee living quarters were separate and unequal. Women enjoyed white-trimmed, dark-brown cabins close to the water tower. Most of the male employees were lodged in what former busboy Paul DeKock described as *Grapes of Wrath* cabins tucked away deep in the woods. Mary Frost, pictured here in front of one of the women's cabins with Bob Richardson and Jan Falkenhagen, is about to head off to the shower wearing fuzzy slippers.

Working at Breezy Point was more than just a summer job. Young people from all over the Midwest came to the North Woods, earned money for college, built lifelong friendships, met their mates, and had the time of their lives living and working at the resort. Pictured here are, from left to right, Vance Walters, George ?, Ilene Opats, Jan Falkenhagen, Mary Frost, Bob Richardson, Jo Ellen Stock, and Pam Johnson.

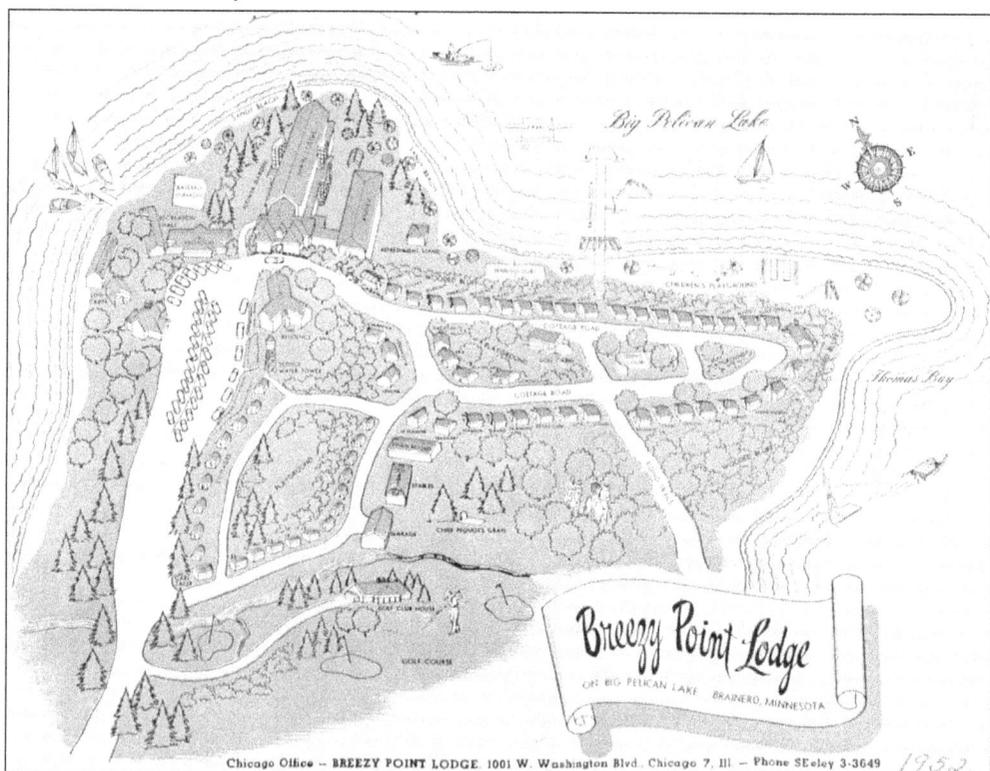

When this brochure was printed in 1952, Breezy Point had essentially the same layout as it did after the construction of the lodge and Edgewater Annex were completed in 1928. The name Thomas Bay rarely appears on maps of Big Pelican Lake. Captain Billy probably named the bay after Thomas Cabin, which he named after Thomas Avenue in Minneapolis.

66

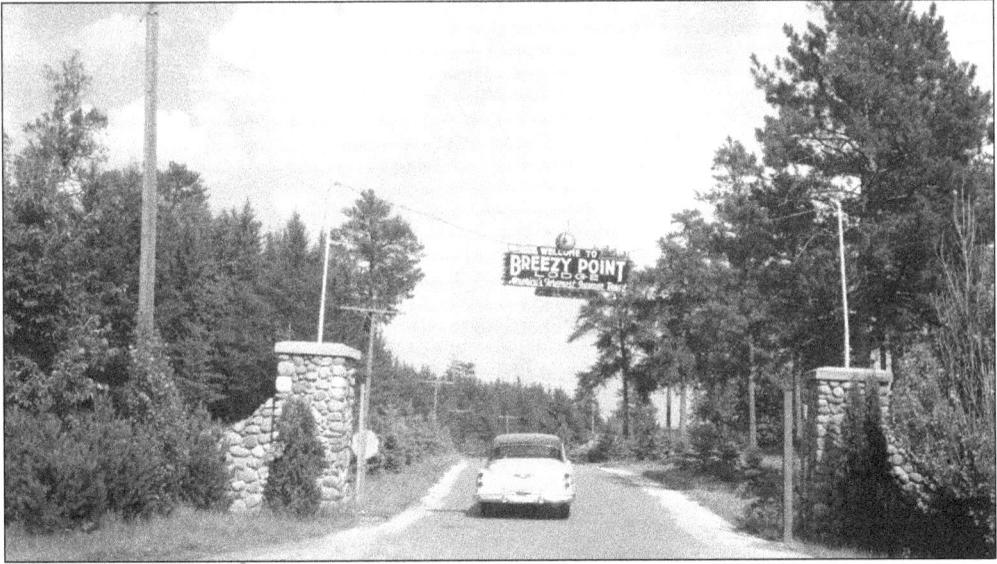

Captain Billy's log mansion became Breezy Point's main office and headquarters. Resort owners and managers often referenced the resort's romantic past but found it difficult to keep up the resort's tremendous public image. Salenger had some luck attracting conventions. In July 1951, Arthur Murray Dance Studios held its national convention at Breezy Point.

Honeymooners from the 1920s returned to Breezy Point for anniversaries in the 1950s. Nostalgia was in the air, but the resort's management was looking toward the future. In an effort to modernize, the dinner dress code was relaxed, and one brochure reminds guests, "Sport clothes or 'just clothes' are the every day fashion. No need for dress-up things, informality is the Breezy Point watchword."

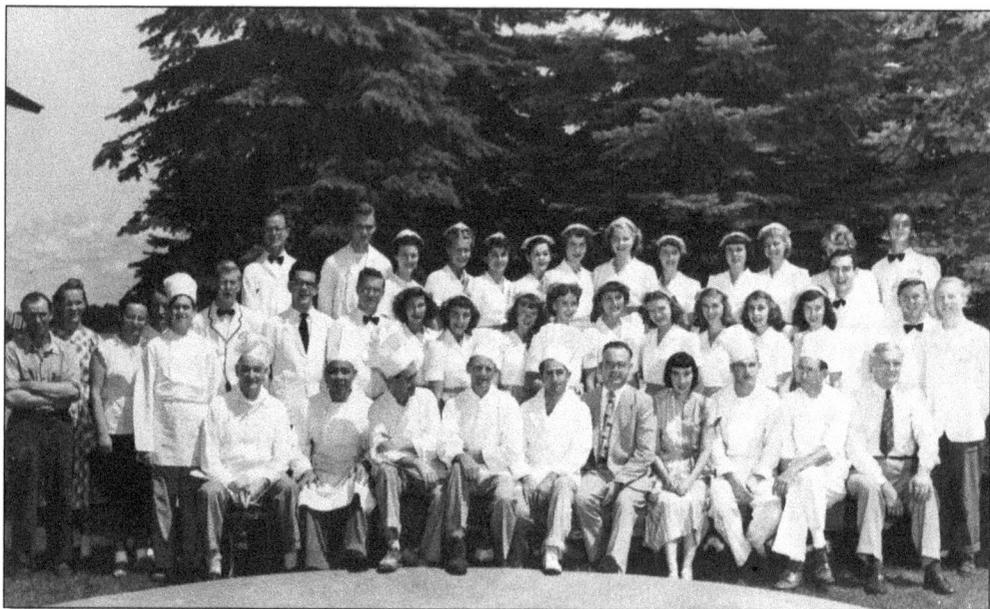

The resort's kitchen staff served up daily lakeside and poolside buffets. Fresh-caught fish, country eggs, vegetables, and milk were available daily, but hot dogs, hamburgers, and Coca-Cola were far more popular. Evening menus included chopped sirloin, filet mignon, Cornish game hens, and roasted Long Island ducklings in orange sauce. Dinner was served in the resort's famous varnished-log dining room.

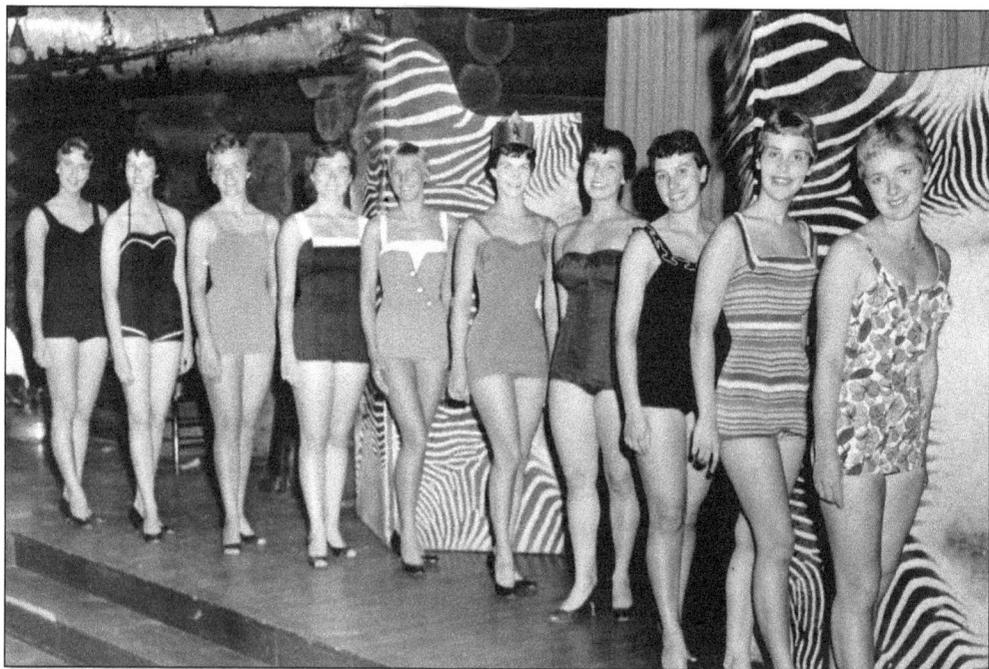

The resort's summer employees kept Breezy Point's guests entertained with beauty pageants, dance routines, and swimsuit competitions. The young ladies third and fourth from the right are Jackie Norby and Sharon Gravdahl. The zebra skin stage props and the old birch-bark canoe (upper left) were remnants from the early days of the lodge.

Roaring Twenties revivals always went over well and gave guests in the 1950s a chance to remember the glamorous days of daring barnstormers, bootlegging, gangsters in pin-striped suits, silent movies, fox-trotting, and *Captain Billy's Whiz Bang*. Sharon Gravdahl is the first flapper on the right. Her brother Dave Gravdahl became Breezy Point's general manager in 1982.

Comedian Sammy Shore (right) appeared at Breezy Point for several shows with actor and "banjoist" Gene Sheldon. Shore went on to form the Comedy Store on the Sunset Strip and was hand-picked by Colonel Parker to be the opening act for Elvis Presley's early 1970s "Comeback Tour." Sheldon is remembered as the star of the 1961 Disney film *Babes in Toyland*. He also played Bernardo in the television series *Zorro*.

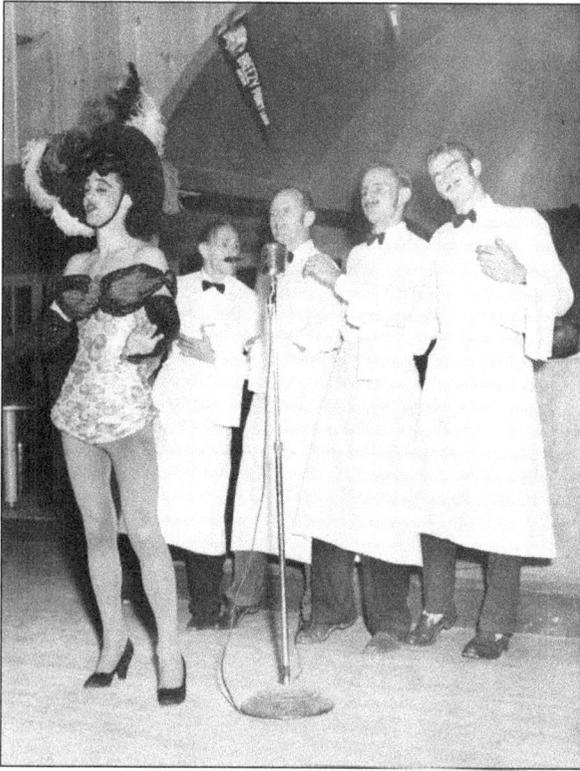

Breezy Point's busboys, waitresses, and kitchen workers entertained guests at weekly talent contests. Employees put on magic shows, sang, danced, and played their musical instruments with the lounge band. Performers earned better tips, and their minor celebrity status allowed them to break Breezy Point's employee-guest fraternization policy. After the show, teenage guests and the resort's talented staff were often found wandering the beach together.

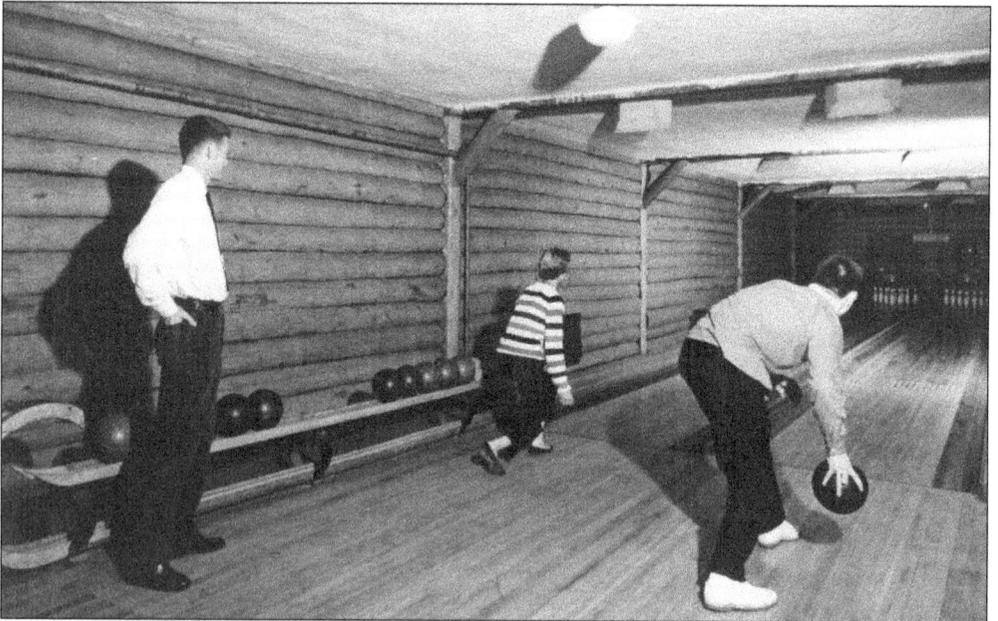

The 1950s were the golden years of American bowling. Television embraced the sport, and the first network coverage came with NBC's broadcast of *Championship Bowling*. In the Twin Cities, shows like *Make That Spare*, *Celebrity Bowling*, and *Bowling for Dollars* began to dominate afternoon programming. Up at Breezy Point, the resort's 1920s-era bowling alley remained a popular attraction. (Courtesy of the City of Breezy Point.)

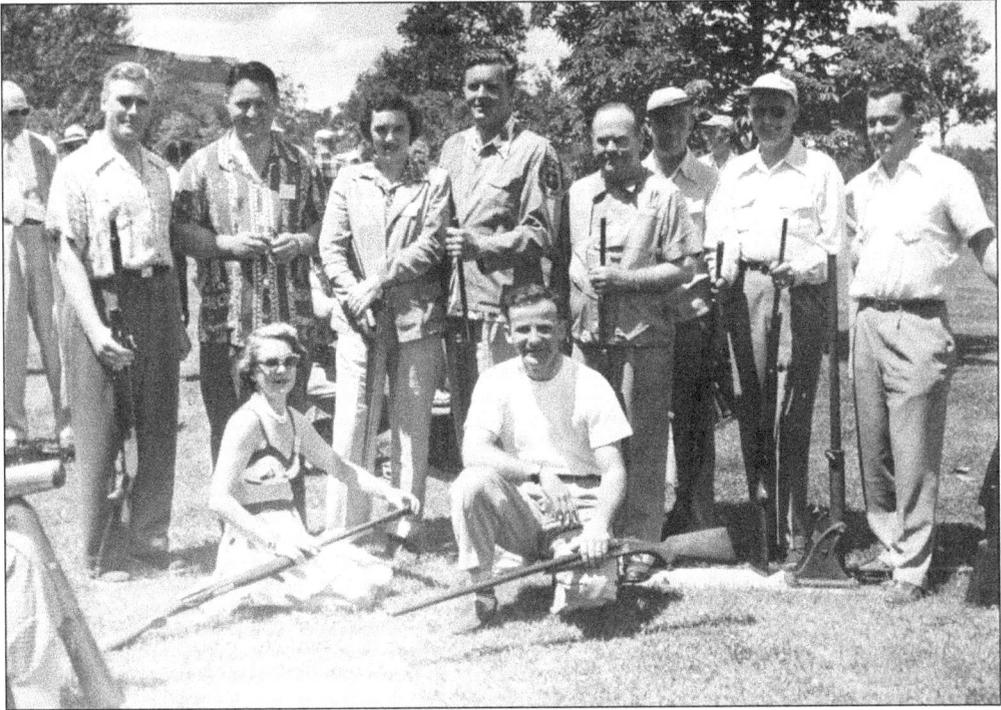

Breezy Point's guests have always been provided with a wide selection of activities. Trapshooting on the resort's championship range was still a mainstay in the 1950s. Competitions were held during the summer months, and many of the resort's guests still remembered Captain Billy's love of the sport and the days when state tournaments were held at Breezy Point. (Courtesy of the City of Breezy Point.)

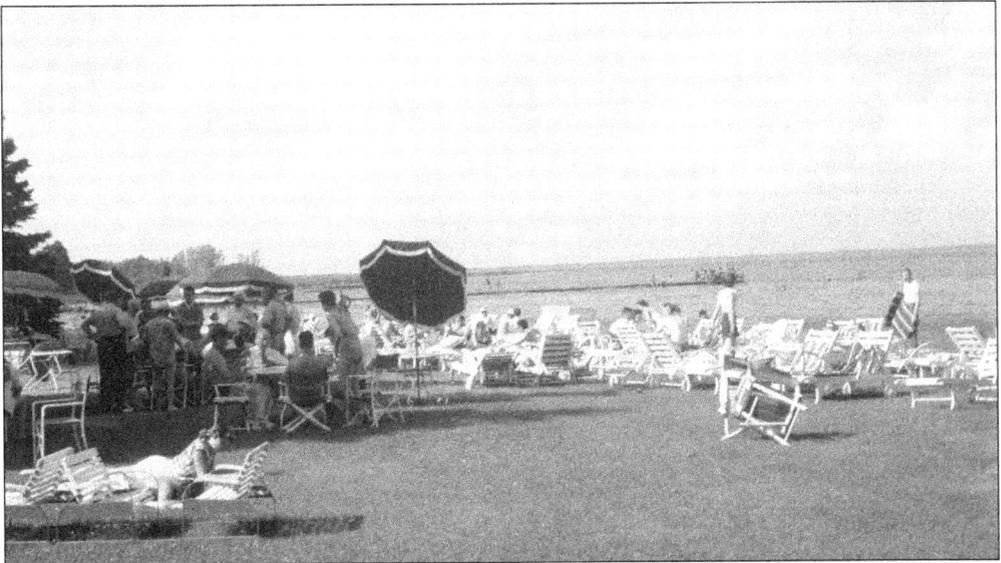

Breezy Point has always had one of the best beaches in Minnesota. In addition to the long stretch of fine sand and clear, shallow water in front of the resort, 13-acre Gooseberry Island sits just a mile off shore. Officially acquired by the resort in 1974, the island boasts an extensive beach for boaters and is home to a herd of poison ivy–eating goats.

The earliest survey maps showing details of Big Pelican Lake were completed in 1858. In the early 20th century, an Italian immigrant named Pasquale Cimino and his Chippewa bride Josette homesteaded 75 acres on the southeast shore. Tourist development began a few years later after a group of Nebraskans established the Pelican Lake Outing Club at Lincoln Point. Covering over 8,000 acres, the lake is still Breezy Point's main attraction.

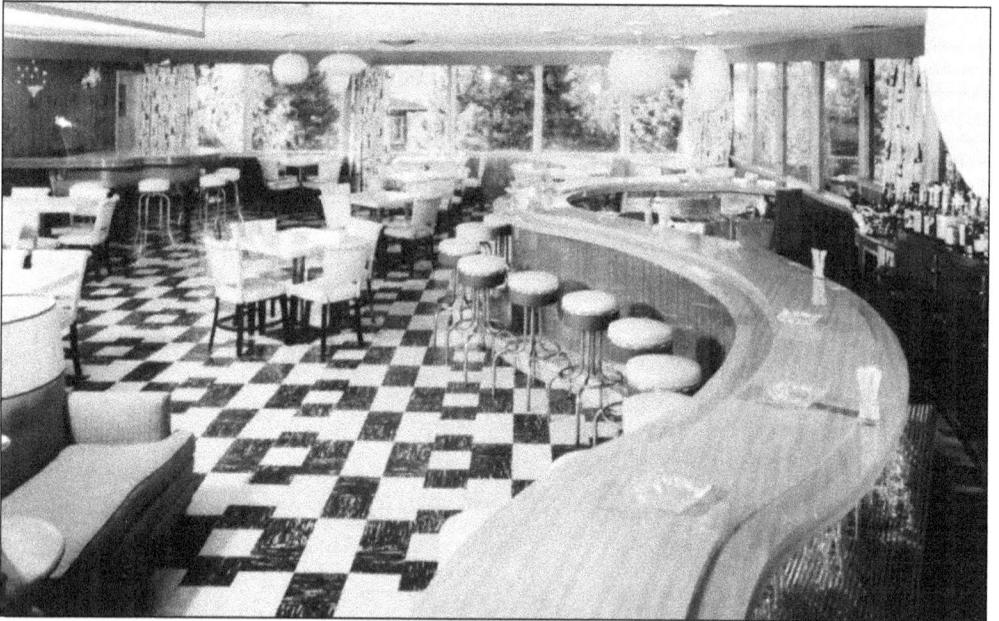

In May 1955, Salenger and Cote sold a substantial interest in the resort to Breezy Point's manager Ken Keller. A $100,000 expansion and remodeling was announced. The project included a cocktail lounge, golf course improvements, and a day camp for children 7 to 15 years of age. Cote already owned nearby Camp Lincoln for boys and Camp Lake Hubert for girls. (Courtesy of the Crow Wing County Historical Society.)

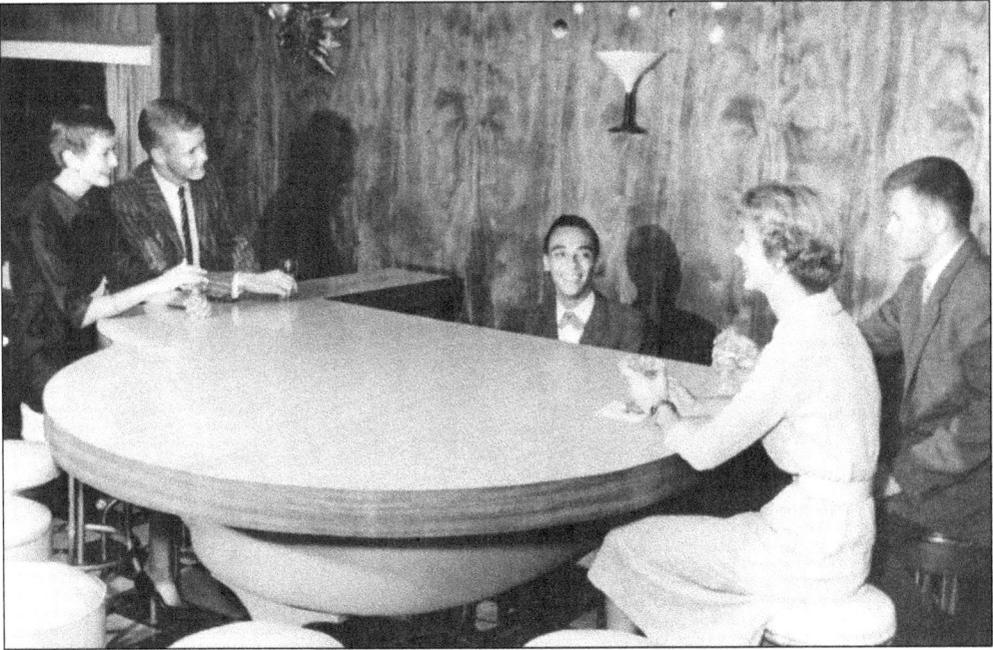

Breezy Point took advantage of a Cuban rhumba craze and booked Latin American bands to play the Antlers Bar and the Supper Club on a regular basis. After the resort brought in Chicago bandleader Kiki Garcia to play at the piano bar, the intimate corner became a popular spot for a cocktail. (Courtesy of the Crow Wing County Historical Society.)

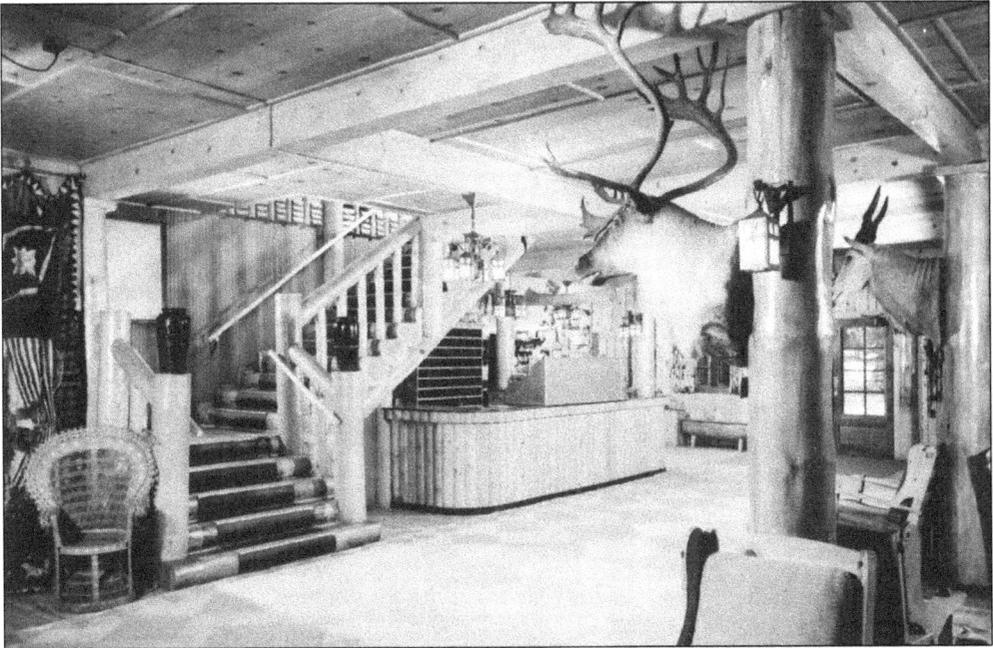

A 1950s renovation replaced the old marble and glass of the reception desk with knotty pine panels. To the left of the lobby's giant log stairs hung a leftover from Captain Billy's era. The 10-by-12-foot wall rug depicting an eagle with a quiver of arrows clutched in its claws was made from the pelts of nearly every type of furbearing animal in North America.

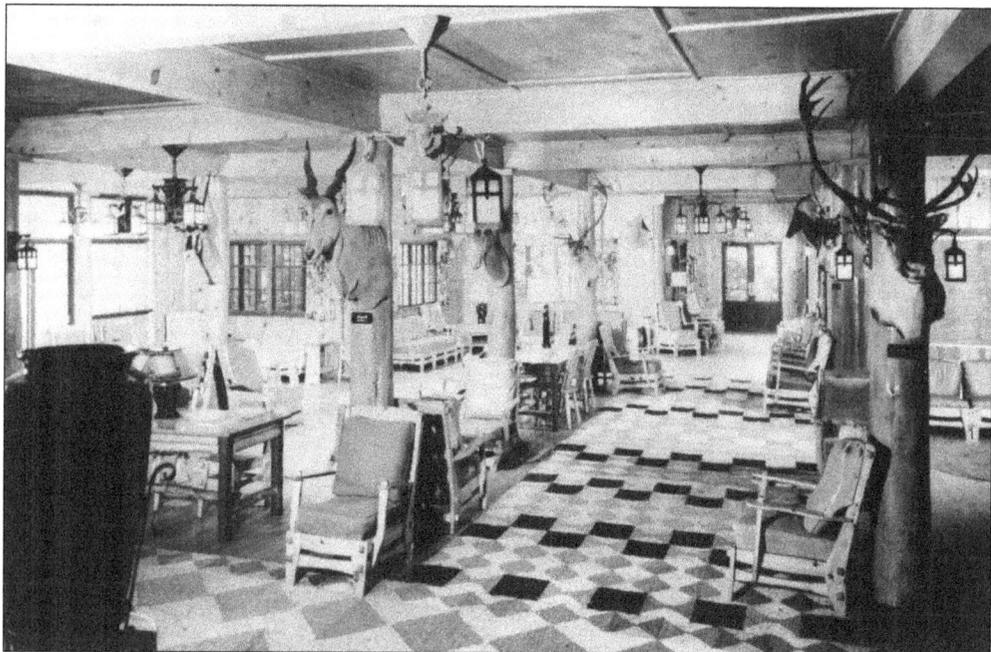

A world-class hunter, Captain Billy circled the globe in search of game. He hunted lions in Africa and bears in Alaska. His trophies adorned every corner of the old lodge. The heads of cheetahs, antelope, gazelle, zebra, gnu, caribou, moose, and buffalo stared down from walls, surprising guests and frightening their children.

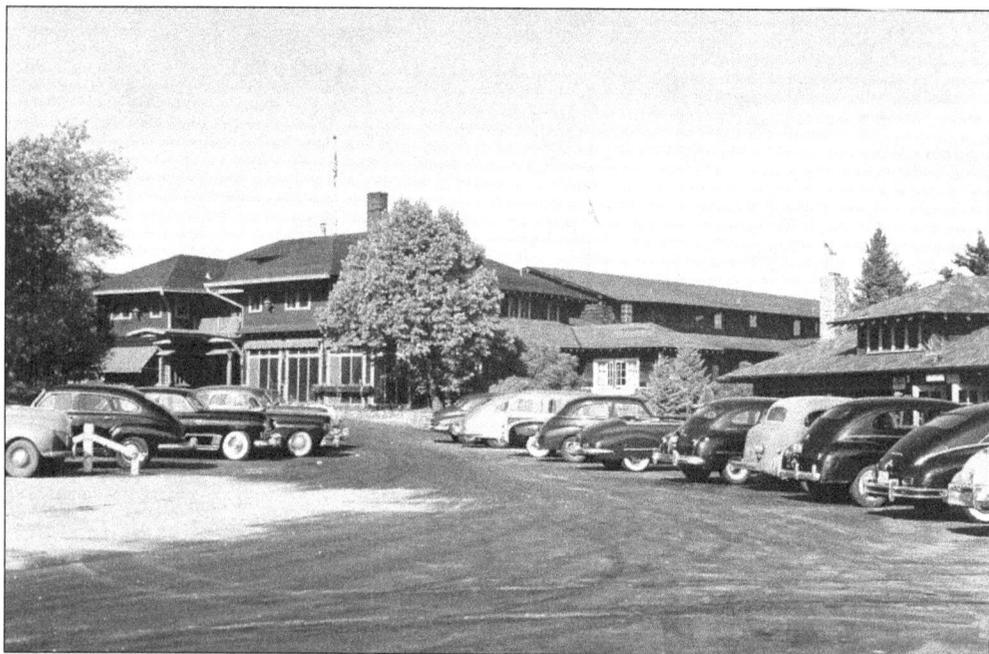

In the 1950s, most of Breezy Point's guests arrived by car. Those that came by train arrived on one of two daily through trains that left Chicago's Union Station on the Burlington Route. By prearrangement, the resort sent courtesy cars to pick up guests at depots in nearby Staples and Little Falls, Minnesota.

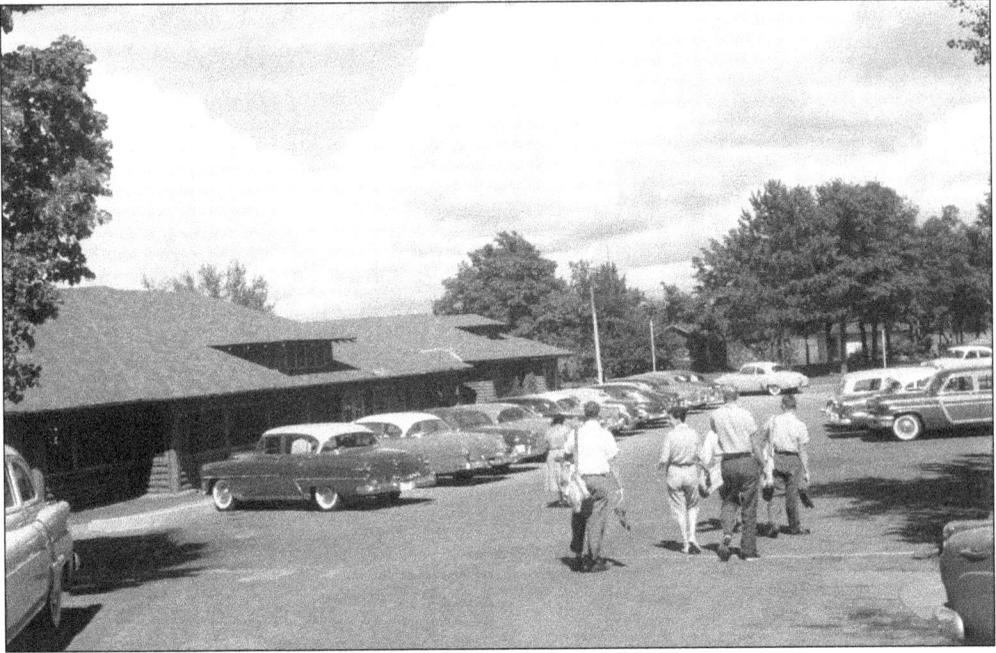

The ambition to own automobiles was put on hold during the Depression. After the World War II, it took time for manufacturers to catch up with demand. In 1946, car sales in the United States reached 2.1 million. The figure was only slightly higher than it was 10 years earlier. By 1955, American manufacturers were building 7 million cars a year, and there were 52 million on the road.

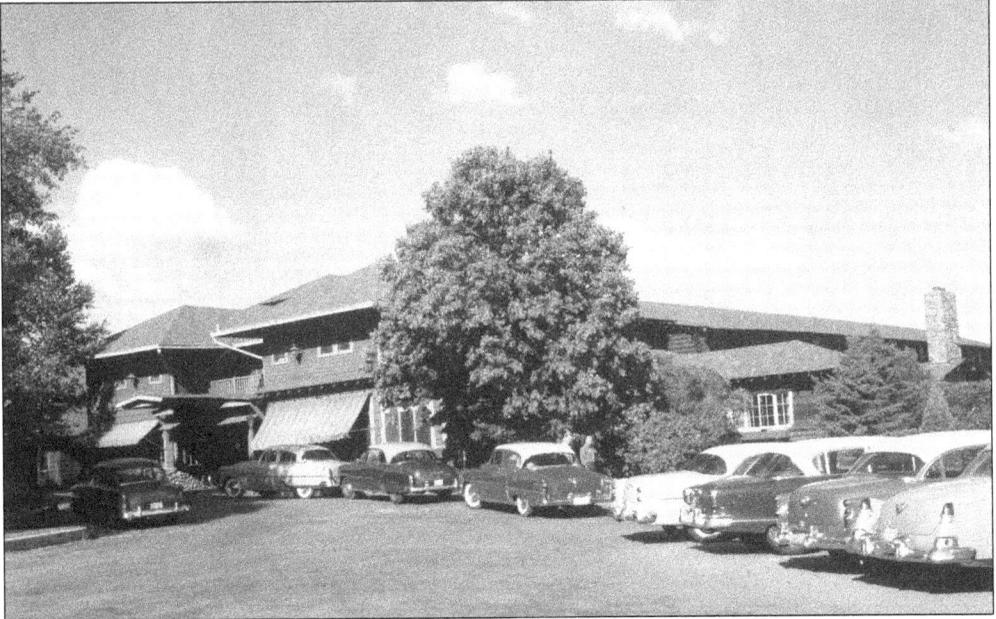

America started cooling off after air-conditioning arrived in the 1950s. Over a million window units were sold in 1953 alone. Breezy Point continued to advertise northern Minnesota's fabulous summer resort country climate as "famed for warm sunny days ideally suited to swimming, golf, fun; nights are refreshingly cool for dancing and quiet restful sleep."

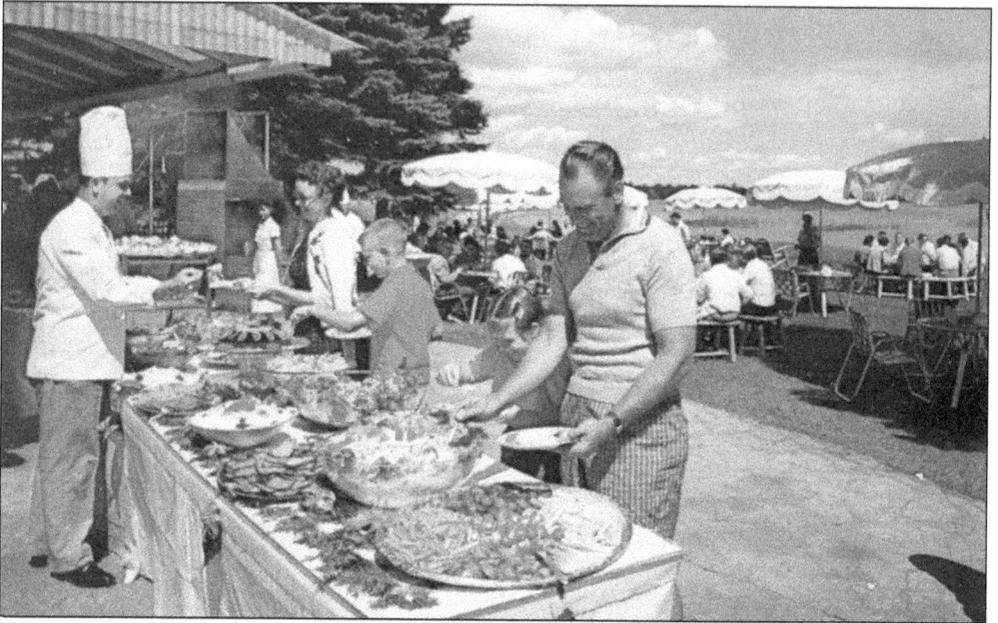

Guests and employees found amazing afternoon meals at Breezy Point's lakeside buffet. In 1953, Swanson's introduced TV dinners and tin trays began making appearances at dinner tables all over America. Heavily advertised, canned and packaged foods filled shelves of supermarkets, but in an era when families ate out less than twice a month, Breezy Point's fresh meals prepared by someone else were still quite a treat.

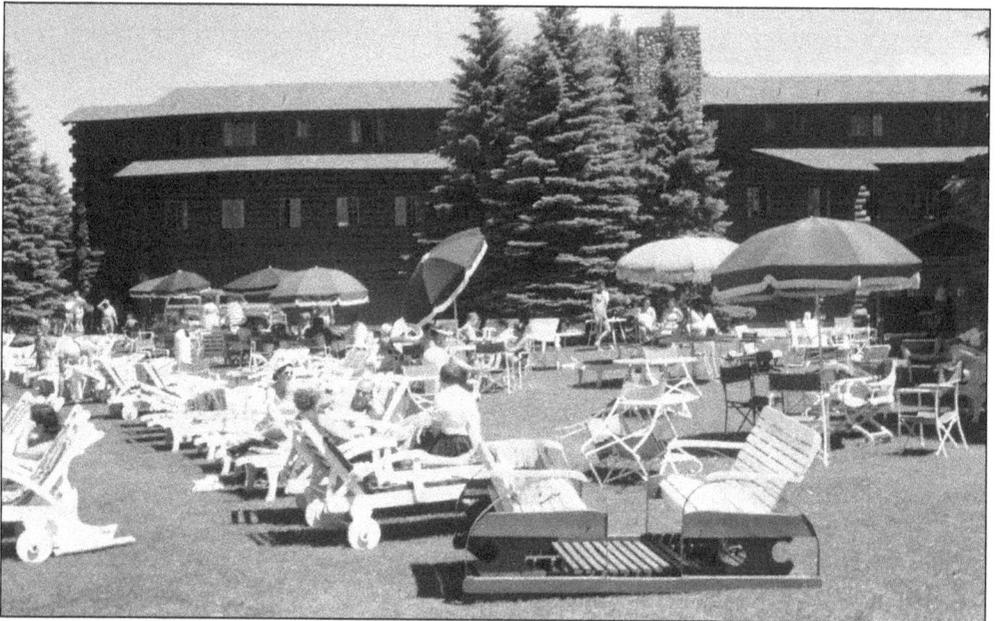

Beach umbrellas and clothing were the only sunscreens available at Breezy Point. In the 1950s, suntanning was considered healthy, recommended by doctors, and promoted by Hollywood stars. Many people used baby oil as a method to increase tanning. Coppertone's iconic logo depicting a little girl and her puppy made its print debut in 1953. The company's mechanical billboards began appearing on roadsides in 1958.

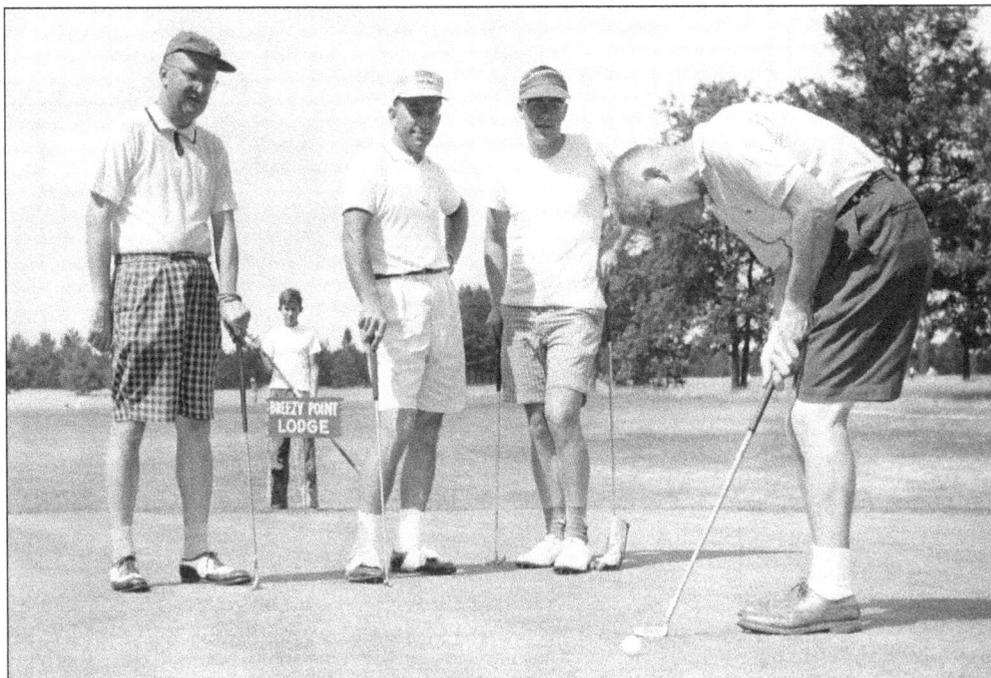

A golf boom that began in the late 1950s brought all sorts north to Breezy Point. Inspired by the success of Arnold Palmer, Bill Wright, and Jack Nicklaus, Americans from all walks of life read through articles by golf gurus like Harvey Penick and spent the summer in pursuit of tournament purses.

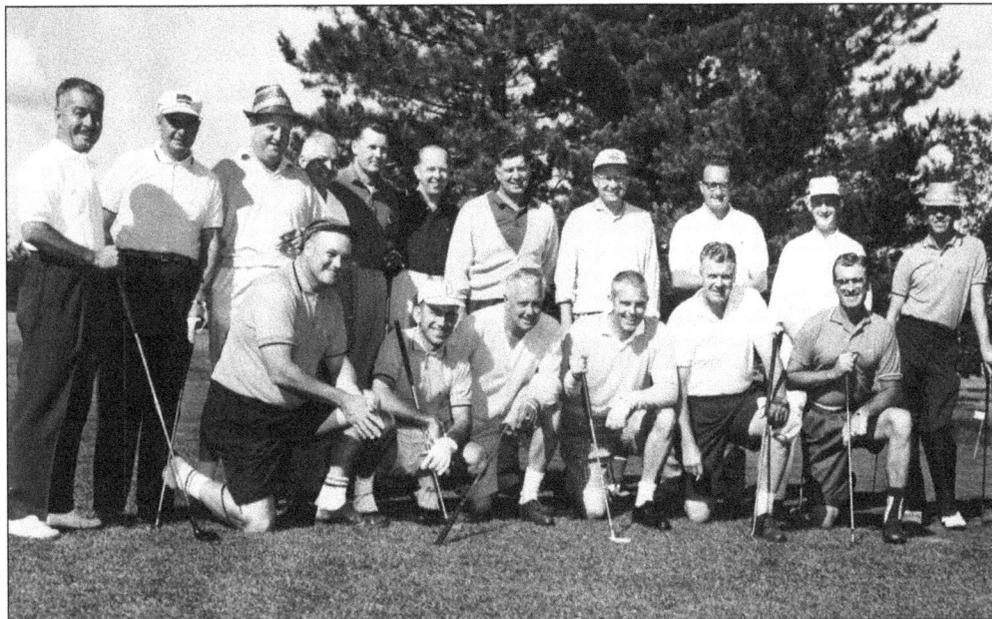

The annual 10,000 Lakes Golf Tournament was a tradition at Breezy Point until 1965. During the first 10 years of the tournament, Harry Legg won twice and Les Bolstad won three times. Plans for increasing Breezy Point's golf course to 18 holes were drawn up as early as 1930, but the Traditional was still a 9-hole golf course when this photograph was taken in 1959.

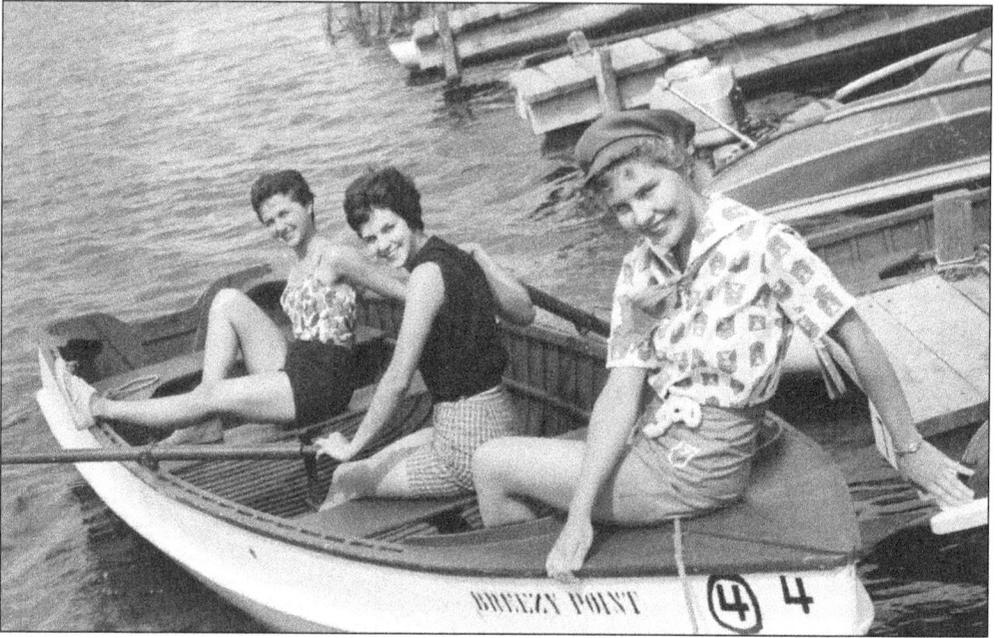

Captain Billy used to tell the tale of three fishermen who caught a mermaid. She told the fishermen she would grant them wishes if they let her go. One wished he could be faithful, and another wished he was as smart as his wife. The third fisherman was bald and wished for hair. The mermaid turned them all into women and swam away. (Courtesy of the City of Breezy Point.)

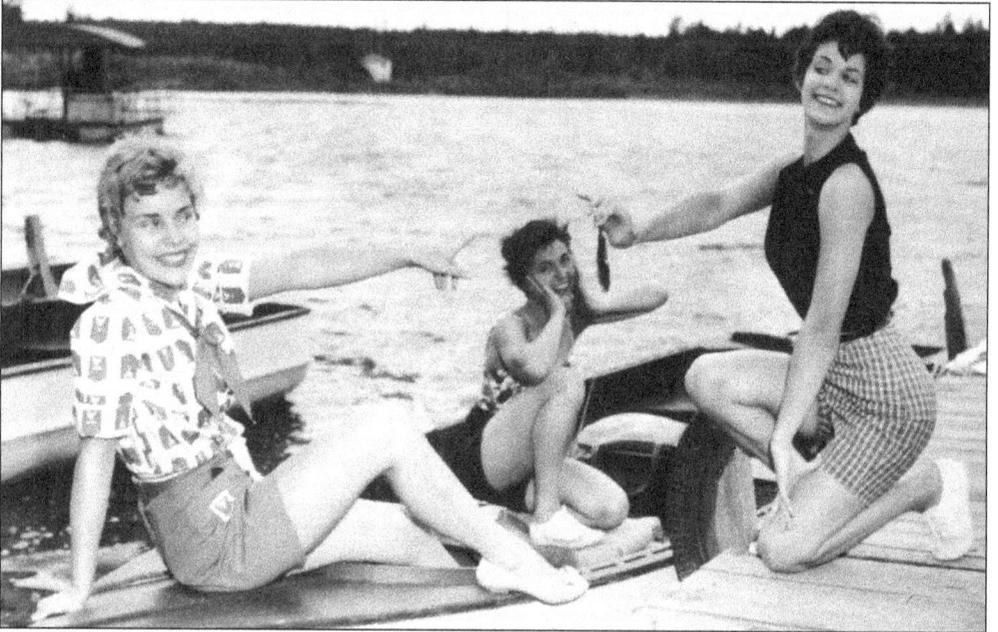

In 1955, Breezy Point still advertised itself as Minnesota's Million Dollar Resort. Glossy brochures invite guests to "enjoy a multitude of waterfront activities along the magnificent sandy beach. For the little tots, wading, splashing, or playing in the clean warm sand; for older ones, swimming, diving, canoeing, speed boating, water skiing, fishing, and sun bathing." (Courtesy of the City of Breezy Point.)

Kids in the backseats of cars had only the following two questions: "Are we there yet?" and "Is there going to be a pool?" In the 1950s, kidney-shaped pools began appearing in motel parking lots and backyards all over the Midwest. As the popularity of swimming pools grew, Breezy Point's new pools and colored concrete patio became important amenities for the resort. (Courtesy of the City of Breezy Point.)

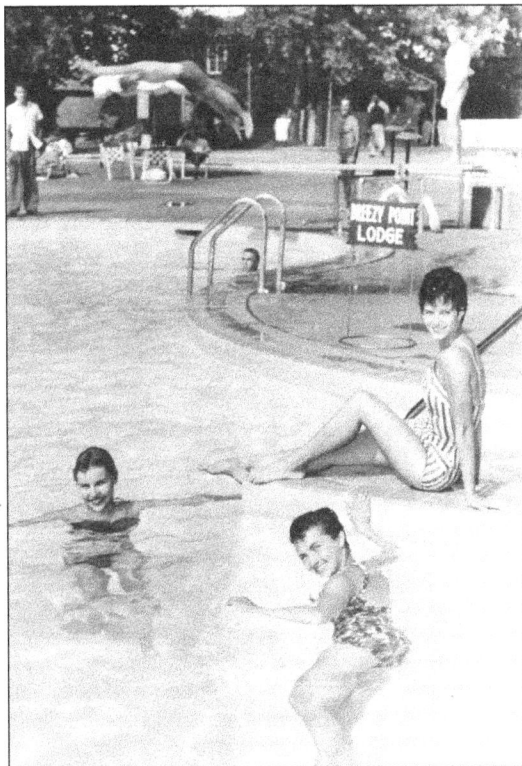

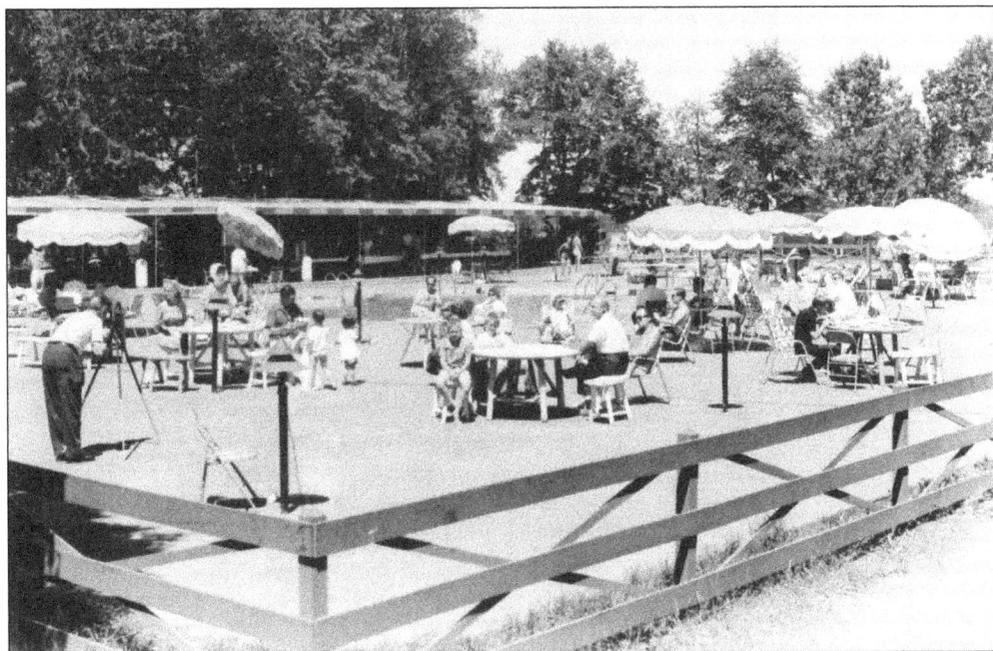

Everyone met at Breezy Point's new patio. There were two heated pools—one for adults and one for children. The resort served up buffets under the shade of a new luncheon terrace, and cocktails were available before dinner. The outlines of the pool and patio are still visible in the employee parking lot behind Breezy Point's Conference Center.

In the 1950s, there were at least 81 cabins on the grounds at Breezy Point, and 35 of these were used to room seasonal help at the resort. The employee area was affectionately referred to as "the Dog Patch." The cabins near the lake were used as vacation rentals. Most of the rental cabins had plumbing, a screened-in porch, and a fireplace. (Courtesy of the Crow Wing County Historical Society.)

This view, looking up from the marina, has changed very little over the past 50 years. The same low rock wall still separates the hillside from the road. The resort sold off the row of little cabins to individual owners in the early 1960s. Siding has been changed, and some alterations have been made, but their simplicity and charm remain much the same. (Courtesy of the Crow County Historical Society.)

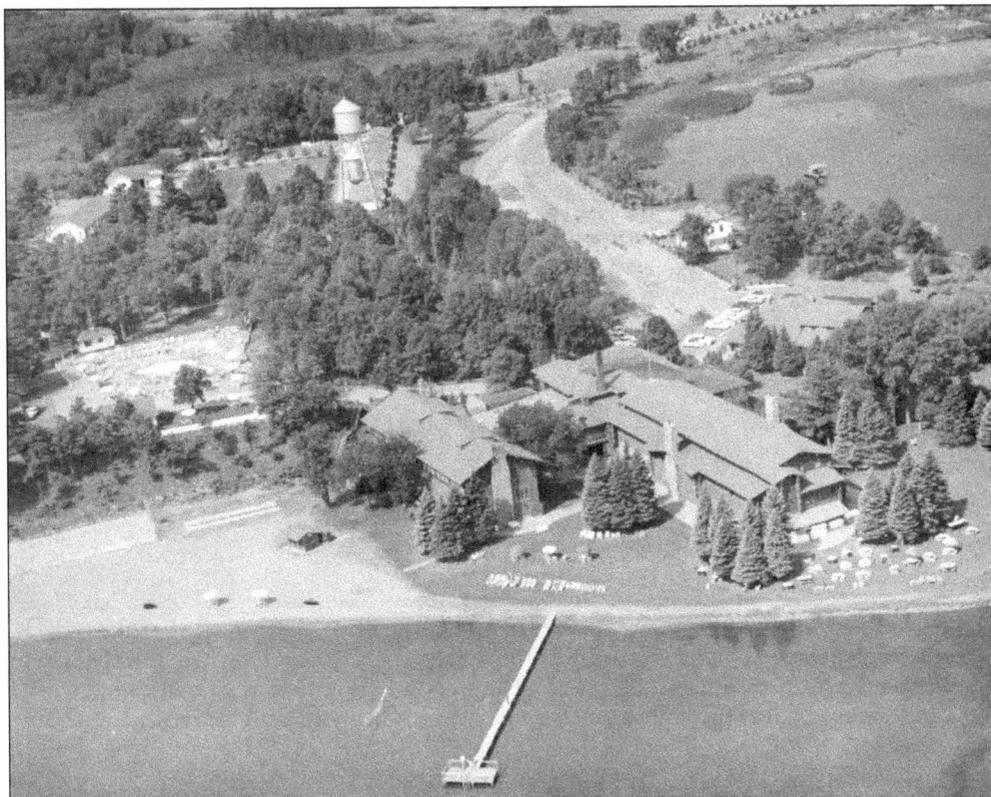

On Friday, June 19, 1959, two hundred members of the Minnesota Butter Poultry and Egg Association and fifty employees of a Minneapolis investment house arrived for conferences at Breezy Point. Eighty of these folks had rooms in the main lodge and annex. The rest were in cottages. At that time, the resort could accommodate up to 500 guests. Fortunately, it was not fully booked. (Courtesy of the City of Breezy Point.)

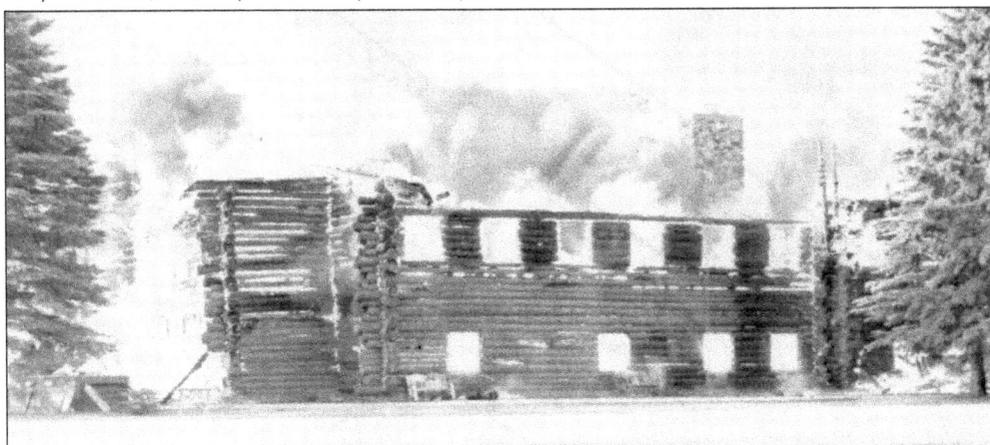

In the early hours of Saturday June 20, 1959, fire swept through the main hotel and annex at Breezy Point. Three separate explosions ripped through the kitchen and destroyed the resort's telephone switchboard. An employee had to drive a mile to call for help. The rest of the staff rushed through the lodge shouting and pounding on doors. Unfortunately, the flames were out of control before firemen from Nisswa and Pequot Lakes arrived.

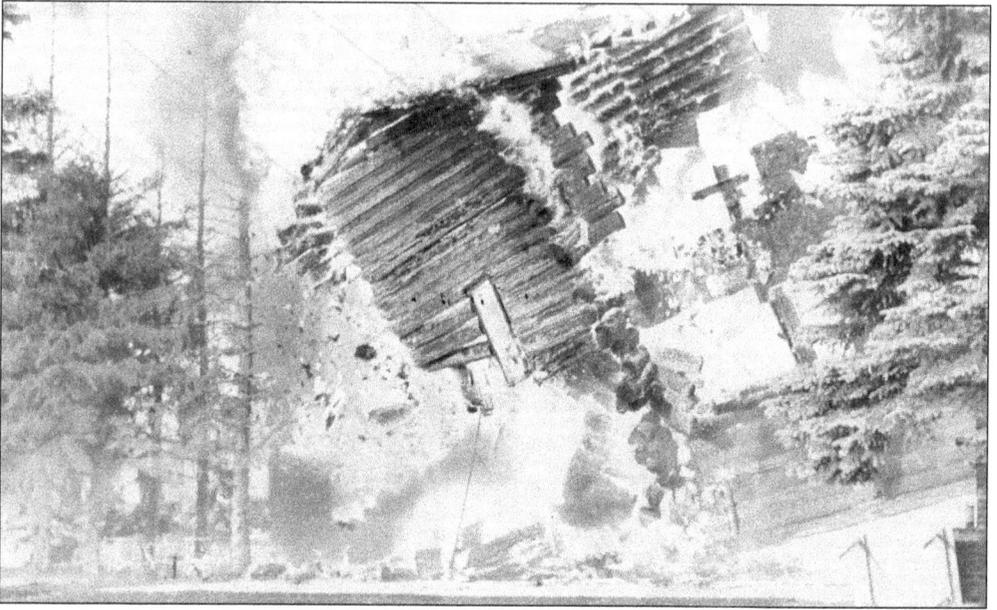

Two people died, and 17 were injured trying to escape the blaze. A few days after the tragedy, deputy state fire marshal Martin Nelson told the *Brainerd Dispatch* that the high toll could have been prevented had people used their heads. Panic spread faster than the flames. Guests who could have walked down the hall to safety slid down bed sheets or leapt out of windows before help arrived.

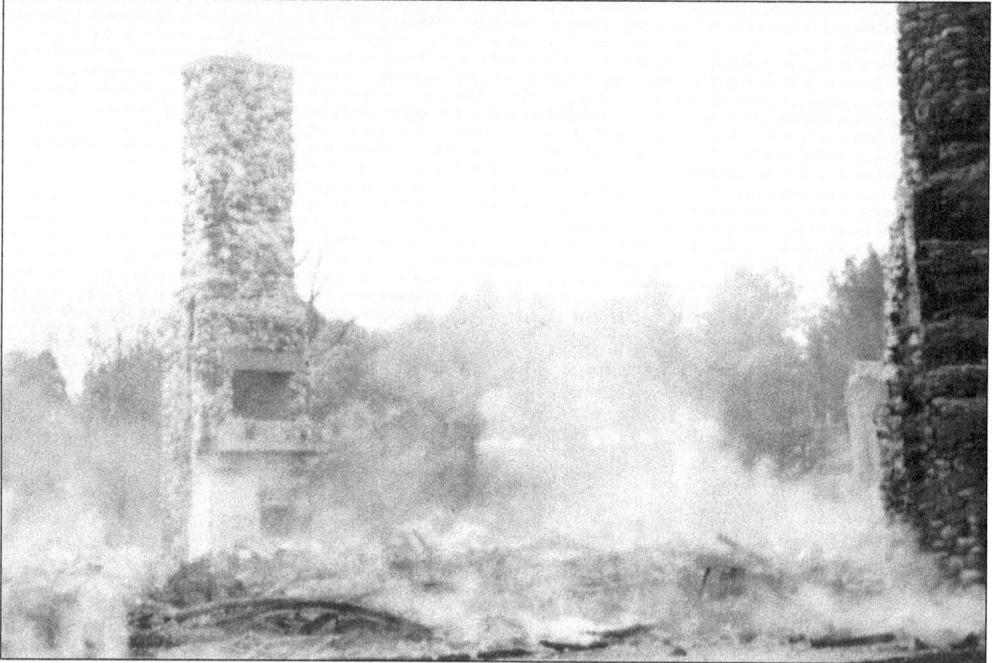

According to witnesses at the scene, 75-year-old Frank Hildinger died when he jumped from the upper story of the lodge. Employees tossed a rope to his wife, Grace, but she lost her grip and fell 20 feet to her death. Arnold Cismoski of Chicago, Illinois, led or carried six guests to safety. The lodge was reduced to ashes in hours. The chimneys were the only things left standing.

Two

Up from the Ashes

A former attorney general for the state of Washington, Don Eastvold went to work for a variety of land development groups after leaving public office. Ginny Simms made a name for herself as a big band singer and MGM film actress. After a long career, she left the entertainment business to pursue an interest in decorating and interior design. Eastvold met Simms when she came to Washington and opened a restaurant in Eastvold's redevelopment of a former military installation called Ocean Shores. The couple married and began looking for opportunities in Eastvold's home state of Minnesota. In March 1963, Eastvold and Simms acquired Breezy Point. Early in the summer of 1964, a full-color supplement advertising "Don and Ginny's Breezy Point Estates" appeared in the *Minneapolis Sunday Tribune*. The resort was rebuilt on a grand scale. Construction began with the first condominium project in Minnesota. Eastvold gave buyers the innovative option of renting the units to vacationers through a management agreement with the resort. Next came the motor inn, a new marina, administration center, lighted airstrip, ski area, gas station, supper club, and golf pro shop. Fifteen miles of roads were paved, and 2,000 homesites were made available. The following year saw the construction of five more condominium projects. Captain Billy Fawcett's cottages were sold, and 42 duplex log homes were finished along the road leading past the golf course. Breezy Point Estates continued to add amenities, including a riding stable, two kidney-shaped pools, and a recreation center. Excitement was in the air. Locals were thrilled to see a little cash and a touch of class return to the area. Unfortunately, the party did not last long. Bankruptcy proceedings began in January 1966, and a couple months later, the resort went into receivership. Eastvold and Simms left town in the dead of night. The sorting and settlement of claims took almost two years. Breezy Point's fortunes brightened again after the owners of a Twin Cities restaurant called the Hopkins House purchased the resort. The grand reopening took place on Memorial Day weekend 1968.

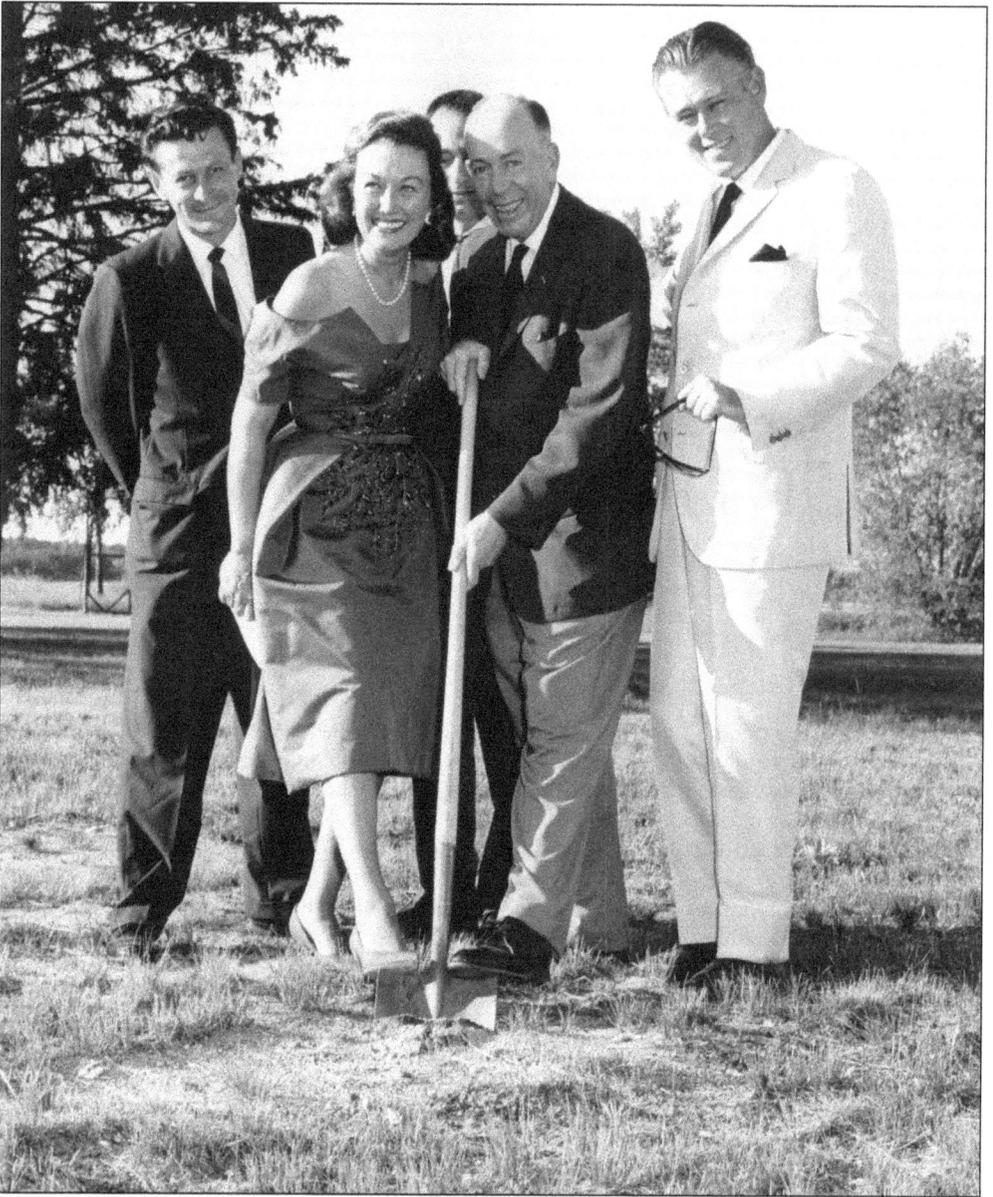

Three years after the tragic five, the winds of change blew again, and Ginny Simms and Don Eastvold acquired Breezy Point. The glamorous couple immediately announced ambitious building and land-development plans for a new year-round residential project called Breezy Point Estates. Breaking ground for a new building are, from left to right, Eastvold's partner, Jerry Lenz; Simms; unidentified; Minnesota governor Karl Rolvaag; and Eastvold.

Ginny Simms and Don Eastvold brought a little glamor back to Breezy Point. Simms made a name for herself as an MGM contract film actress and singer with Kay Kyser's Orchestra. She made her first movie, *That's Right You're Wrong*, with Lucille Ball in 1939. Her third husband and partner, Don Eastvold, was a Minnesota native and former Washington State attorney general.

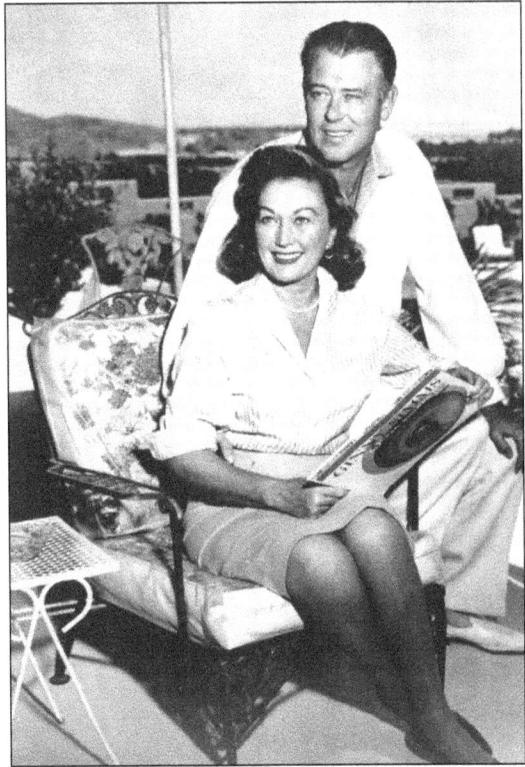

After Ginny Simms retired from Hollywood and the entertainment business, she opened a restaurant in Ocean Shores, Washington. There, she met Don Eastvold, who was working on a development project in the area. He convinced her to expand and remodel. Financed and supported by Eastvold, Simms spent $400,000 redesigning the restaurant. Ginger Rogers, Hugh O'Brien, and Walter Winchell attended the grand opening. Eastvold and Simms were married in 1962.

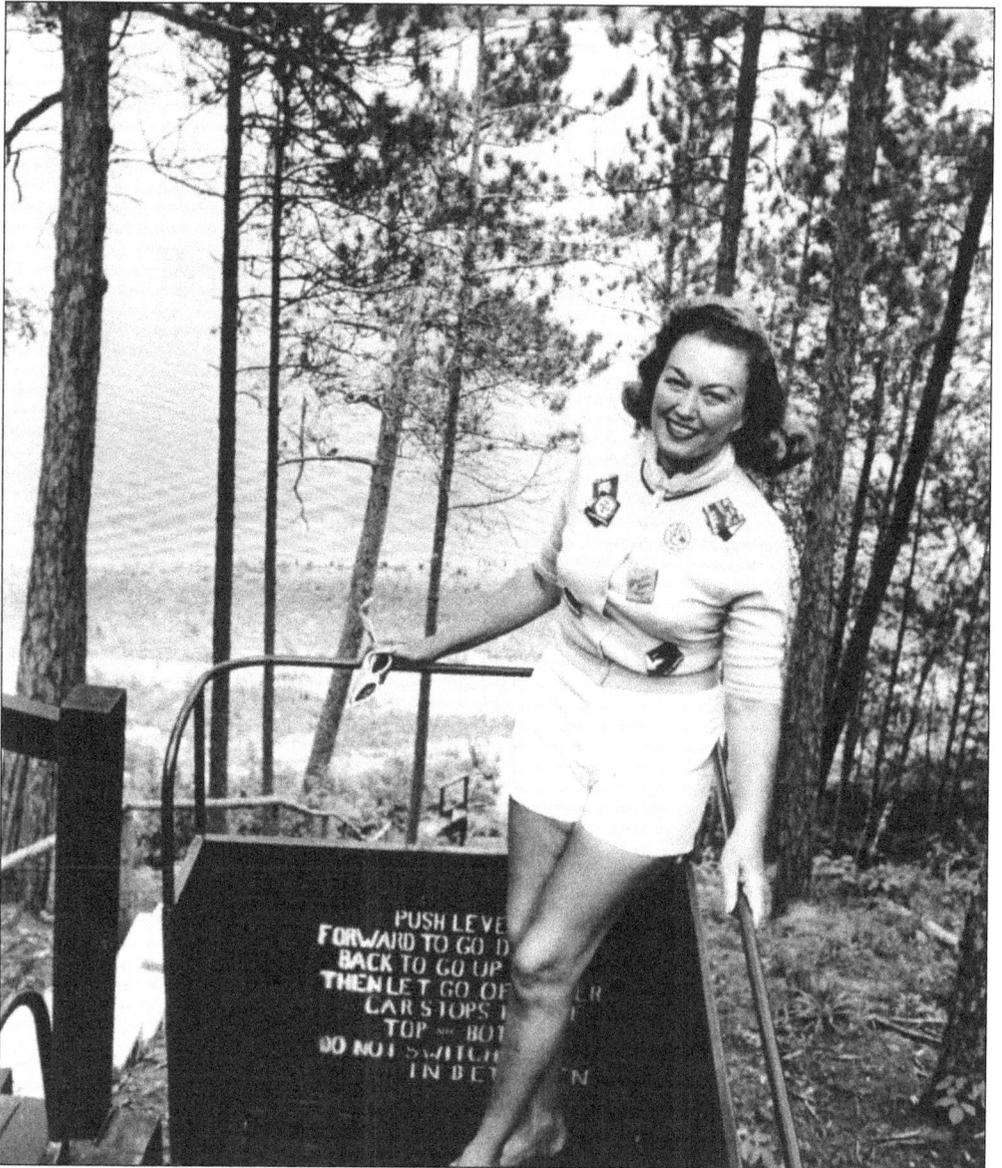

Eastvold and Simms began their Minnesota development efforts with a vacation home concept on Crookneck Lake near Motley. The project, called Ginny Simms's Lake Estates, included ball fields, a swimming pool, tennis courts, horseback riding, and a clubhouse. Simms built an A-frame model on the west side of the lake. Lots were sold for $1,600. Buyers who purchased the same day they viewed the property got a $400 rebate.

In 1964, a multimillion dollar development plan called Breezy Point Lodge and Estates began taking shape on the shores of Pelican Lake. The massive resort renovation included a 100-unit motor inn, small airport, marina, gas station, grocery store, restaurant, and swimming pool. Fifteen miles of new roads were paved. Two thousand wooded lots went up for sale.

An advertisement in the *Minneapolis Tribune* described the Breezy Point's new marina, informal coffee shop, and restaurant as a triumph of styling made possible through unique construction features. The marina and many of the new structures at the resort were designed and built using full, round, solid logs manufactured by Lumber Enterprises of Billings, Montana. The marina stayed open from 7:00 a.m. to 1:00 a.m. on weekdays and 24 hours on the weekends.

The new marina, complete with a bar and dining area for 220 guests, opened on May 1, 1964. A lower-level grocery store sold bait and tackle. Boat sales and rentals were available on the lake. At the end of the season, plans were drawn up to increase capacity by 400 slips. These days, the boat ramp is used as a walkway from the parking lot to the Dockside Bar.

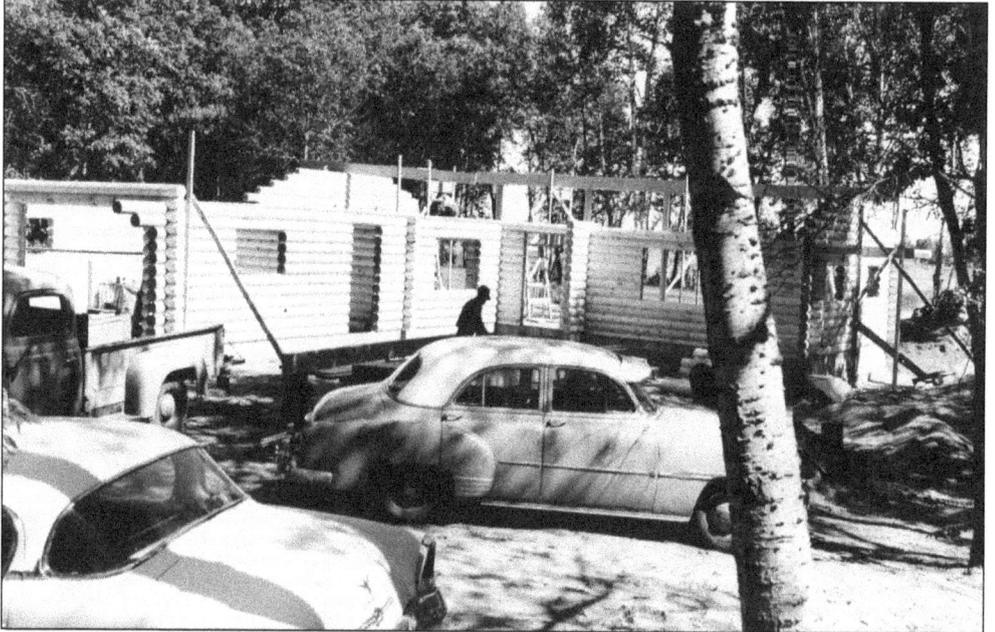

Breezy Point Estates claimed that 2,000 lots for homesites were available. Over $200,000 dollars was spent on a modern, German-made telephone communications system that gave Breezy Point a separate exchange and direct dial facilities. Buyers were offered a free life insurance policy that included payment on property in the event of the owner's death. The total land area involved in the project was over 1,200 acres.

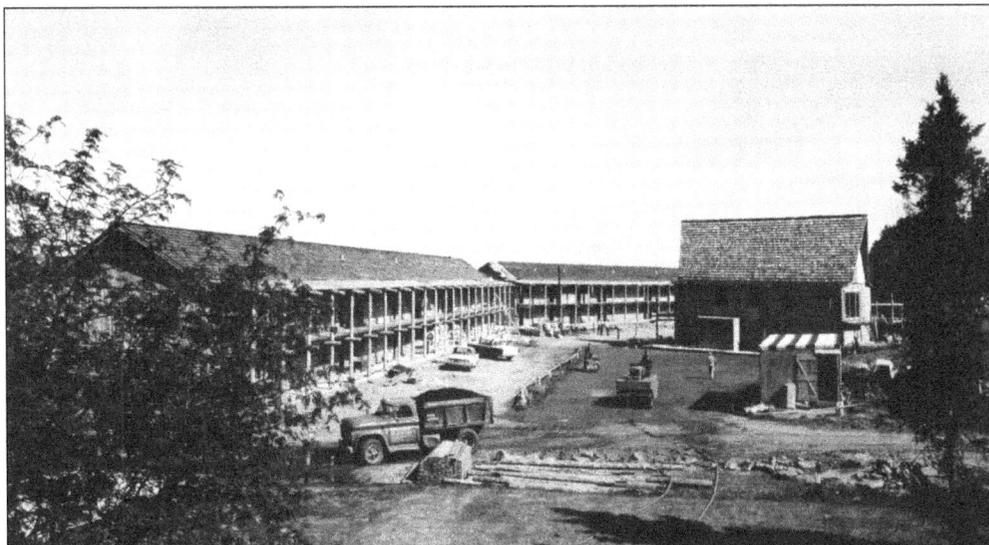

The ambitious building program under the supervision of Don Eastvold's partner, Jerry Lenz, included a two-story, 50-unit condominium project on the site of Captain Billy's old lodge. Buyers had the option of renting the units to vacationers through a management agreement with Eastvold and Breezy Point Estates. Completed in 1964, the co-op lodge apartments became the first condominiums in Minnesota.

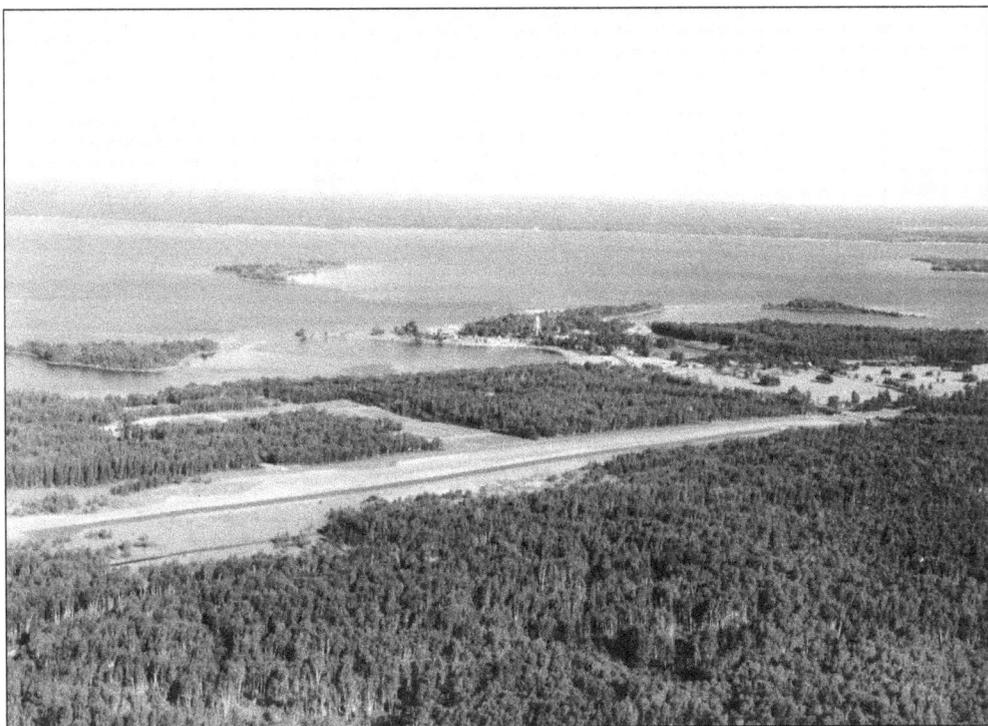

Aviation has played a part in the development of Breezy Point since the earliest days of the resort. Don Eastvold decided to build on this legacy. In 1963, he purchased a nearby stretch of farm field and construction began on a new landing strip. When the Breezy Point airport opened in 1964, the facility featured gas pumps, 24-hour service, free landing, tie downs, and courtesy car service.

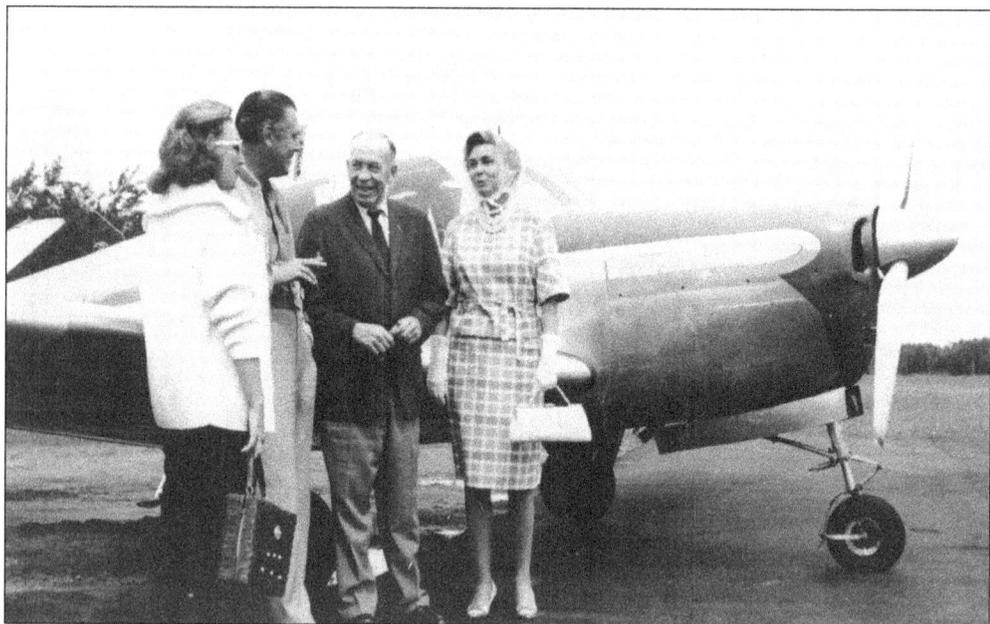

Ginny Simms and Don Eastvold greeted Minnesota's 31st governor Karl Rolvaag and first lady Florence Rolvaag shortly after the completion of the resort's lighted 2,600-foot-long airstrip in 1963. The Breezy Point Airport is still available for day use. The lighting along the runway was damaged in a storm and has since been removed. The airport was sold to its pilots in 1981.

Ginny Simms took Mexican waterskiing champion and cliff diver Mundo Villega fishing with Minnesota governor Karl Rolvaag (second from right) and an unidentified local guide. When prospective condominium buyers rented boats and motors at Breezy Point, they were offered free waterskiing lessons by Villega, who was billed as the star of Diamond Bay's Acapulco "Club de Ski."

Breezy Point's glamorous co-owner and developer Ginny Simms had years of experience in the hospitality business. Her first husband, Hyatt von Dehn, founded the Hyatt Hotels chain. Inspired by her success in Washington, Simms used her business and entertainment connections to promote the resort. Vacationers filled the woods around Big Pelican Lake. In 1963, identical twins Abigail Van Buren and Ann Landers had a double honeymoon at Breezy Point.

Don Eastvold (left) and Governor Rolvaag, pictured here on either side of Breezy Point's golf pro, graduated from St. Olaf College in Northfield, Minnesota. Eastvold convinced Rolvaag to run for class president and organized a write-in campaign that brought his first political victory. Rolvaag's gubernatorial election was the closest in Minnesota history. He won by 91 votes. When he took office he told reporters, "This is a great day for me and my friends."

Ginny Simms brought in former Kay Kyser's Orchestra novelty singer and trumpeter Merwin "Ish Kabibble" Bougue to book entertainment at the Breezy Point Supper Club. Guests and locals were thrilled to see big-name acts like Tommy and Jimmy Dorsey, Count Basie, the Glen Miller Orchestra, Sammy Kaye, Ralph Marterie, Si Zenter, and Russ Carlyle perform at the resort. (Courtesy of the Crow Wing County Historical Society.)

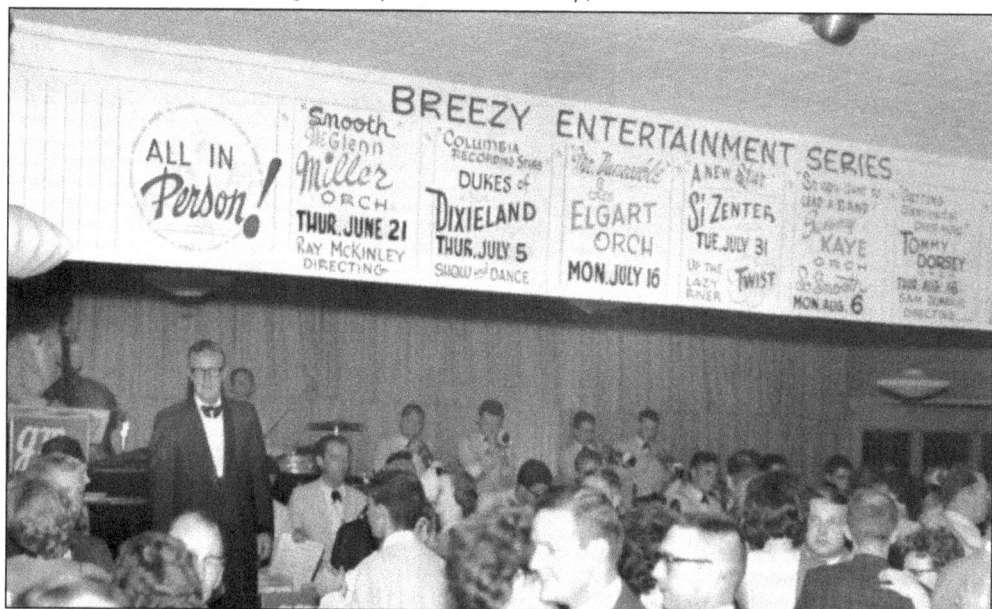

Ray McKinley and Glenn Miller were working together in Maj. Glenn Miller's Army Air Force Band when Miller was lost in action during World War II. McKinley stepped up and led the band until the end of the war. In 1955, he was chosen as the leader of a revived Glenn Miller Orchestra, which played at Breezy Point in 1964. (Courtesy of the Crow Wing County Historical Society.)

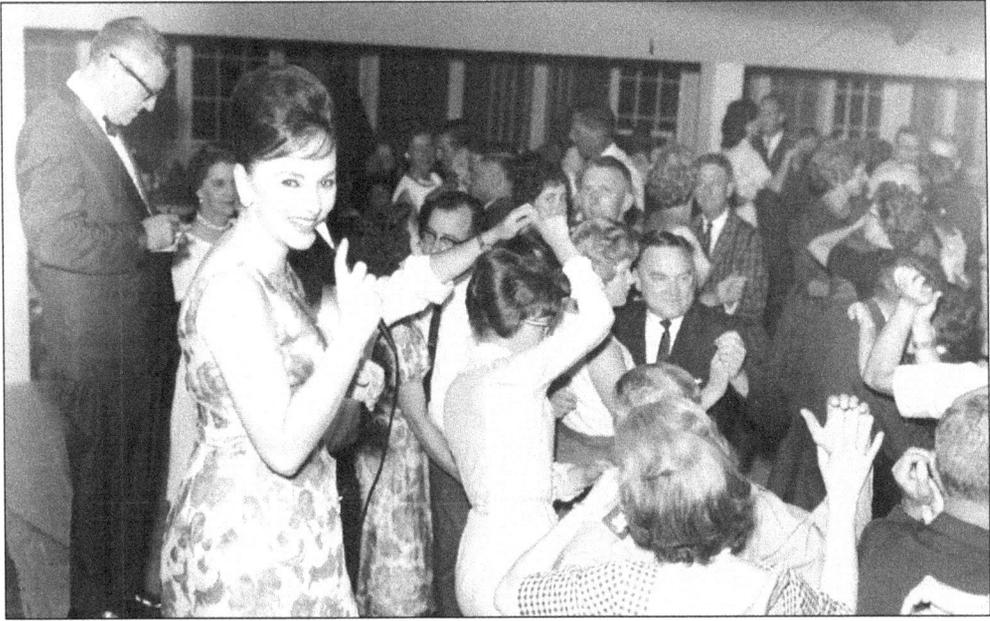

Ginny Simms promised that nights at Breezy Point would be filled with music. Bands were booked on a weekly basis and performed nightly. She never actually performed at the resort, but Simms released a private-label promotional album with Harry Betts called *Ginny Simms at Internationally Famous Breezy Point Lodge*. The album cover features a young, smiling Simms and Breezy Point's waterskiing instructor, Mundo Villega.

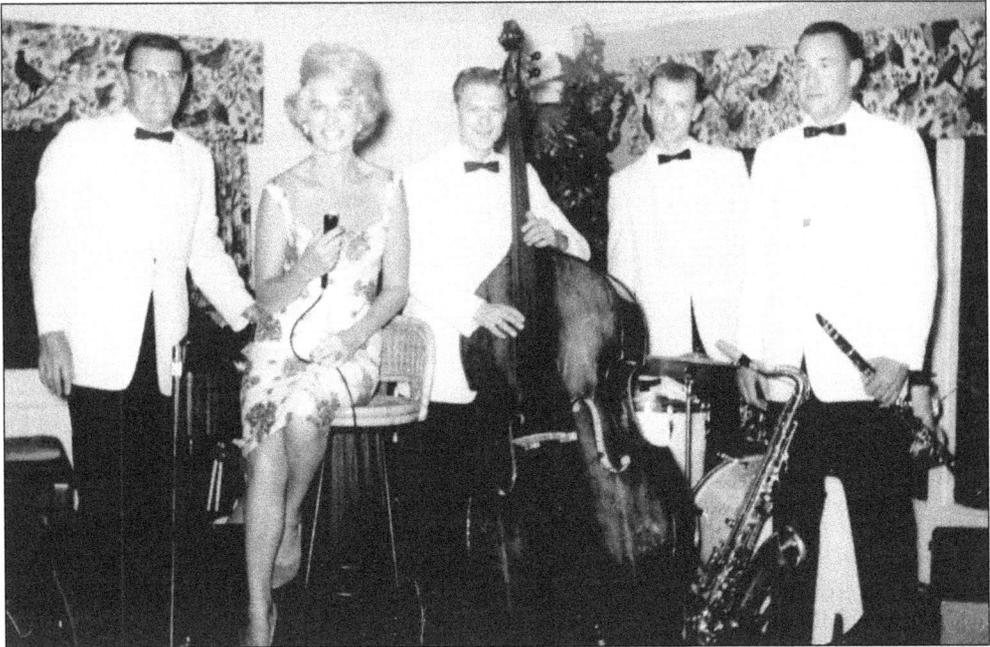

The Breezy Point Supper Club gained renown for sheer elegance. The room seated up to 500 under crystal chandeliers. Reservations were made in advance. Women put on gloves and evening gowns. If the supper club was booked up tight, a less formal scene was available across the parking lot in the marina bar, where the Susan and Keith Quintet played Monday through Saturday.

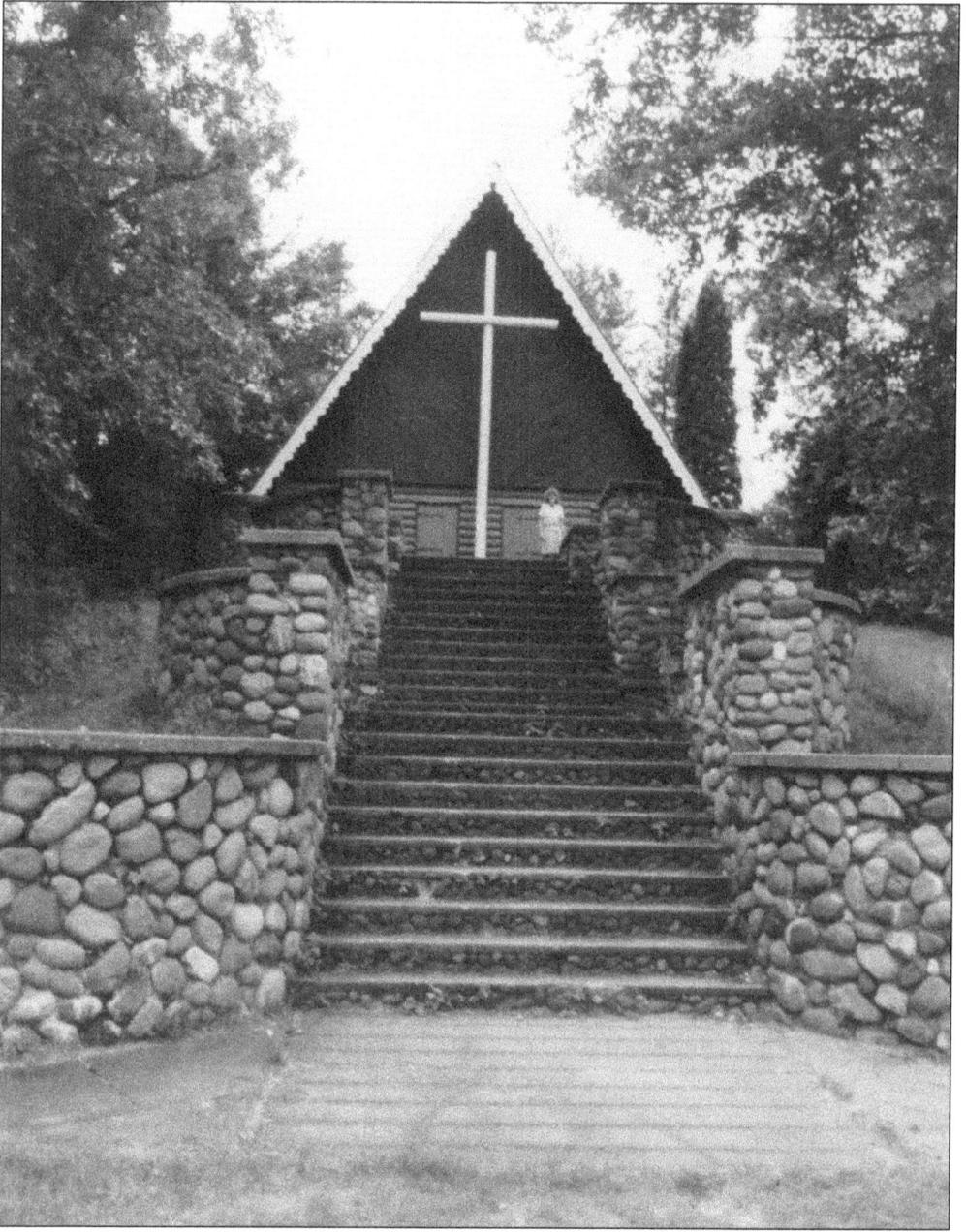

Some say Captain Billy planned to build a mansion for his mistress at the top of this turreted, stone stairway. Postcards from the 1920s advertised the steps as an entrance to Fawcett's first subdivision. The *Brainerd Dispatch* claimed Captain Billy had plans for a golf clubhouse. After Don Eastvold acquired the property in 1964, he offered the land and $10,000 toward the construction of a church on the site.

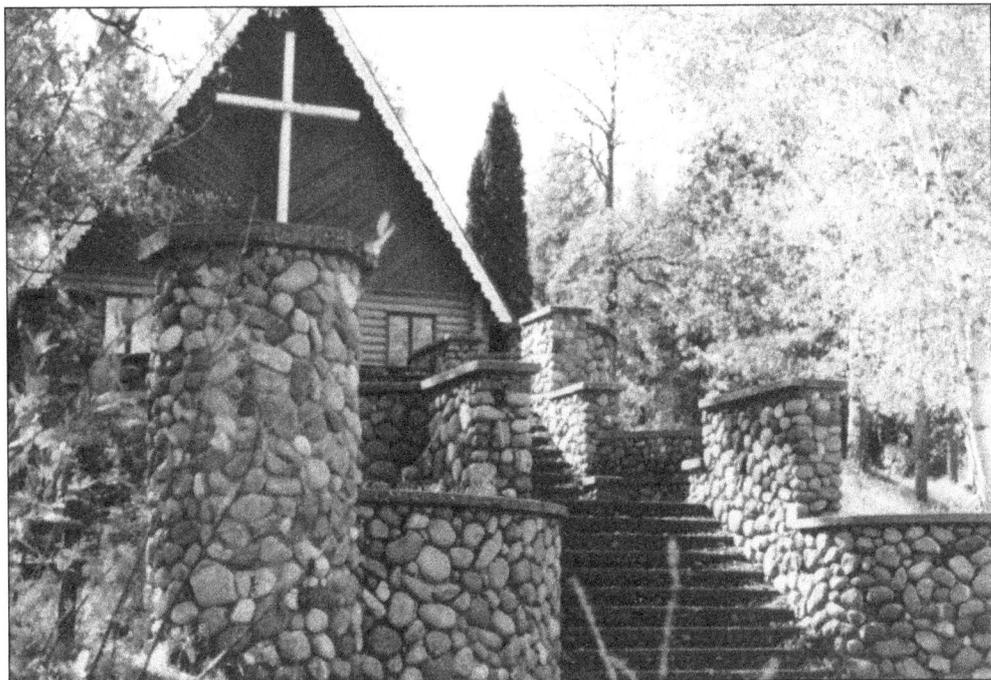

The Missouri Synod of the Lutheran Church took Don Eastvold up on his offer and spent $20,000 to complete Breezy Point's log chapel. Rev. Stanton Hecksel of Pequot Lakes arranged for local pastors to hold services during the summer months. Although the alternating pastors were all Lutheran, worshippers from all faiths were welcome. Breezy Point Chapel still provides Sunday morning services from Memorial Day weekend through Labor Day.

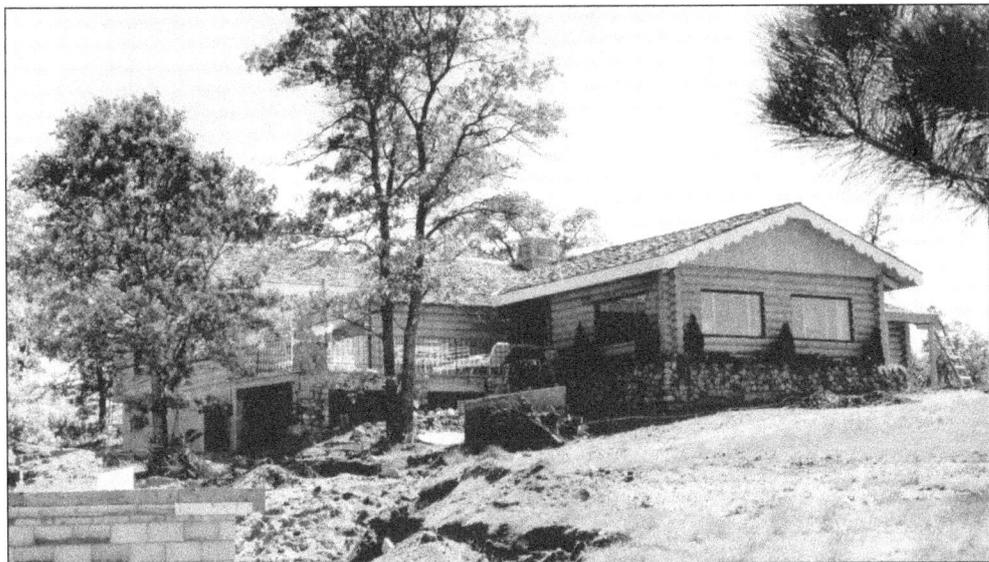

A 1964 advertisement claims that "so taken with the rugged pine country and with the Gopher State's people, Ginny has nigh become a native." Ginny Simms and Don Eastvold settled in and built one of the resort's most elegant homes. Furnishings for the house and other buildings were paid for by a promotional deal with Power's Department Store in Minneapolis. Today, the home is known as the Governor's House.

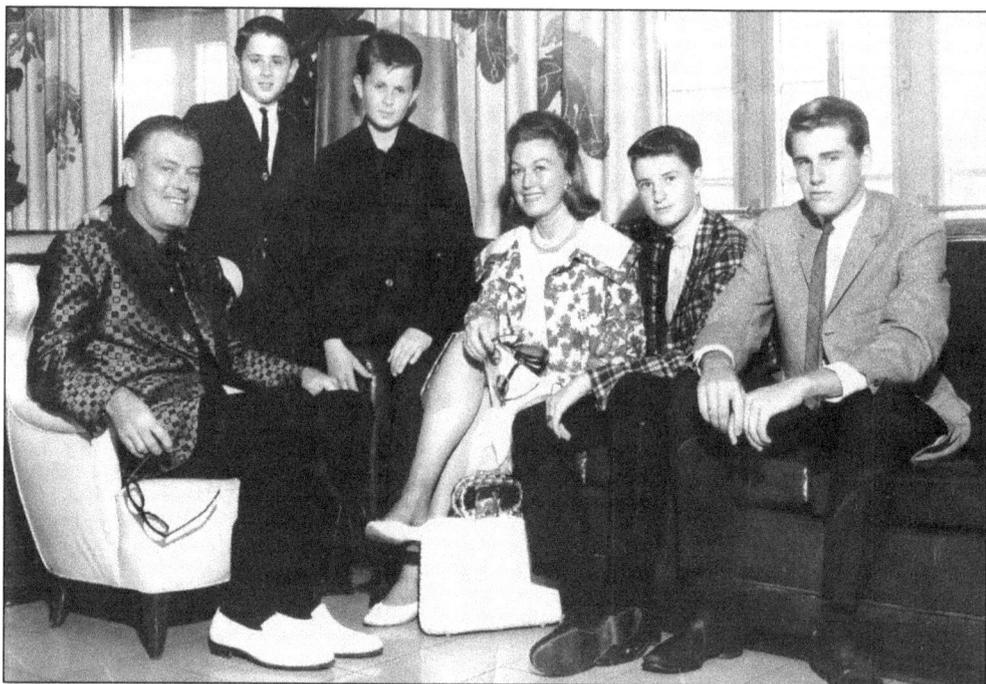

Across from the marina, a new recreation center included a bowling alley and the Teen-a-Go-Go dance hall. Newspaper ads hyped nightly entertainment provided by the Coal Streamers. Don Eastvold is pictured with his family. His son Carl (third from left) was the group's organ player. Also pictured are son Donald Jr. (second from left), Ginny Simms, and Simms's two sons from her previous marriage to Hyatt Robert von Dehn—Conrad and David von Dehn (far right).

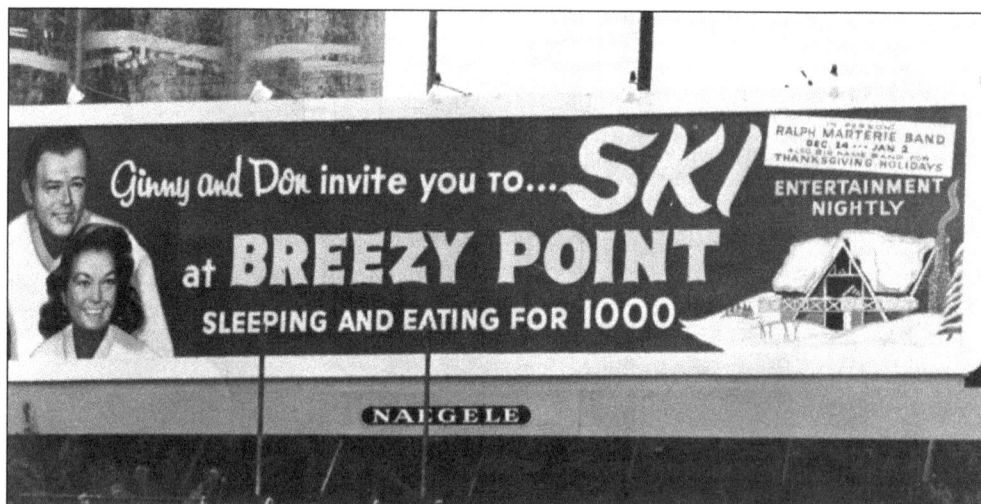

Don Eastvold and Ginny Simms hoped to make Breezy Point a year-round proposition. In 1964, they built a small ski complex. The chalet hosted a bar, restaurant, and ski shop, which offered the latest fashions and equipment. Billboards, like this one on Excelsior Boulevard, went up all over the Twin Cities. These days, the ski hill is used for tubing, and the chalet has become the Prime Time Restaurant.

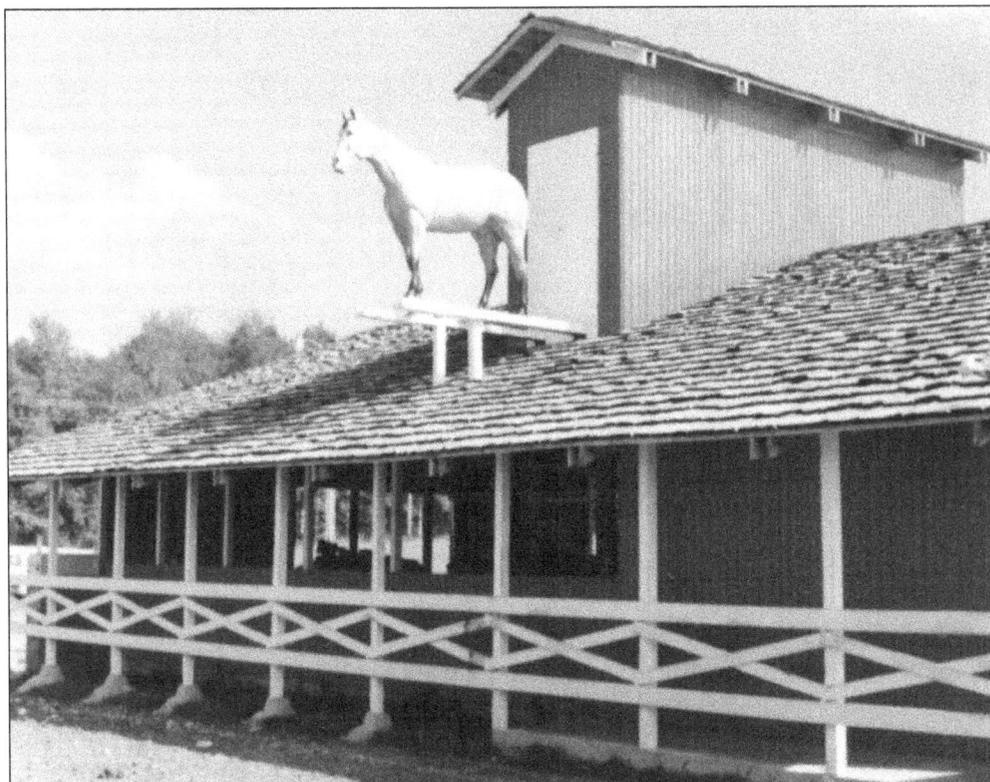

In 1965, a riding stable opened on the southwest corner of County 11 and Ranchette Drive. Ginny Simms announced plans for an equestrian development. Land was purchased and lots were reserved for people trying to find homes for themselves and their horses. Wooded trails surrounded the new subdivision. As an incentive, some lots came with a free horse. (Courtesy of the Crow Wing County Historical Society.)

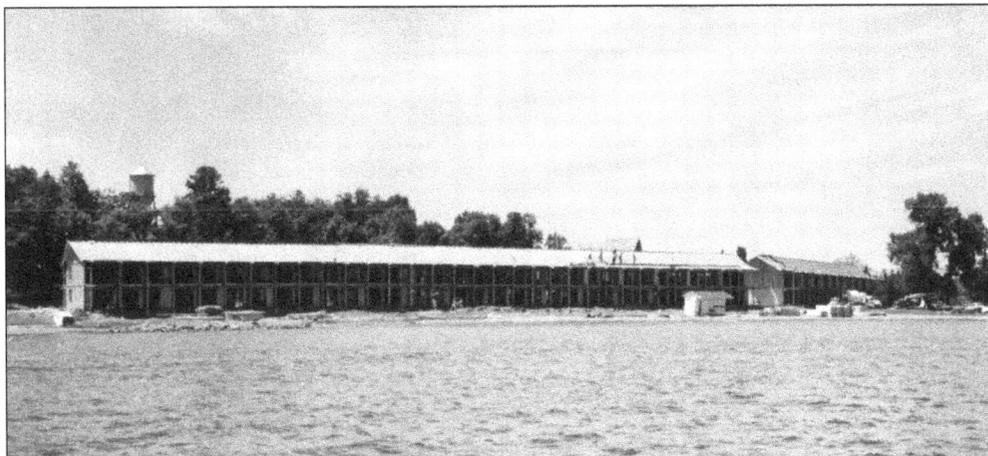

In September 1965, the Beachside, Surfside, Bayside, and Waldenheim condominiums were ready for sale. Visitors and prospective buyers flooded in. There were magnificent parties, and the resort was once again a fashionable destination, but after three years of excitement and opulence, things began to unravel. Breezy Point Estates was spending more than it was taking in. Suppliers for goods and services were owed over $225,000, and credit was stopped.

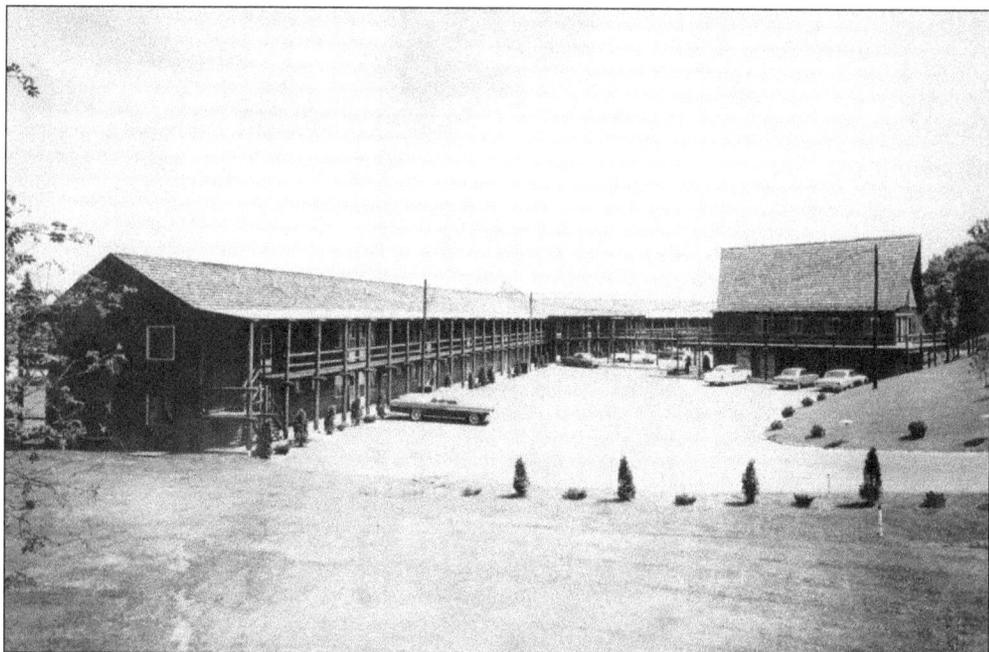

Creditors were assured that everything was fine, but bill payments ceased. After all the bank accounts were closed, payroll checks had to be cashed at the administration building. Financial woes were hidden from guests and prospective land buyers. Jerry Lenz told the *Brainerd Dispatch* that Breezy Point Estates "has not and is not selling out." The supper club was closed, and an auction was scheduled for October 1, 1965.

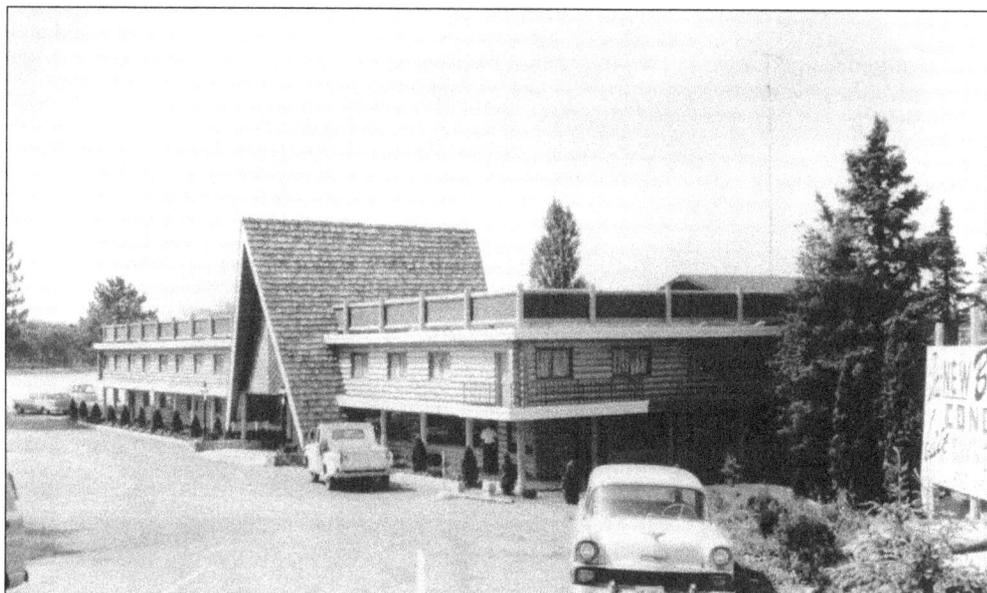

Powers Dry Goods Co. brought foreclosure with a sale notice stating Breezy Point Estates owed the company $155,752.16. The Minneapolis department store had lavishly furnished the supper club, marina, and Eastvold's home. Breezy Point partners were not immune. Simms and Eastvold were forced to surrender jewelry, automobiles, and other personal property. A notice for auction called for the sale of a 1965 Chevrolet owned by Jerry Lenz.

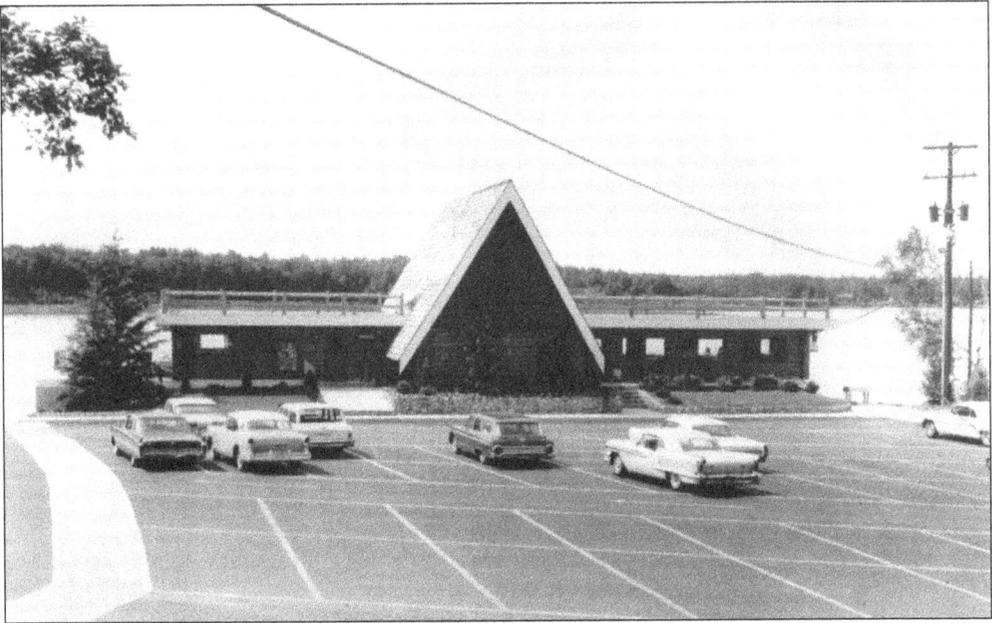

Breezy Point closed for the winter in 1965, but the gas station at the airport, the golf course, and the marina grocery store stayed open. Three condominium buildings were still available for rental and a few winter reservations were taken. The Fawcett House was rented to the Fawcett family, which had reserved it for a reunion in December and January. Breezy Points Estates declared bankruptcy on May 3, 1966.

While Breezy Point was in bankruptcy, Twin Cities businessman Loyd Brandvold acquired two one-year leases from the trustees. Golfers across the state sighed in relief, put their clubs in the trunk, and headed north. Two years earlier, Eastvold and Simms had expanded the popular golf course from 9 to 18 holes. They also built a 9-hole pitch and putt course near the supper club.

The new golf clubhouse, built by Eastvold and Simms in 1963, offered all the modern conveniences. There were locker rooms for men and women, cardrooms, and an exclusive clubhouse lounge for members and guest. The health club facilities included a sauna, steam baths, and the full-time services of resident masseur and masseuse.

Brandvold was able to attract golfers and vacationers, but his lease gave him little incentive to improve facilities or expand operations. The cavalry arrived for Breezy Point in 1968 when the nine owners of the Hopkins House motel and restaurant chain successfully negotiated the purchase of the resort. Included in the sale were the marina, supper club, grocery store, golf course, gas station, airport, motor lodge, and four condominium units.

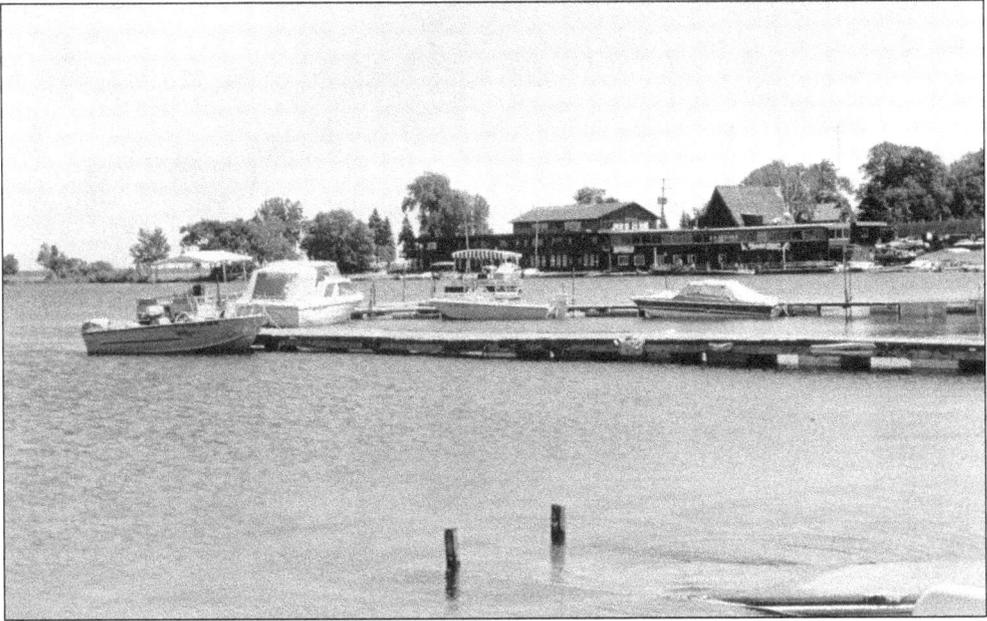

On Memorial Day 1968, the new owners, led by Cal Olsen, reopened the resort as Hopkins House Breezy Point Resort. The tourist season did not get underway until the end of June, but Hopkins House bet on early business and staffed the supper club with bartenders, cooks, waitresses, busboys, and musicians seven days a week for the whole season. Unfortunately, business remained slow until the beginning of July.

Hopkins House promoted the resort throughout the state. In 1969, Franklin Hobbs (pictured with two of the resort's employees) broadcast live from Breezy Point. Hobbs hosted a popular late-night show on WCCO radio for over 20 years. The station's clear-channel broadcast was heard all over America. Hobbs moved to KEEY in 1981 and joined KLBB in 1983. He remained a listener favorite until he passed away in 1995.

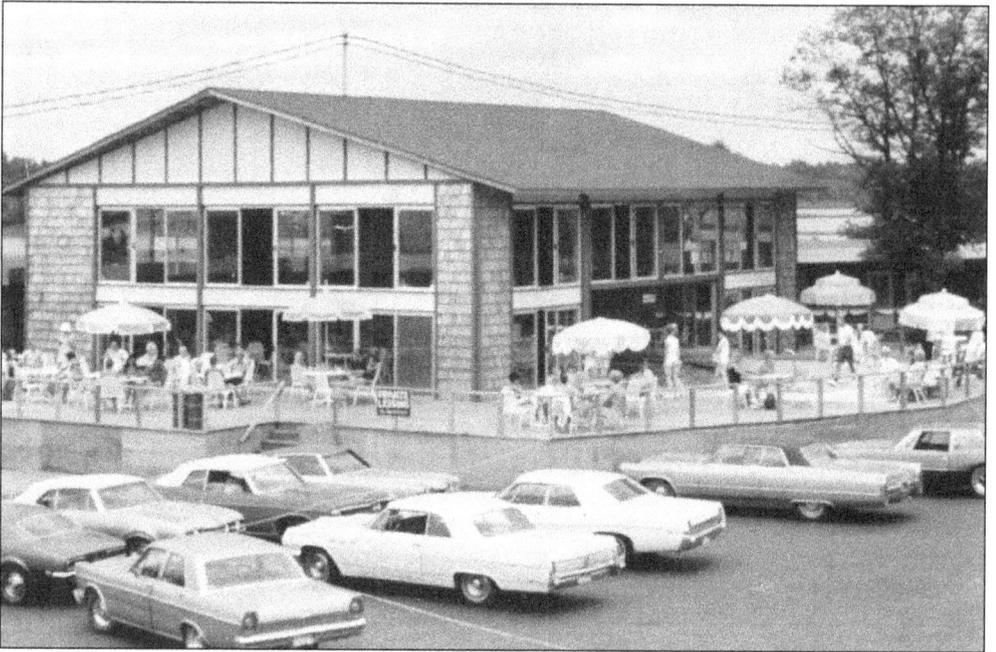

When Cal Olson and his group of investors took over the resort in 1968, he predicted Breezy Point would be back in the black by 1971. The new owners had made a name for themselves in the Twin Cities with the Hopkins House motel and restaurant chain. Olsen went to work on the resort's reputation. Bills were paid on time. The resort was modernized, advertised, and remodeled.

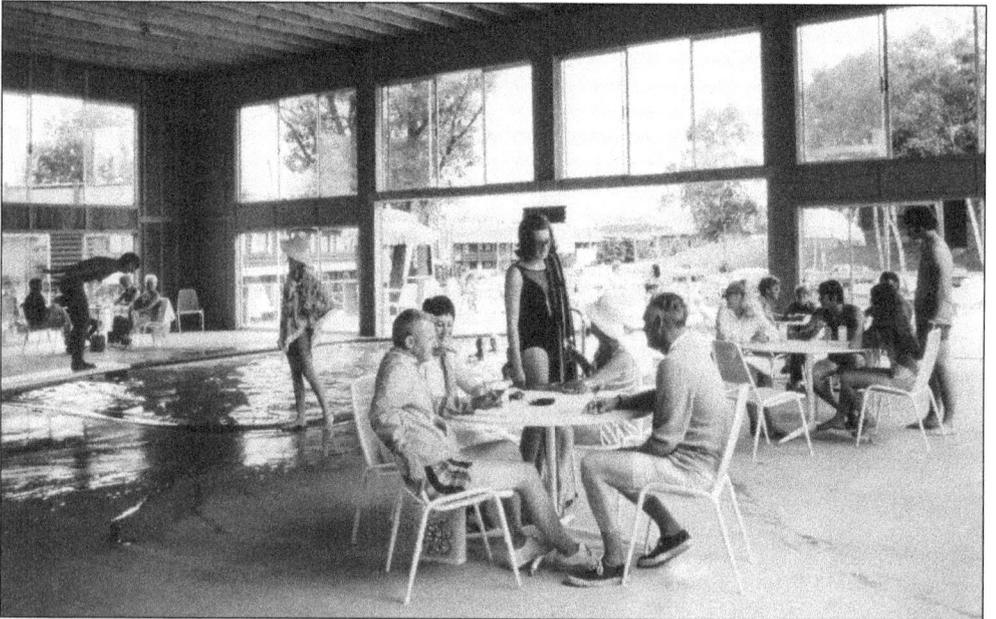

Completed in 1970, Breezy Point's indoor/outdoor pool was a first for northern Minnesota. Most of the area's resorts had swimming pools but not like this one. The indoor section is where the recreation center pool is today. The outdoor portion extended into what is now the parking lot. The new pool was a hit with the guests, but it quickly became a heating and maintenance nightmare for the resort.

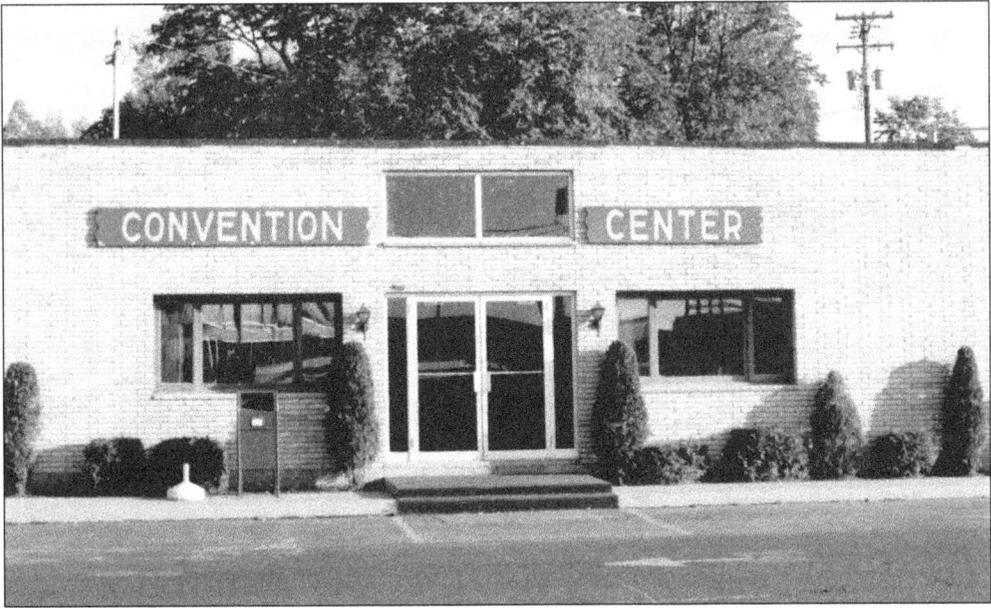

In hopes of attracting lucrative conference business, Hopkins House created two new meeting rooms in Breezy Point's convention center. Eastvold's teen center and dance hall was renovated to host Don Stolz's famous Old Log Theater; productions were put on three nights per week. In 1970, Breezy Point hosted a conference for the Minnesota Association of Secondary School Principals and meetings for local Buick, Chevrolet, Pontiac, and Oldsmobile dealerships.

The Hopkins House relationship helped the resort overcome obstacles and attract new convention business. Twin Cities companies that restricted their employees' attendance to locally held conventions could receive billings for Breezy Point gatherings from the Hopkins House office in the cities. The resort also operated two reservation offices. A toll-free number connected guests to the Twin Cities office where a switchboard operator forwarded calls to Breezy Point.

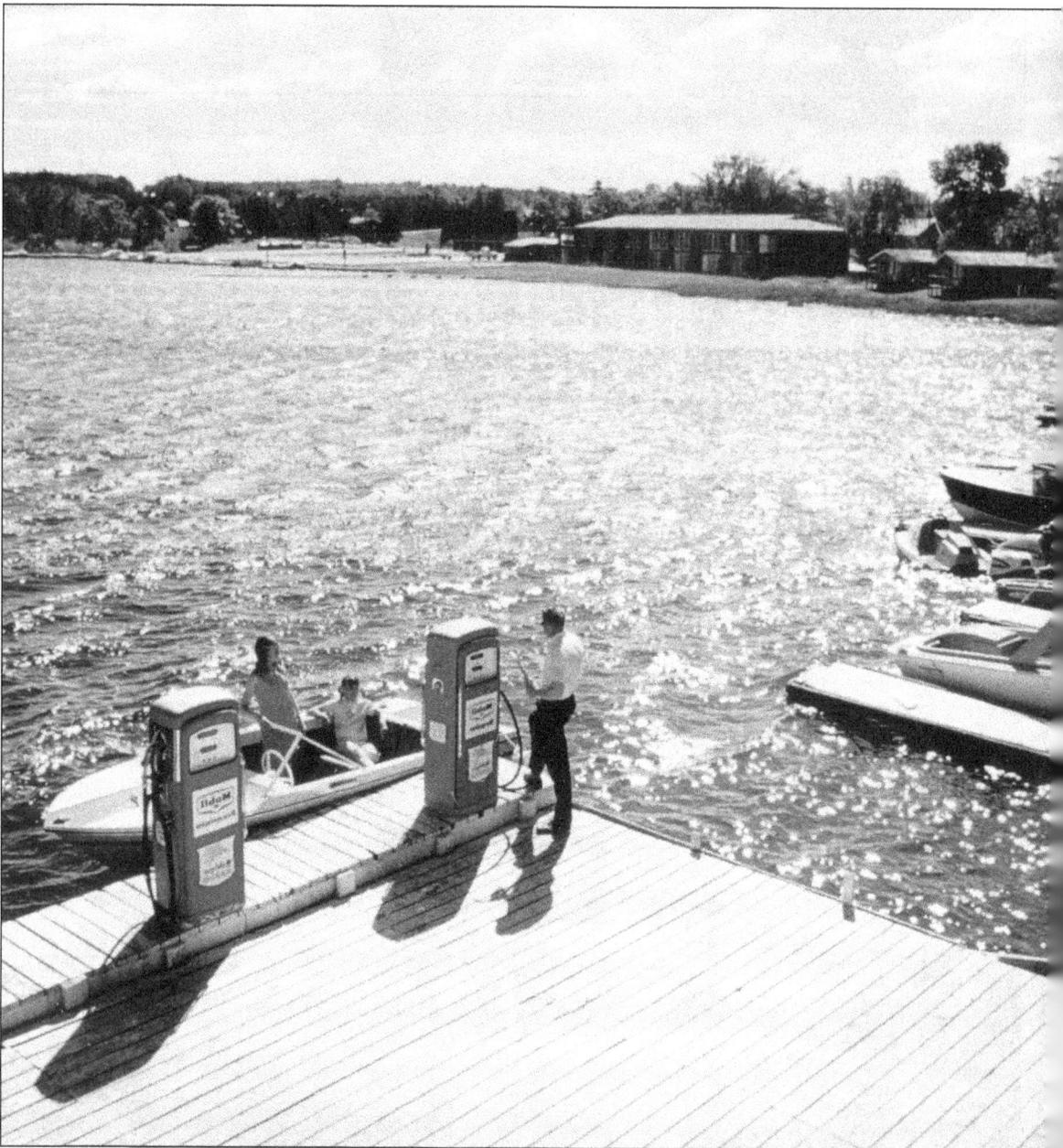

Regular and premium gas pumps installed in front of Breezy Point's dockside bar provided bartenders and wait staff many an anxious moment as guests, drawn to the view, wandered the deck drinking cocktails and waving lit cigarettes. Getting them away from the gas pumps and back into the bar became an important part of every employee's job description.

In 1968, George Montgomery carved a three-mile racetrack out of the pine country 25 miles south of Breezy Point. Montgomery's Donnybrooke Speedway grew into the Brainerd International Raceway. The sport brought big names to the area, such as A.J. Foyt, Carrol Shelby, Jackie Stewart, and Paul Newman. Racing fan Dick Smothers called Breezy Point home during the racing weekends, and locals went looking for celebrities at the supper club.

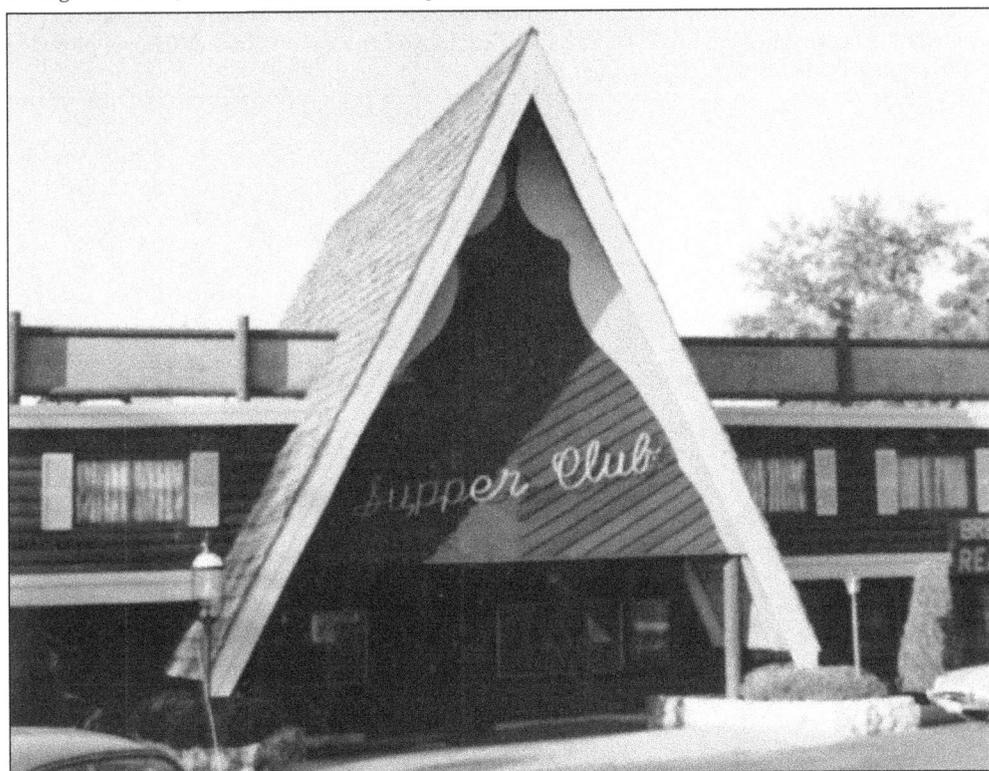

Hopkins House Breezy Point brought popular entertainment back to the North Woods. Comedy acts, ballroom dances, and Las Vegas–style show bands kept guests up late in Breezy Point Supper Club's Chandelier Room. The atmosphere was still formal and guests dressed for dinner. Headliners included William and Rae, the Swinging Ambassadors, Gene White, and Russ Carlyle.

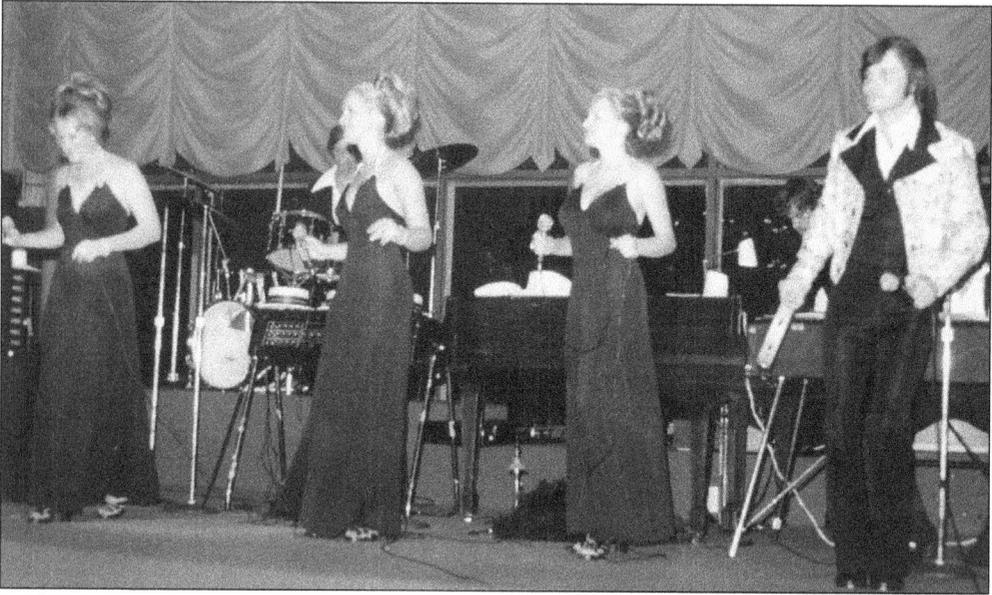

In the 1970s, most of the resorts in the Brainerd Lakes area only opened their restaurants on weekends during the early part of the season. In an effort to bring people north during the week, Breezy Point advertised "Unweekender" promotional packages. The Supper Club stayed open seven days a week from Memorial Day to Labor Day. Lloyd Peterson and friends (above) provided nightly entertainment in the Chandelier Room.

When they were not swinging and swaying in the supper club's Chandelier Room, Lloyd Peterson's backup singers (pictured) soaked up the northern sun on Breezy Point's sandy shore. Pelican Lake still has some of the finest beaches in the Midwest. Shallows extend for hundreds of feet. Even a dog has to walk a long way out before the water gets deep enough for a swim.

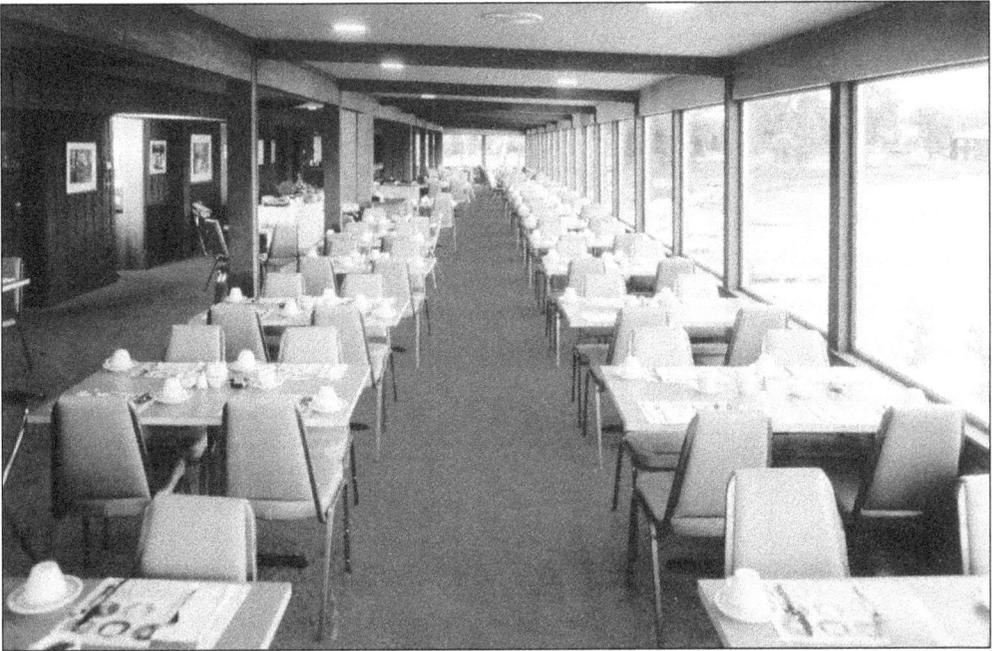

On hot summer days, diners and drinkers found the lakeside screen porch of the marina restaurant unbearable. A decision was made to enclose the porch and open up the marina's dining room. The sloping floor, originally designed for runoff, retained a steep pitch. Guests seated near the windows must have felt like they were about to topple into the lake.

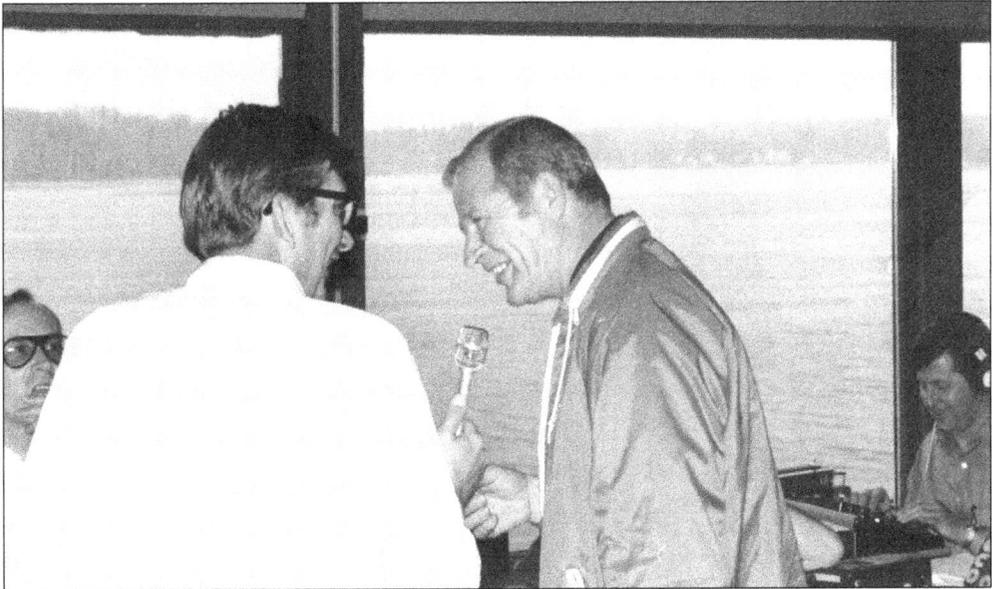

In the spring of 1970, Breezy Point and Pequot Lakes found themselves in the spotlight when they hosted Gov. Harold LeVander's "Governor's Fishing Opener." Volunteers and professional fishing guides like Marv Koep, Harry VanDorn, and Ron Lindner provided services and took advantage of widespread press coverage. WCCO's popular morning show team, Charlie Boone and Roger Erikson (above interviewing the resort's general manager Jim Harmon), broadcast live from Breezy Point.

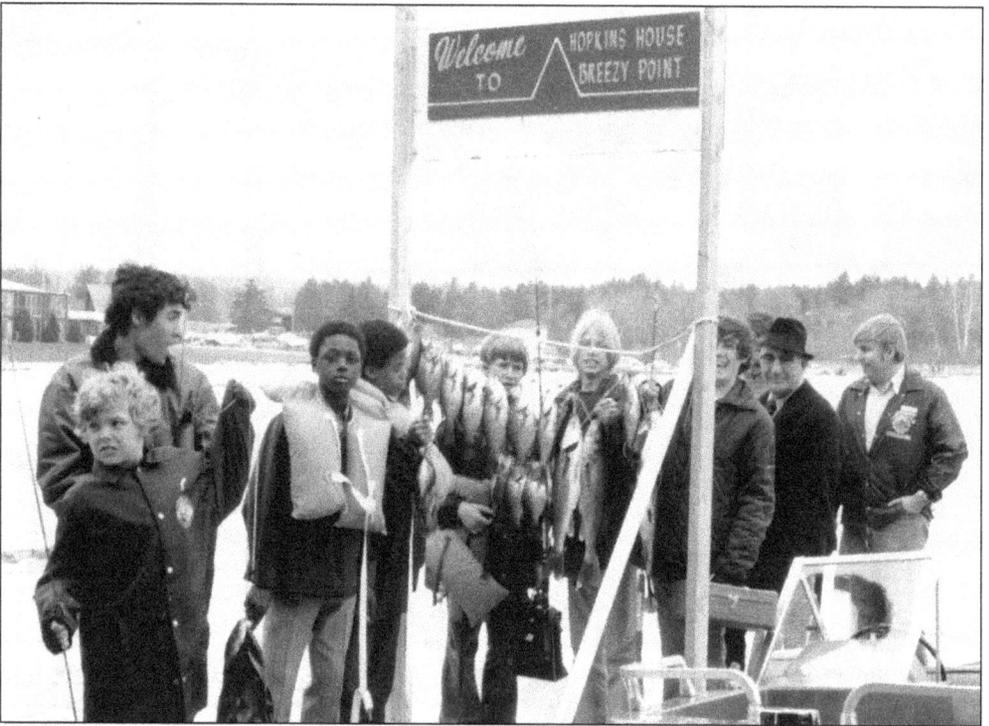

An abundance of walleye, northern pike, largemouth bass, pumpkinseed, and bluegill has made Big Pelican Lake one of Minnesota's premier fishing destinations. Generations of anglers, youth groups, and professional guides have spent countless summers learning the ropes and reefs of this legendary body of water. The lake can be pretty windy, but clear water allows trawlers to follow the weed lines. Most are lucky more often than not.

Breezy Point's ownership was shuffled again in 1972. The Hopkins House partners reorganized and created partnerships for Dave Gravdahl and Jim Harmon. Another group was formed with Hopkins House and Don Eastvold's former partner, Jerry Lenz. This forerunner of Whitebirch, Inc., purchased 2,700 acres of adjacent land from Grandview Lodge owner Reynolds "Brownie" Cote. Plans called for another golf course, a ski area, an RV park, and 5,000 campsites.

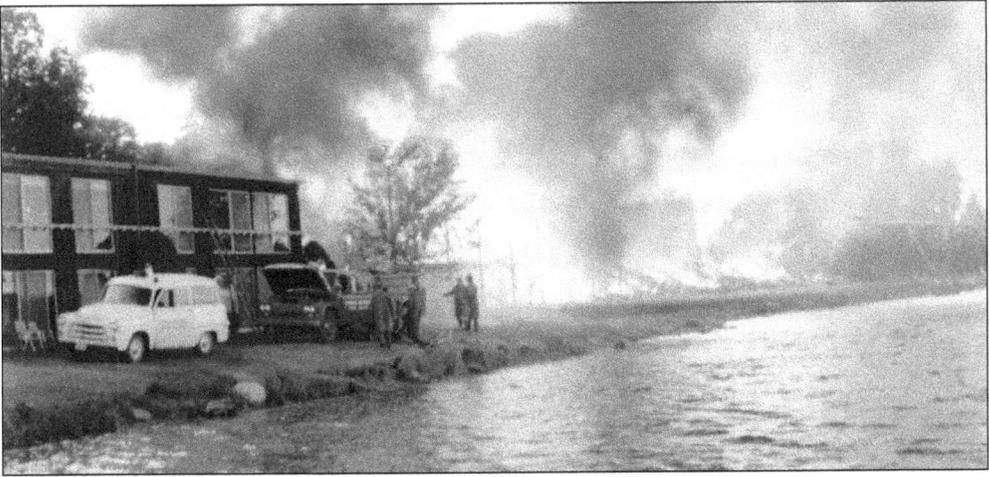

On July 14, 1976, a terrible fire tore through the lodge apartments. The flames destroyed 20 of the building's 50 apartments before they were brought under control. The blaze may have been caused by a case of liquor left on a stove. The remaining 30 units were used for the rest of the season. The 20 units destroyed in the fire were rebuilt the following year.

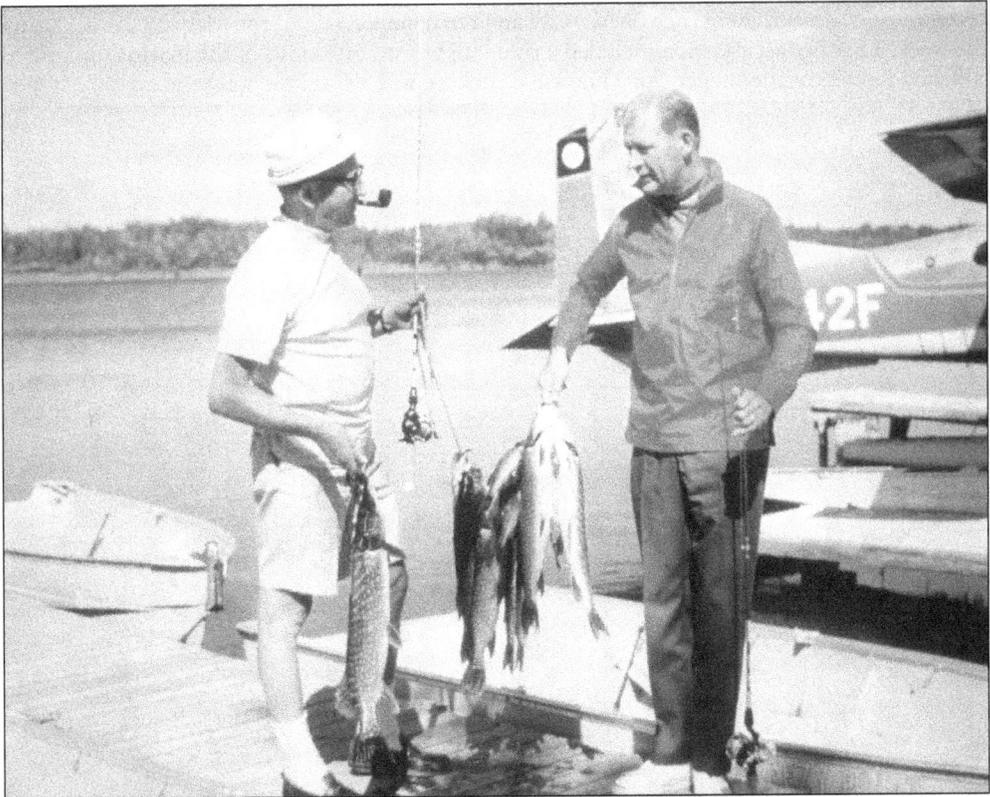

Jim Harmon (left) became Breezy Point's resident manager in 1968 after the resort was acquired by Hopkins House. Harmon was put in charge of the resort's reopening. He had no employees, no reservations, and poorly maintained facilities, but he went to work and Breezy Point was ready for business on Memorial Day. Four years later, Harmon become a partner with Hopkins House and the general manager of Breezy Point.

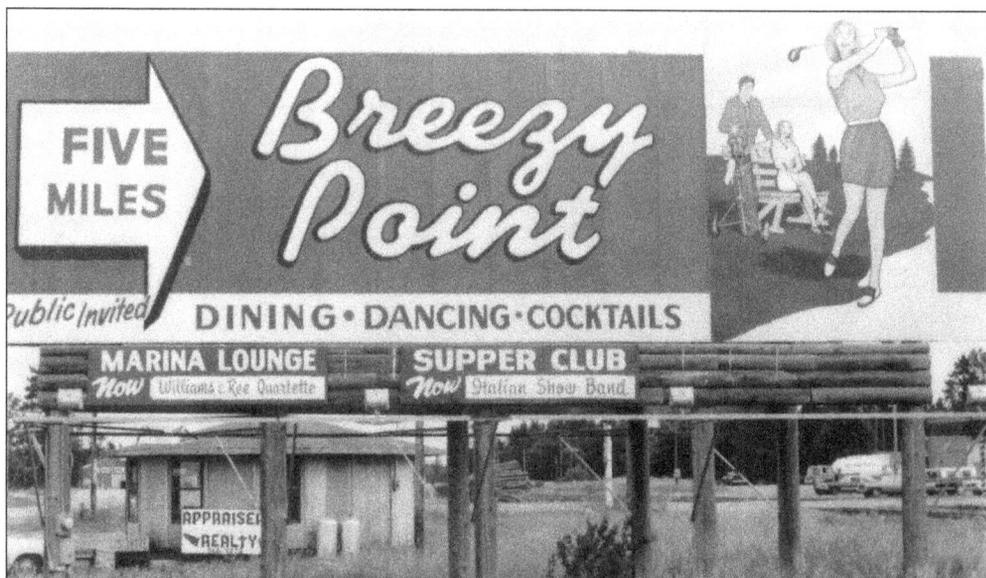

Breezy Point built on the resort's golf course reputation. In the 1970s, Hopkins House bought Twin Cities television advertising time on WTCN and ran commercials on the *Mel Jazz* show. During the week, a $79 budget vacation included a three-night stay, breakfasts at the marina, unlimited golf, and dinners at the supper club. The same package was $89 on the weekend.

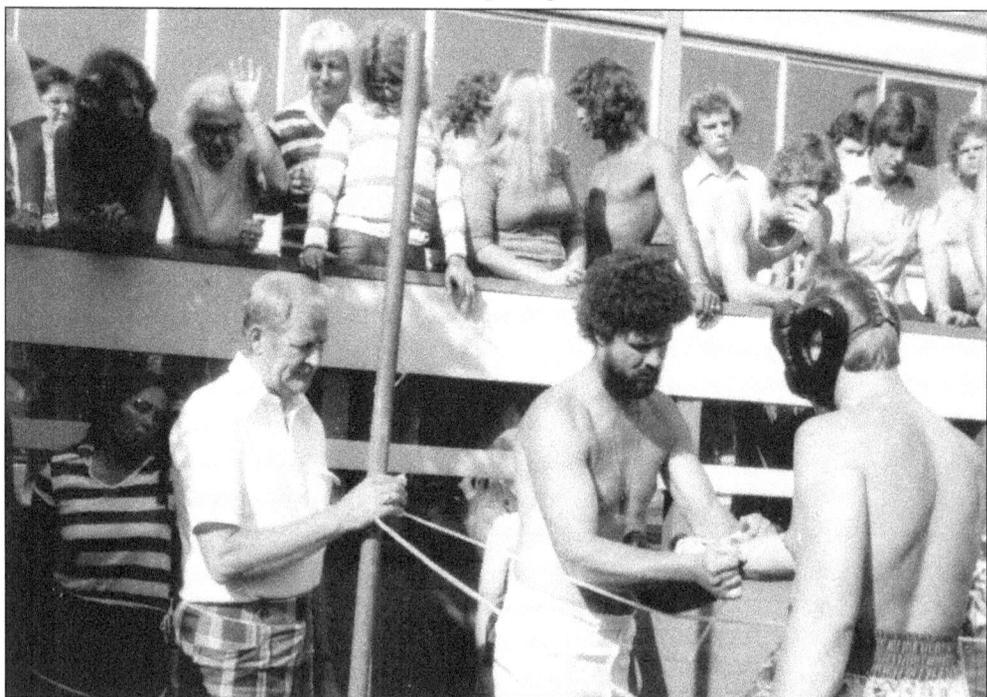

In 1976, the first Breezy Point Celebrity Golf Tournament drew Minnesota Vikings Paul Krause, Mick Tingelhoff, Bob Lurtsema, Dave Osborne, and Grady Alderman. After a round of golf, the resort set up a boxing ring in the parking lot. Professional heavyweight Scott LeDoux went six rounds with a sparring partner before Mick Tinglehoff and Dave Osborne got in the ring and took a beating from the "Fighting Frenchman."

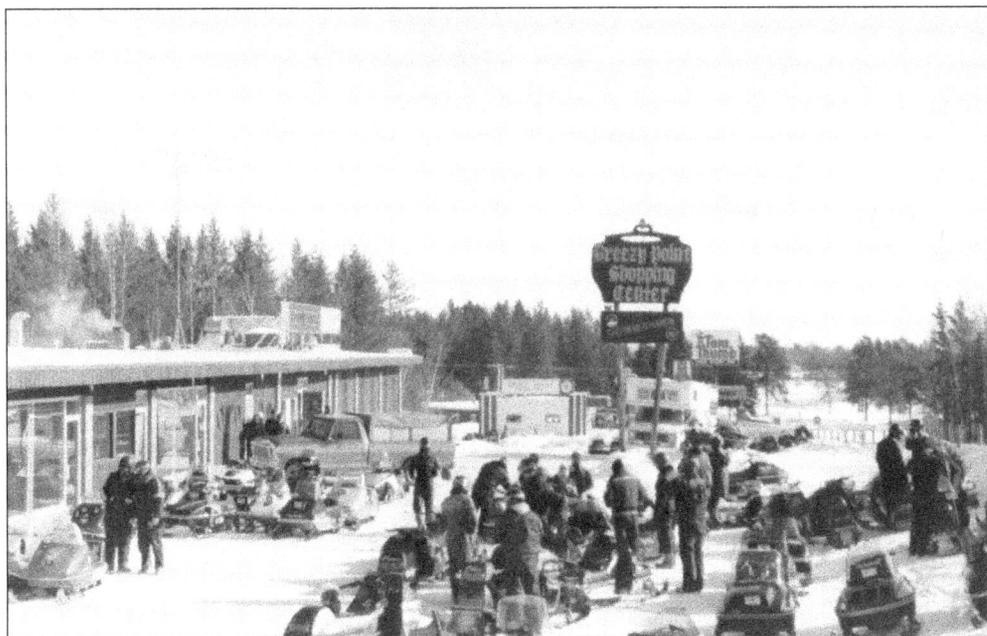

Winter business at the Hopkins House Breezy Point Resort picked up in the early 1970s. A few years of better-than-average snowfall brought thousands of snowmobilers into the Brainerd Lakes area. Breezy Point became a favorite for clubs. The resort operated a fleet of 20 rental snowmobiles in hopes of attracting those who did not own a machine. In 1975, John Deere headquartered its racing team at Breezy Point.

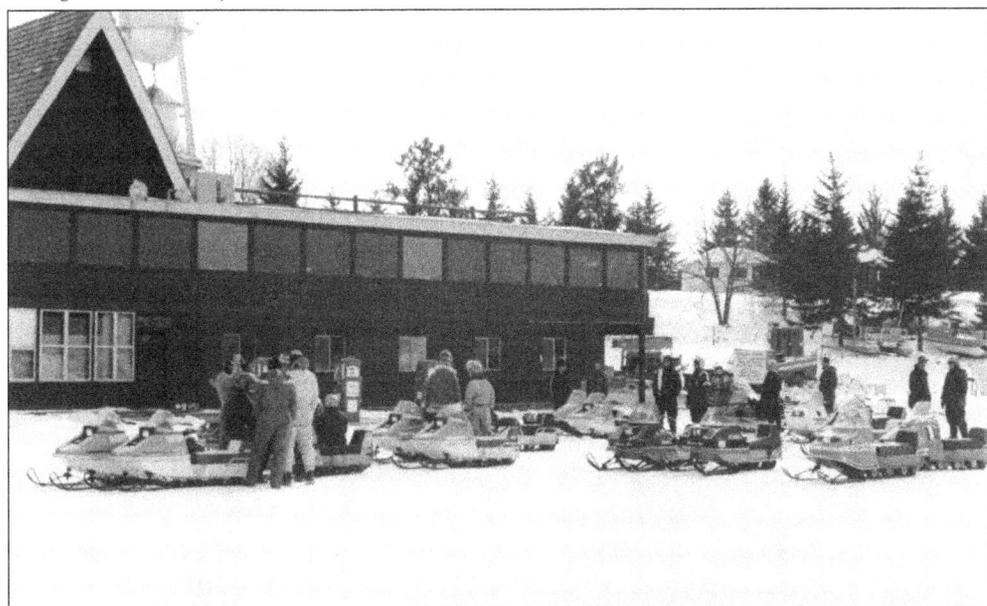

The snowmobile business kept Breezy Point open on weekends from Christmas through the middle of March. Unfortunately, the snowmobiles of the era were less than reliable. Local mechanics did a brisk business, and the resort's bartenders were kept busy by disappointed riders drowning their sorrows and waiting for repairs to be completed. For much of the 1970s, Breezy Point closed at the end of March and reopened for summer season in May.

Less than a decade after Ginny Simms invited "all young ladies and gentlemen" to come and dance to rock-and-roll music at Breezy Point's Teen-a-Go-Go club, bands like the Jet and Toni, Asian Society, and the Italian Show Band made the resort's marina lounge a Brainerd Lakes area hot spot. The casual atmosphere brought in young guests and provided an exciting alternative to the formal dining atmosphere of the supper club.

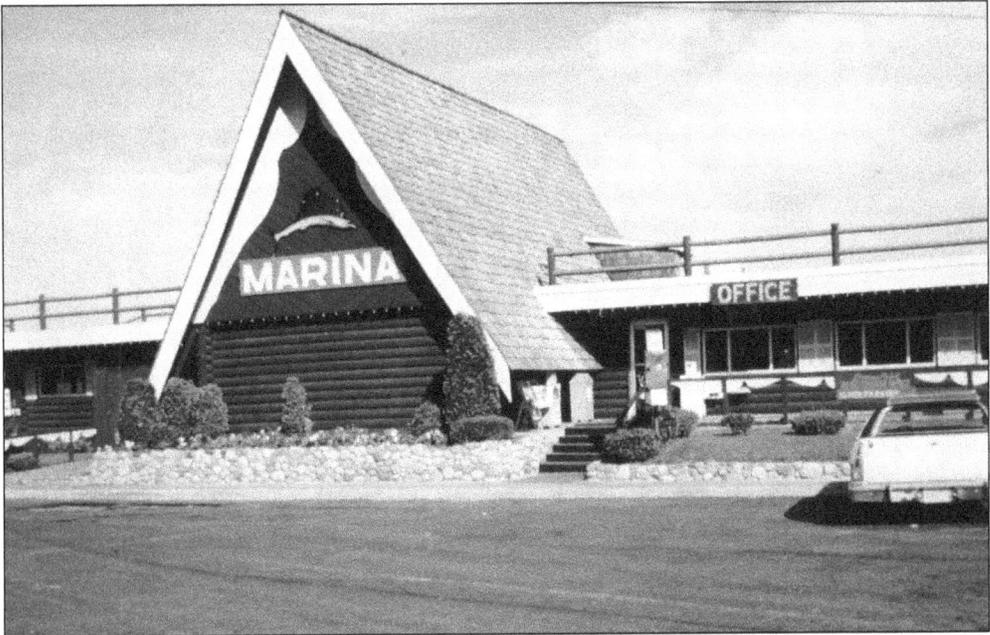

In the late 1970s, conferences began to fill the gaps between busy weekends. Breezy Point hit the big time when Bayliner Marine booked the resort for five days. The company trucked in boats from Seattle, and the resort reconfigured docks to accommodate a 34-foot sailboat and 42-foot cruiser. At the end of the week, Bayliner boasted that sales at the conference topped $23 million.

Captain Billy's Whiz Bang began pushing the cultural envelope decades before the appearance of *Playboy*. Fawcett's lasting impact on American culture may be summed up best in Meredith Willson's lyrics to *The Music Man* show tune "Ya Got Trouble": "Is there a nicotine stain on his index finger? A dime novel hidden in the corn crib? Is he starting to memorize jokes from *Captain Billy's Whiz Bang?*" These Playboy bunnies are unidentified.

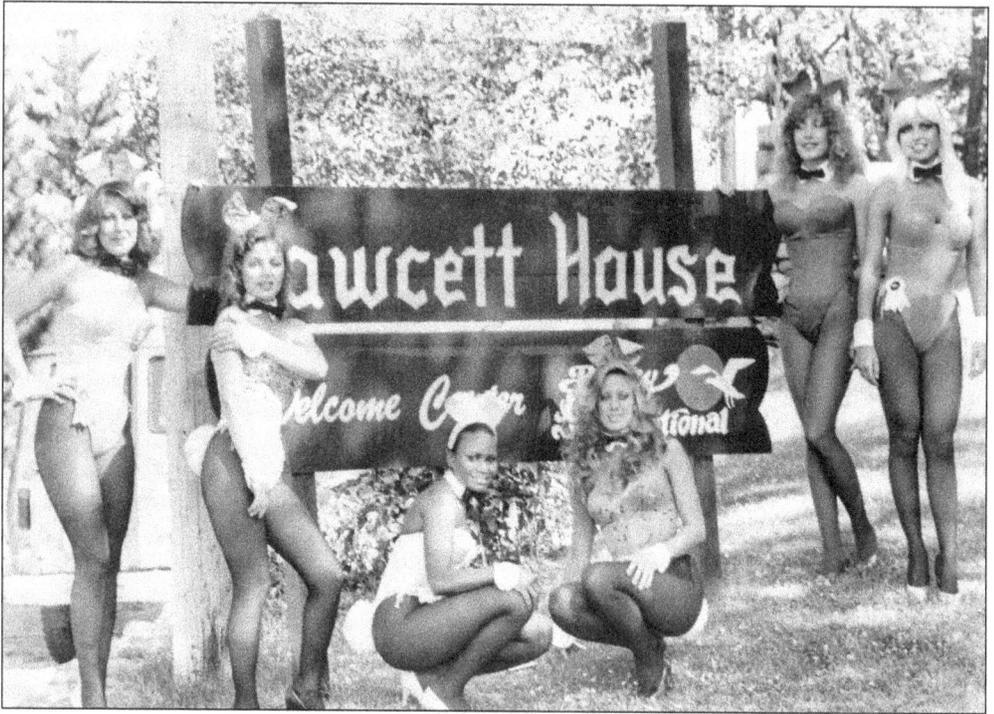

The night the Playboy bunnies stayed in the Fawcett House, Breezy Point's lone police officer Glen Peppel responded to an unusual call. Bats had flown through one of the bunnies' bedrooms. Peppel searched the house but could not find any bats. The bunnies asked him to spend the night in case the animals returned. Peppel apologized and said he could not do that because he was the only officer on duty.

Minneapolis contractor and builder Bel Aire completed the construction of Breezy Point's 100-unit motor inn in 1964. At that time, Minnesota's new condominium law allowed buyers to rent their units and use them as income-producing property for tax purposes. Prices for the units started at $6,500. In the early 1970s, the motor inn was renamed and marketed as the Pinewood Cabanas.

Hoping to attract winter visitors, Breezy Point Estates built a ski area in 1965. The chalet featured a bar, restaurant, and stone fireplaces. Unfortunately, the resort went bankrupt, and the slope was closed. The chalet sat empty until 1969, when the building was remodeled and opened as a restaurant called the Four Seasons. The name was changed to Charlie's after Hopkins House Breezy Point purchased the business in the 1970s.

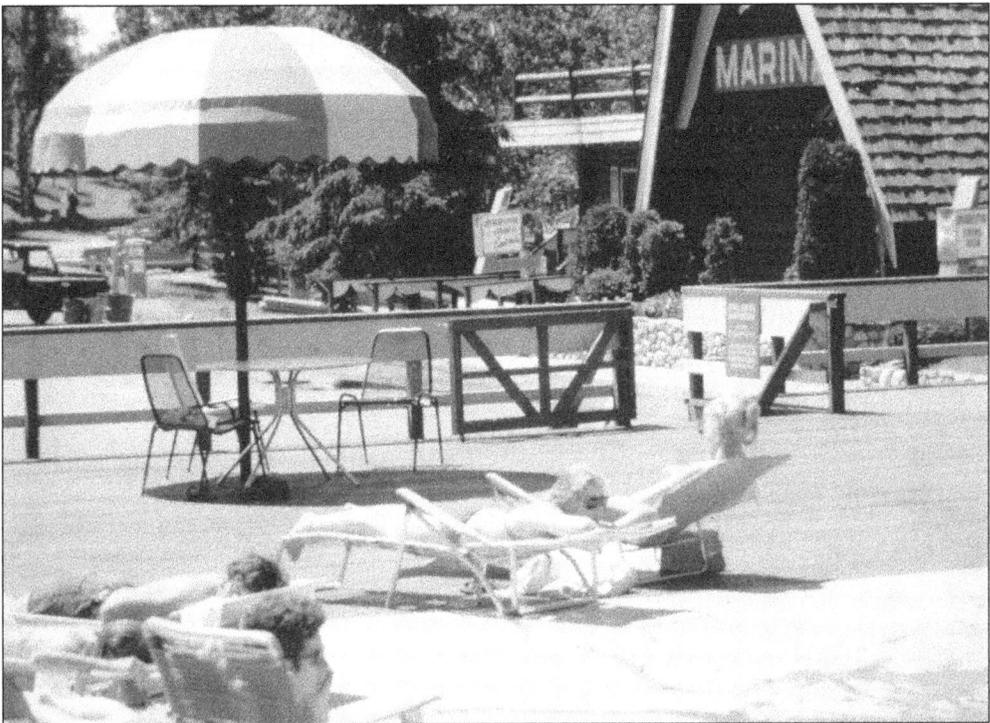

The community around Breezy Point incorporated as the Village of Pelican Lakes in 1939. The name caused some confusion because the village was located on Big Pelican Lake next to Pelican Township. The resort petitioned the village council for a name change. On January 5, 1970, the name of the incorporated village was changed from Village of Pelican Lakes to Village of Breezy Point. The village became a city in 1974.

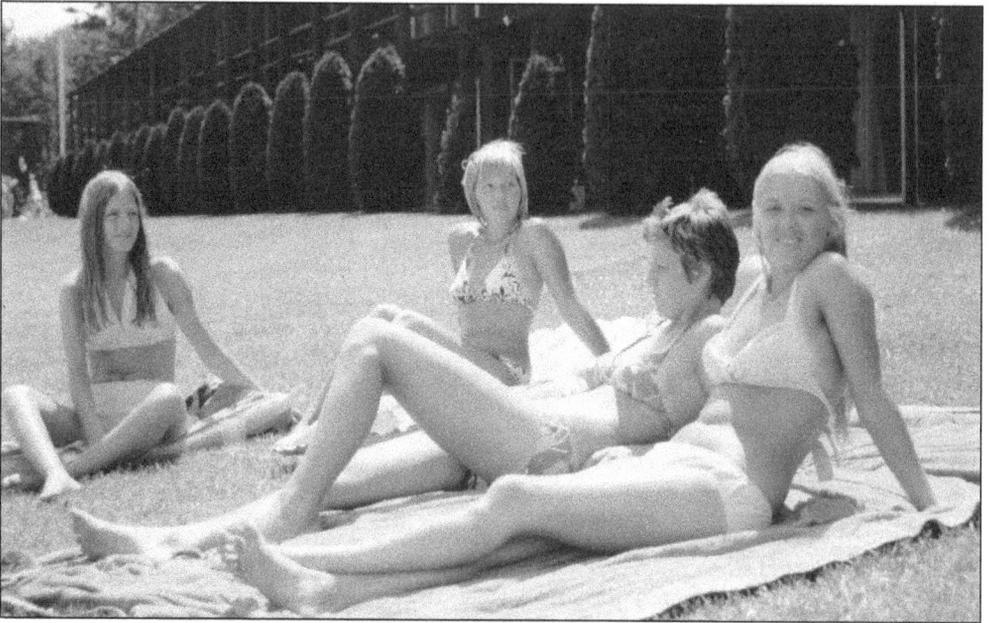

Jerry Lenz and Hopkins House formed Whitebirch, Inc., to develop 3,000 acres of Breezy Point. In 1977, Bob Spizzo bought a portion of Lenz's ownership and began the development of Minnesota's first time-share operation. In 1981, Spizzo offered to purchase a 50 percent ownership in Whitebirch, Inc. Hopkins House countered with an offer to sell the entire resort. After the financing was arranged, Spizzo and Lenz became Breezy Point's new owners.

Dave Gravdahl (holding the towel) got his first Breezy Point job as a caddy in 1953. He went from the golf course to the kitchen before he joined the Marines in 1955. Gravdahl returned to the resort with the Hopkins House in the late 1960s and became a partner. In 1982, the resort was sold to Bob Spizzo and Gravdahl became the general manager of Breezy Point.

Three

TOWARD 100 SUMMERS

In 1974, Hopkins House investors and former Eastvold partner Jerry Lenz established Whitebirch, Inc., for the purpose of marketing and developing 3,000 acres of woodland adjacent to Breezy Point Resort. The initial plans called for single-family residential subdivisions and camping sites. In 1977, Bob Spizzo was recruited by Whitebirch to develop a 750-unit campground. Spizzo had spent the previous five years brokering properties for a Mexican developer on the Sea of Cortez. Opportunity banged on the door. Spizzo bought a portion of Lenz's ownership and moved his family from the sunny beaches of Mexico to the snowy shores of Big Pelican Lake. In 1981, Spizzo and Lenz approached the Hopkins House investors with an offer to buy Whitebirch, Inc. The investors countered with an offer to sell their interest in Whitebirch and the rest of the resort. Hopkins House had helped to reestablish Breezy Point's reputation, but the resort was showing its age and an overhaul of the facilities was needed in order to compete with the area's other well-known destinations. Working with the City of Breezy Point, the new owners created an ambitious 25-year, wide-scale development plan. Spizzo's experience with time-share sales in Mexico convinced him there was a market for time-sharing in the Midwest. Consultants and bankers were skeptical, but Minnesota's first time-shares began with a row of cabins beside Breezy Point's Traditional Golf Course. Architects drew up plans for two units in each cabin. Contractors stripped them down to bare walls before installing all the modern conveniences. Interior decorators transformed the cabins into beautiful studios and two-bedroom homes. The State of Minnesota had never regulated a time-share operation. There were no laws on the books governing the marketing and sale of these units. Whitebirch hired a law firm and draft documents for the adoption of regulations were presented to the state. Upon approval, sales and marketing efforts began. Over the years, 12,000 time-share units have been sold, and today, Breezy Point is the largest time-share operation in the Midwest.

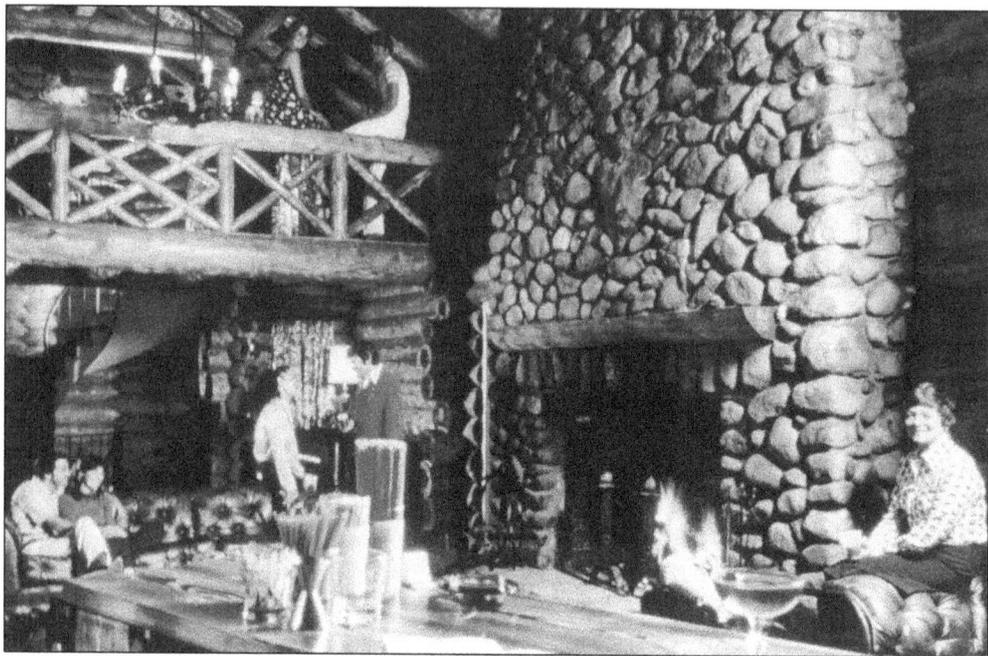

Generations have rented the landmark Wilford H. Fawcett House for vacations at Breezy Point. The fabled log mansion's cathedral ceiling, loft, bar, 11 bedrooms, and 9 baths can easily accommodate family reunions. In 1979, a fire damaged a few rooms, but the outside of the building was unharmed. The interior has been modernized over the years, but renovations have been sympathetic to the history of Captain Billy's beloved resort home.

When Bob Spizzo (center) brought time-sharing to Breezy Point, very few Minnesotans were familiar with the concept. Spizzo went to work educating, advertising, and using events like the annual fishing opener to promote time-sharing as a vacation concept. The idea caught on, and over the years, Whitebirch, Inc. has developed over 240 new time-share units for at least 12,000 owners. Also pictured are WCCO radio's Charlie Boone (left) and Roger Erikson.

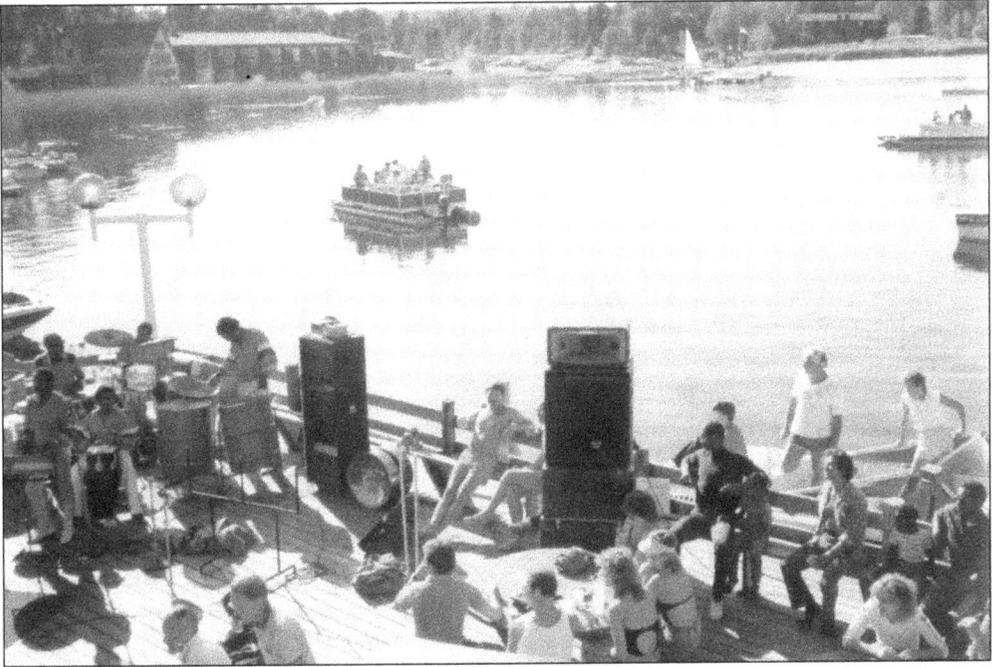

The first time-share units at the resort were created in the row of log cabins near the Traditional Golf Course. The cabins had to be renovated and insulated for winter use. After Whitebirch, Inc., joined Resort Condominiums International, time-share owners could trade their vacation time in Minnesota for equal time at resorts around the world. Breezy Point had something for everyone. Evening entertainments included great music at the marina.

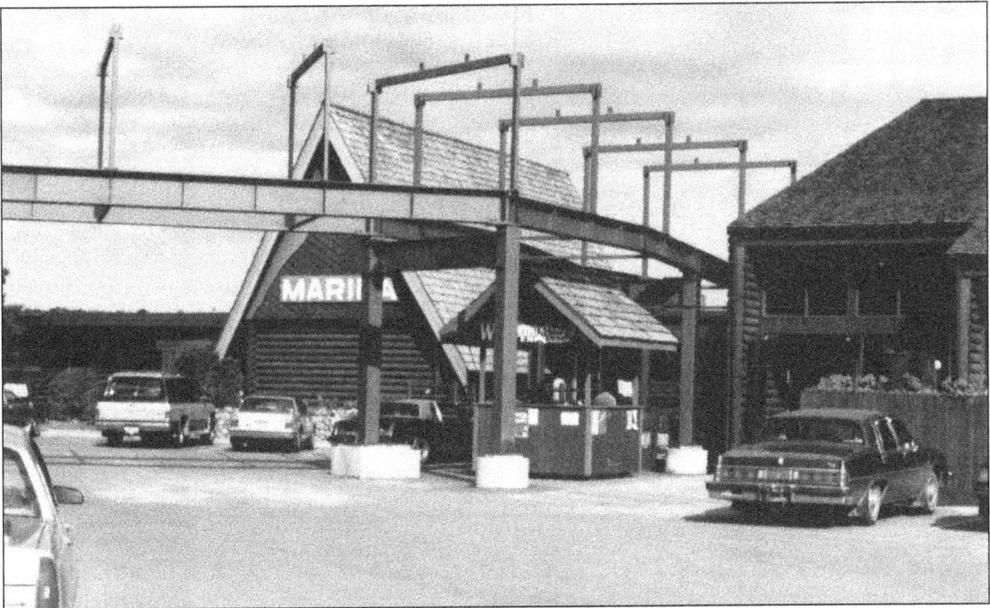

The success of time-sharing at Breezy Point allowed the resort to invest in new facilities. In the early 1980s, about $16 million were spent on construction and renovations. In 1986, Breezy Point built an enclosed, elevated walkway from the new convention center to the marina and Breezy Center's recreational complex.

In 1989, Breezy Point hosted a fishing opener with Minnesota governor Rudy Perpich. After five hours on the lake, Perpich caught a 4.5-pound northern pike. The governor said it was the biggest fish he had ever caught and thanked his guide, Margaret Kavanaugh. Perpich told the *Brainerd Dispatch*, "Margaret is half Finnish and half Irish, I owe it to her Irish luck and her Finnish fishing skills."

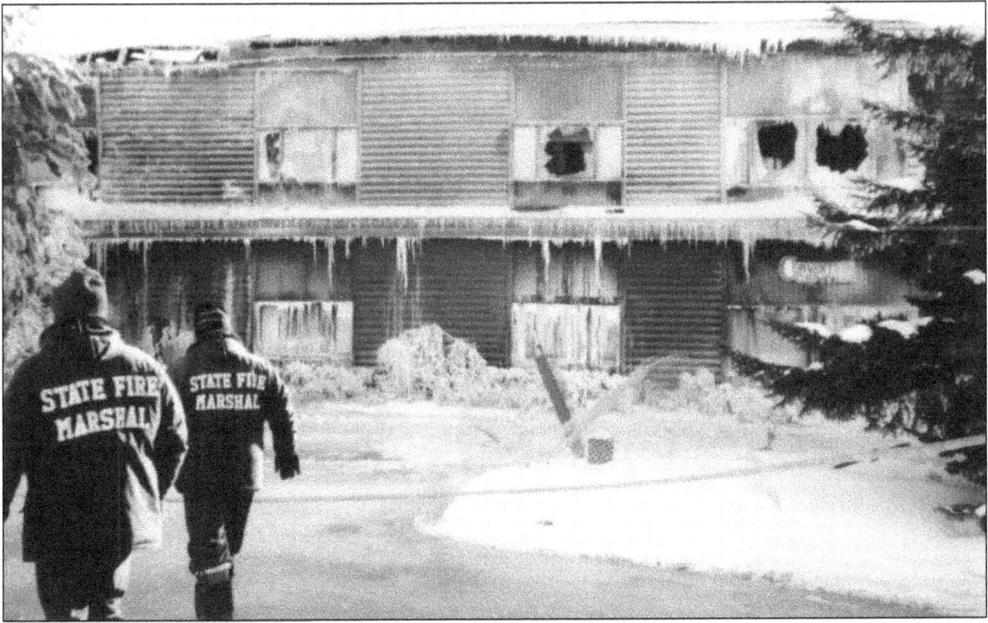

When a January 1996 fire was spotted on the roof of Breezy Point's convention center, calls from cabins on Fawcett Hill warned employees that the building was on fire. Fire departments from Pequot lakes, Nisswa, Ideal, and Mission responded as flames swept through the 10-year-old building. Firefighters prevented the fire from moving through the walkway to the marina. A few firefighters suffered minor injuries. No guests or employees were injured.

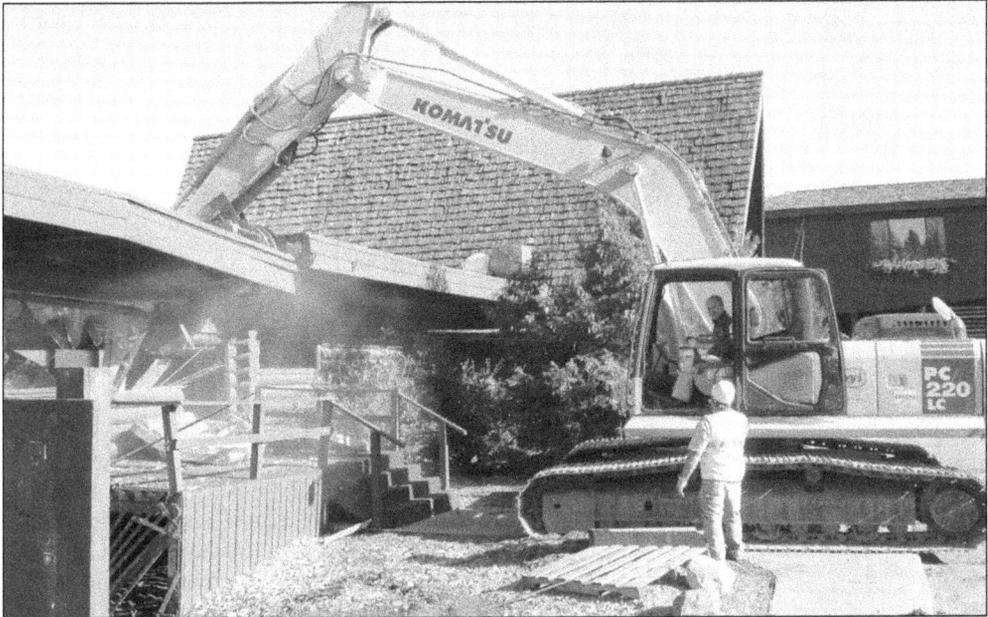

The Breezy Point Marina Restaurant & Bar, built by Don Eastvold and Ginny Simms in 1963, was torn down on October 3, 2007. A crowd, which included some who were there when the marina first opened, watched as resort president Bob Spizzo climbed into an excavator and took a ceremonial swipe at the building. Trucks lined up to haul away debris, and the site was prepared for the construction of the Breezy Point Marina II building.

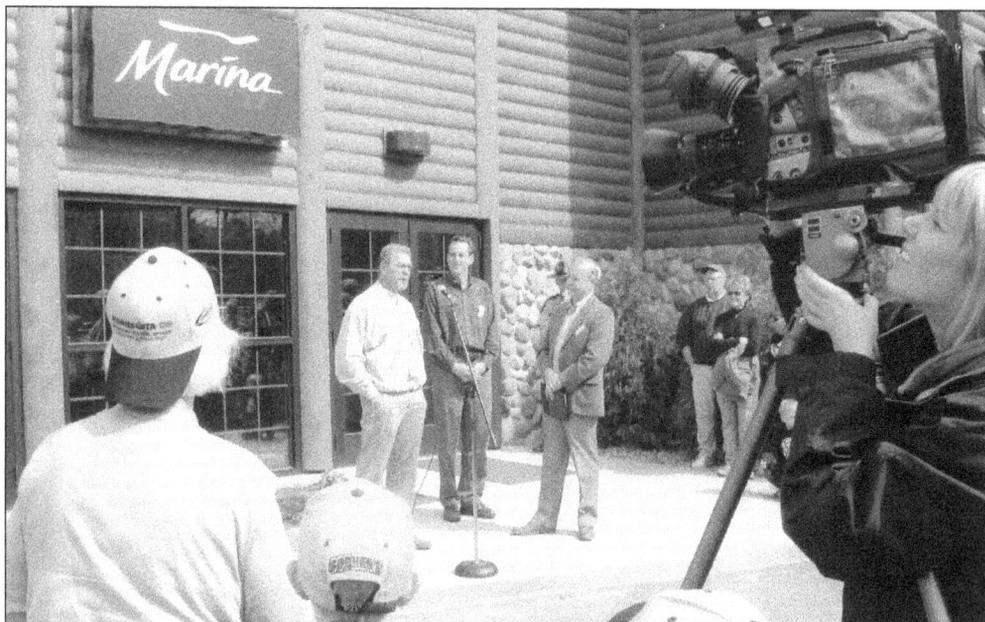

In 2008, the grand opening of Breezy Point Marina II Restaurant & Dockside Bar happily coincided with the Minnesota Fishing Opener. Gov. Tim Pawlenty (center) joined resort owner Bob Spizzo (right), honored guests, locals, and news media from all over the state at the ribbon cutting. Shortly after the ceremony, the fishing results came in, and it was announced Carol Molnau, Pawlenty's lieutenant governor, had out-fished him.

Chris Olson did not know he was born to play Elvis; fortunately, his wife and booking agent, Mary Ann Olson, did. When they met, she listened to nothing but Elvis. When she heard her husband singing along, she decided that she needed to share him with the world. Olson agreed to grow sideburns, and the *Memories of Elvis Show* was born. The act has been attracting fans to Breezy Point for over 20 years.

Arnold Palmer's consulting group, Palmer Design, started work on the layout for Deacon's Lodge in 1997. The golf course beautifully incorporates 450 acres of the rolling pine country. Due to environmental concerns, Deacon's Lodge was created with a minimum of earthmoving. Designed to blend in with the landscape, the Craftsman-style clubhouse features an inventive, rustic interior. The back patio offers dramatic wetland views.

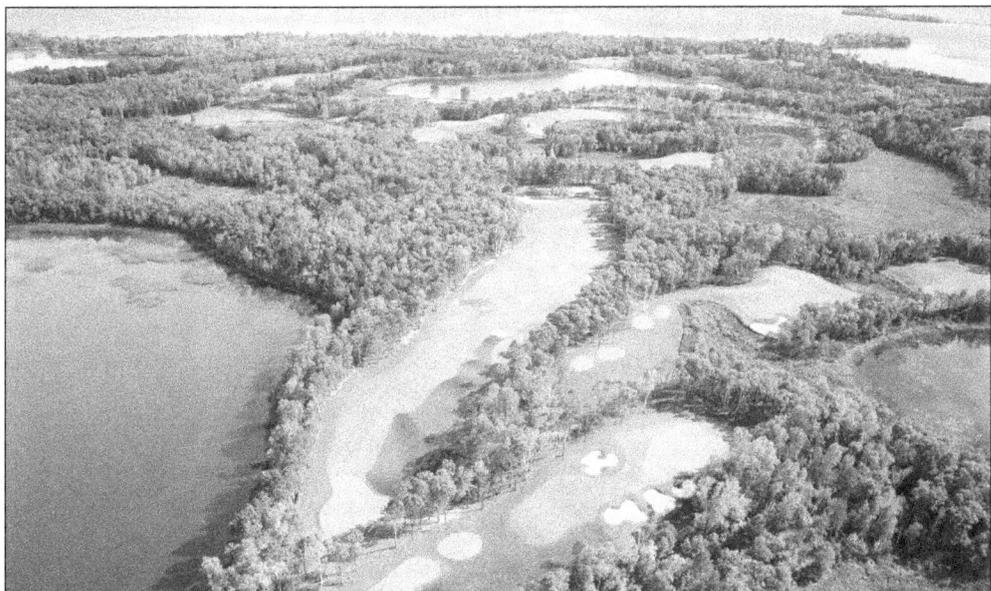

Deacon's Lodge opened on May 31, 1999. Opening ceremonies featured Arnold Palmer and Minnesota governor Jesse Ventura. Palmer designed the course and named it after his father. After Breezy Point Resort's parent company, Whitebirch, Inc., purchased nearby Deacon's Lodge in 2013, the company invested in new equipment and worked to restore and maintain Palmer's design. *Golf Digest* ranks Deacon's Lodge among "America's 100 Greatest Public Courses."

After the idea of a city-owned ice arena met with a lukewarm reception, Bob Spizzo proposed a facility owned and operated by the resort. Commercial banks had no interest in underwriting the project; fortunately, financing was available through a US Department of Agriculture Rural Utilities Service development program. Ground-breaking ceremonies for Breezy Point Ice Arena took place on April 15, 1999. The arena opened for business the following winter.

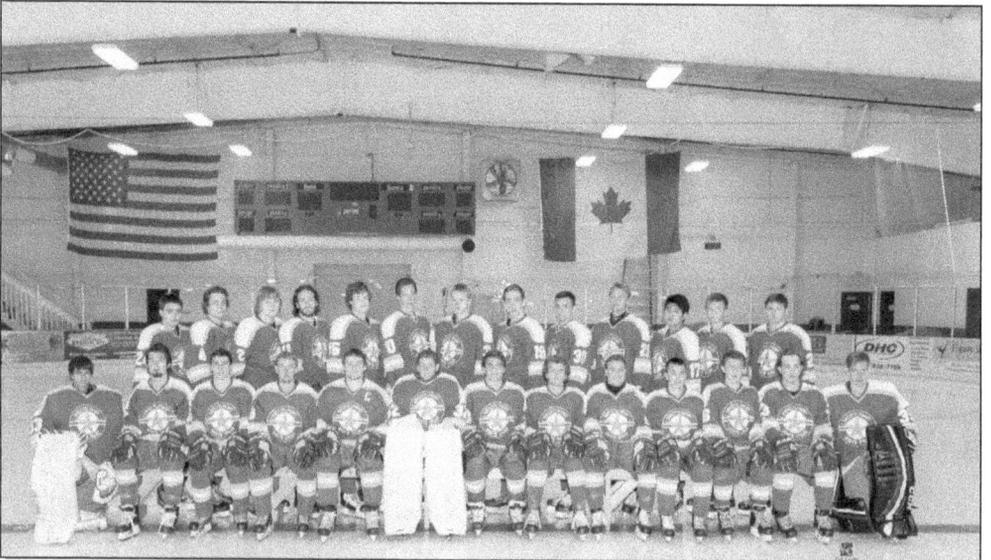

In January 2012, Whitebirch, Inc., officially acquired a franchise in the North American Hockey League's Junior Tier III circuit. The Breezy Point North Stars are based in the resort's ice arena. The program is committed to amateur players, 20 and under, in search of advancement to collegiate programs and professional opportunities. Players are recruited from all over the country and housed in dormitories behind the arena. (Courtesy of Kelli Engstrom.)

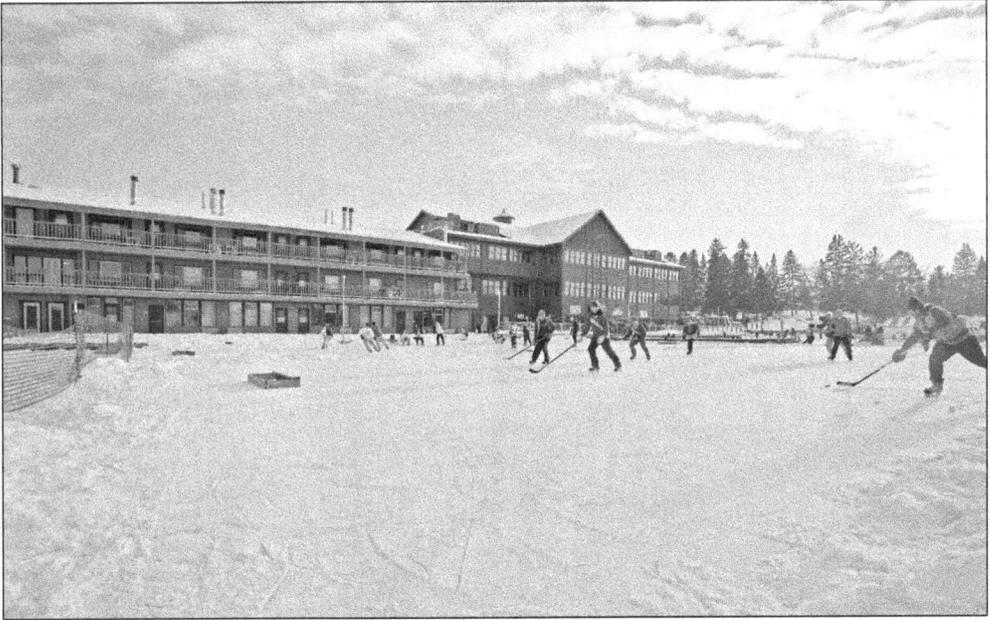

Breezy Point has been a winter vacation destination since the 1970s. In addition to snowmobiling and ice fishing, the resort draws crowds to a variety of annual events. Every January, Breezy Point Ice Fest features broomball, snow golf, sleigh rides, ice sliding, pond hockey tournaments, and the Power Ice Auger World Championships. In March, hundreds jump through a hole in the ice for the annual Special Olympics Polar Bear Plunge.

In 1977, Bob Spizzo joined Whitebirch, Inc., moved his family to Northern Minnesota, and went to work developing residential acreage around Breezy Point. Four years later, Spizzo purchased the resort. Under his leadership, Breezy Point introduced time-sharing to Minnesota, added a convention center, two 18-hole golf courses, a 120-unit hotel, three indoor pools, a recreation center, and an ice arena.

Commissioned for Breezy Point Estates by Ginny Simms, this steel and porcelain enamel sculpture was designed and constructed by Warren T. Mosman, art director for Ellerbe Architects in St. Paul. Mosman's other works include relief sculptures on the Farmers and Mechanics Savings Bank Building in Minneapolis and the granite murals of Notre Dame's University Library in Indiana. Originally installed at the gates, the sculpture has been relocated to the marina.

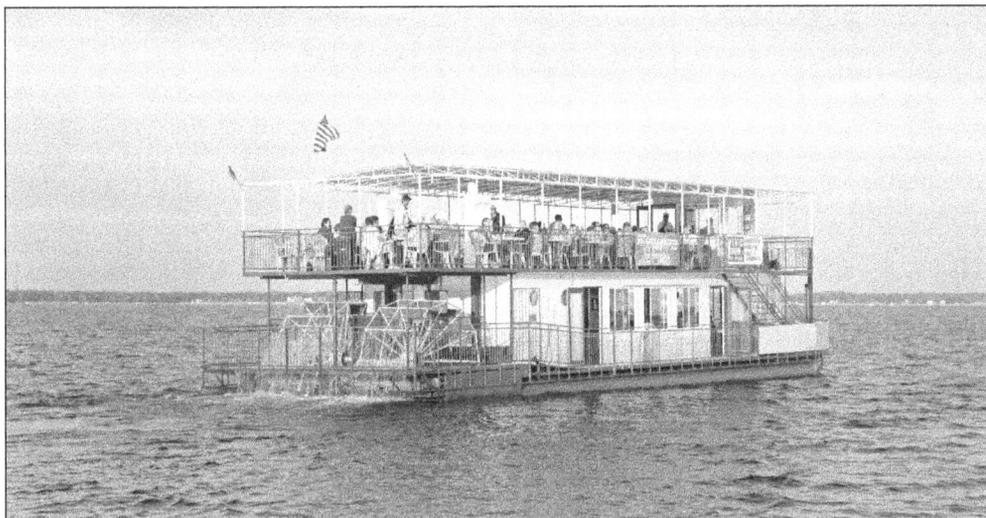

In 1981, a 57-foot, 50-passenger cruise boat called the *Paddlin' Pelican* made its debut on Big Pelican Lake. For the next 15 years, the boat, commanded by Fredrick "Captain Bud" Gaylord, hosted countless scenic tours. The *Paddlin' Pelican* retired with its captain in 1996. Dinner cruises and tours returned to the lake when the 75-foot, 100-passenger stern-wheeler *Breezy Belle* hosted its premier cruise in 2010.

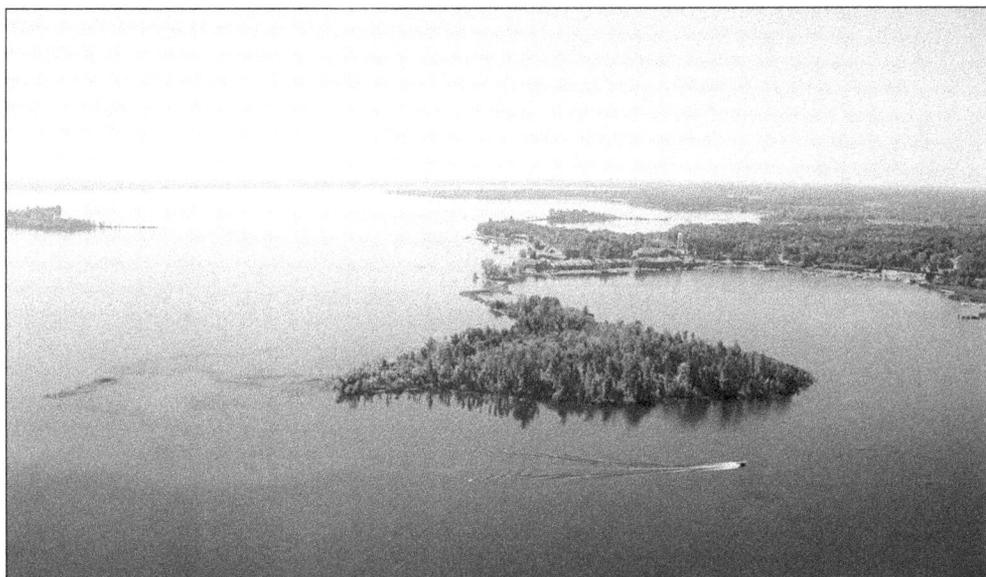

For generations of Minnesotans, the mere mention of Breezy Point has conjured up warm memories, elicited wild stories, and evoked wry smiles. Almost 100 summers after Captain Billy built his Whiz Bang resort on the sandy shores of Big Pelican Lake, Breezy Point is still the "Queen Summer Resort of the Northern Pines."

Visit us at
arcadiapublishing.com

www.ingramcontent.com/pod-product-compliance
Lightning Source LLC
Chambersburg PA
CBHW080602110426
42813CB00006B/1382